A(ZX)103

An Introduction to the Humanities

The Open University

History, Classicism and Revolution

Block 3

This publication forms part of an Open University course A(ZX)103 *An Introduction to the Humanities*. Details of this and other Open University courses can be obtained from the Student Registration and Enquiry Service, The Open University, PO Box 197, Milton Keynes, MK7 6BJ, United Kingdom: tel.+44 (0)870 333 4340, . email general-enquiries@open.ac.uk

Alternatively, you may visit the Open University website at http://www.open.ac.uk where you can learn more about the wide range of courses and packs offered at all levels by The Open University

To purchase a selection of Open University course materials visit http://www.open.ac.uk, or contact Open University Worldwide, Michael Young Building, Walton Hall, Milton Keynes MK7 6AA, United Kingdom for a brochure. tel. +44 (0)1908 858785; fax +44 (0)1908 858787; e-mail ouwenq@open.ac.uk

The Open University
Walton Hall, Milton Keynes
MK7 6AA

First published 1998. Second edition 2005.

Edited and designed by The Open University.

Typeset by The Open University.

Printed and bound in the United Kingdom by Scotprint.

ISBN 0 7492 9665 8

2.1

31612B/a103b3i2.1

INTRODUCTION TO BLOCK 3

Written for the course team by Derek Matravers

In the previous block you examined the Colosseum from the perspective of both classical studies and art history. You saw that the Colosseum is more than simply a ruin; both as a piece of architecture and as an embodiment of a view of life it continues to exert an influence upon us. This is, at least in part, because people have been, and remain, fascinated by 'the classical ideal': the thought that human life is best guided by reason, justice and beauty, all in perfect equilibrium.

In this block we look at one period in the past during which people attempted to draw on that ideal: the French Revolution. Appropriately enough, it is also the block in which you are introduced to the study of history; that will occupy the first two weeks of the block. The third and fourth weeks return you to philosophy. In Block 1 you looked at the essential philosophical techniques governing reason and argument; here you will apply those techniques to a problem in political philosophy. In the final unit of this block, the methods of looking that you learned in the art history unit of Block 1 are placed in the context of a broader historical analysis.

UNITS 8 AND 9 INTRODUCTION TO HISTORY, PART 1: ISSUES AND METHODS

Written for the course team by Arthur Marwick

Contents

STUDY WEEKS EIGHT & NINE

STUDY COMPONENTS

Weeks of study	Texts	TV	AC	Set books
2	*Resource Book 2* *Illustration Book*	TV8 TV9	AC4, Band 1	–

Aims and objectives

The aims of these units are:

1 to introduce you to the basic purposes, methods and principles of historical study (to be continued in Units 25 and 26);

2 to discuss some of the main aspects of the origins, course and aftermath of the French Revolution with a view (a) to exemplifying some of the fundamental features of historical study, and (b) to providing the necessary historical context for your studies later in this block of Rousseau, David and Friedrich.

AGSG, ch.2, sect.3.4, 'Setting targets'

The following objectives list what you should be able to do once you have reached the end of each section (as numbered below). You may find this rather overwhelming, so just run through the objectives at this stage, returning to the appropriate one as you start on a new section. Taken together the objectives for these units will seem long and daunting. However, I am particularly anxious to take you step by single step through what it means to study history.

Unit 8

1 Explain the distinction between 'the past' and 'history'.

2 Summarize the argument that 'history is a social necessity'.

3 Explain the distinction between primary and secondary sources.

4 Explain why the past cannot be apprehended directly, but only through the traces it has left (primary sources).

5 Explain what historians mean by 'leg work' and 'strategy'.

6 Describe the enormous range and variety of primary sources, and explain why different types of source have different strengths and weaknesses.

7 Discuss the problems historians face because most primary sources are fragmentary, imperfect and difficult to interpret.

8 While recognizing the subjective elements in history, make the case for the objective basis of historical knowledge.

9 Relate the activities of historians to the argument that all human activities are culturally determined.

10 Explain the significance of controversy in history.

11 Outline the problems involved in the use of technical terms, conceptual terms, collective nouns and clichés (a matter to be investigated more thoroughly in Units 25 and 26).

12 Relate the issues discussed in the unit – and, in particular, the way in which the great range of primary sources can be used to challenge myths – to an outline history of the British family from Roman times to the present. (At summer school you may have the opportunity to do some computer-based data analysis of census material relating to family history.)

Unit 9

1 List the series of questions that has to be asked of any source (and resolved) before evidence or information can be extracted from it, and state why these questions have to be asked.

2 In analysing primary sources, make the distinction between the deliberate, overt message the source was designed to convey and its deeper, 'hidden' assumptions, attitudes and values – that is, distinguish between the 'witting testimony' and the 'unwitting testimony'.

3 Explain the importance of understanding past societies on their own terms (as distinct from our later standpoint).

4 Developing from these three objectives, analyse selected primary sources with respect to their usefulness for the study of particular historical topics, identifying their strengths and weaknesses with respect to the topic in question, and specifying the witting and unwitting testimony they contribute to it. (This rather complex objective summarizes one of the main history assignments you will be asked to do – always on a primary source related to the French Revolution.)

5 Deal succinctly with the question of 'historical facts'.

6 With free access to all the relevant course materials, produce the minimum contextual information needed to do a primary source exercise and to work out the historical context for Rousseau, David and Friedrich.

7 Write several sentences defining history, its aims and achievements, and its value as a training in the handling of evidence of many kinds.

Note on the relationship of Units 8 and 9 to the course so far and to the rest of this block

So far, among other things, you have been introduced to the ways in which works of art, literature, music, philosophy and architecture are created, and to ways in which you should analyse and respond to them. These units continue that approach in that they analyse how history comes to be produced and discuss some of the basic principles of historical study. They are also intended to provide you with essential ideas and information for the studies of the philosopher Jean-Jacques Rousseau (pronounced 'Rouss-oh'), and the artists Jacques-Louis David (pronounced 'Dav-eed') and Caspar David Friedrich (pronounced 'Freed-rick'), which make up the remainder of this block. Rousseau (1712–78) lived during a period in which there was intense discussion among educated people about human rights, equality, liberty, and the nature and legitimacy of government, and in which myth and superstition were challenged by rationality. This period was referred to, both at the time and since, as 'the Enlightenment'. It has often been said that Enlightenment philosophers such as Rousseau (another famous one is Voltaire) provided the intellectual arguments upon which later the claims of the French revolutionaries were based; certainly when the French Revolution did begin in 1789, Rousseau was widely hailed as the originator of revolutionary ideals. In the following years many statues were put up to him, and in April 1794 his ashes were transferred to the Pantheon – the burial place for French heroes. David (1748–1825) lived through the Revolution and is sometimes seen as its 'official painter', representing revolutionary ideals in his paintings. Friedrich (1774–1840) was a lifelong opponent of the attempts of Napoleon, ruler of the French within ten years of the outbreak of Revolution, to conquer Europe. Thus this entire block has quite a sharp focus on the French Revolution: hence the word 'revolution' in the title. In Block 2 you studied some aspects of 'the classics', and were introduced to the notion of 'the classical tradition' as a vital theme in the history of Western culture. Some of the French revolutionaries saw themselves as reviving the best practices of the Roman Republic; David was overtly classicist in his painting (and was a proponent of Neoclassicism – 'new classicism' – in painting). Hence the appearance also of 'classicism' in the block title. Friedrich was a proponent of Romanticism, which was a reaction against classicism and was stimulated in part by revolutionary change. In these two units the example of the French Revolution (and one or two other topics as well – including the history of the British family, something close to home) will be used in explaining what history is and why and how we do it.

Study note

Unit 9 contains more detailed information (on the French Revolution) than Unit 8, which is divided into a large number of relatively short sections. Unit 8 should take you less than a week to complete; Unit 9 will probably need more than a week.

Ideally you should work on Unit 8, Section 12 in conjunction with TV8. I would suggest two alternative approaches, depending on your circumstances:

1 View the programme, work through the section, view the programme again.

2 Read quickly through the section missing out the exercises and my discussions, view the programme, work carefully through the section doing the exercises.

UNIT 8 ISSUES IN HISTORY

1 WHAT IS HISTORY?

One of the most fundamental lessons to be learned from study at this level is that most of the really important words we use have several meanings. When talking about 'culture' or 'class' or 'history', we cannot say: 'this word shall have this meaning and no other'. What we have to do all the time in academic work is make absolutely clear what meaning we have in mind when we use certain important words. Now, my contention is, we will not make progress in our study of history if we do not make a clear distinction between, on the one hand, 'history' and, on the other, 'the past' (a distinction, I fully admit, that is not always made in ordinary conversation – nor indeed among some of those who approach the study of history in a different way from mine). Think about it yourself for a moment or two: can you see the distinction that could be made between 'the past' and 'history'? To avoid misleading you, let me say that by 'the past' I really mean 'the human past'; there's a long past (the 'cosmic past') before the advent of human beings, but that's not what is at issue here.

EXERCISE

What is the difference between 'the (human) past' and 'history'? Here is a clue: we can talk about 'taking a course in history' but would be unlikely to say 'a course in the past', or you might speak of a 'history book' though scarcely of a 'past book'.

DISCUSSION

The distinction is that between, on the one hand, what actually happened in the (human) past (whether or not historians have written about it), which is what we mean when we say 'the past', and, on the other hand, the accounts of the past provided by historians, that is, 'history'. It is a distinction fundamental to our study of what history is and how you do it.

In fact, the two definitions do need more careful spelling out, so here are two more elaborate definitions which you can use for reference, though there is no need to memorize them:

The (human) past is: 'what actually happened, existed, developed and changed, appeared and disappeared – events (battles, assassinations,

invasions, general elections, etc.), societies and dynasties, ideas and institutions, eating habits, marital customs, all aspects of human behaviour, matters large and small – in the past'. The past is there, or rather *was* there, independently of the activities of historians.

History is: 'the study of the past; the past as we know it through the studies of historians; the bodies of knowledge about the past produced by historians'. It is an activity of human beings and the products of that activity. By this definition there are analogies between history and the natural sciences: historians study the past to produce history as scientists study aspects of the natural world to produce science (chemistry, physics, biology, etc.). 'Study the past', as we shall shortly discover, is actually a rather unsatisfactory phrase, and it would be better to say, 'carry out research into (aspects of) the past'. To a great extent, as will be stressed in these two units, this means carrying out research into the evidence, or *sources*, left by the past.

Self-evidently, 'what actually happened in the past' is almost infinite. Inevitably historians select which topics and problems they wish to study (as do scientists). No doubt topics which 'ought' to have been addressed have sometimes been ignored. On the whole the range has expanded remarkably over the years since the end of the nineteenth century, when history as a scholarly discipline became firmly established.

My hope in these units is to induct you into the thought-processes of the historian, to get you – up to a point at least – to 'practise history' (though inevitably you will be practising it on carefully preselected sources) and to apply the basic principles of historical study. I hope also that my approach will encourage you to think about 'the history all around you' (a loose phrase but let it be for the moment) in buildings and museums, and about the issues coming up in the next section on the historical origins of major contemporary developments and events, always there in your newspaper and on your television screen. The word 'history', meticulously and correctly used, covers a range of activities and products: research, the writing up of that research, specialist books and textbooks at various levels, teaching (very important and usually ignored), studying at various levels. A big enterprise, though I hope we can make it a shared one. But why get involved in the enterprise in the first place? Why study history?

2 WHY STUDY IT?

AGSG, ch.6, sect.1.2, 'Studying the arts and humanities'

The key lies in the importance which the past has for the present. Because of this, I argue, societies *need* history. Societies need to be able to distinguish between reliable knowledge and mere myth. This is the argument that history is a *social necessity.*

EXERCISE

Can you think of any ways in which what happened in the past has determined what is happening in the present? Give examples.

DISCUSSION

It is generally agreed that most of the problems of the world today have their origins in the past. I don't know what particular issues will be in the headlines when you read this, but at the time of writing political divisions in Northern Ireland, Palestine, the former Yugoslavia and the former Soviet Union all owe their current state to the past, often the quite distant past. If we are to have any chance of coping with them, we need to have systematic knowledge of these origins (the rise, spread and splintering of religious beliefs, conquests and atrocities, the oppression of the then weak by the then mighty) – that is, history. Modern ideas of democracy, liberty, feminism, etc. originated in specific circumstances in the past; 'liberty, equality, fraternity' – as you may know – was a slogan of the French Revolution, a past event which seems to stand out as demanding close and systematic attention.

Putting it generally, the human past has determined much of our present environment, field patterns and roads, as well as streets and buildings, the political boundaries which divide country from country, their forms of government, the precise character of social and economic distinctions, the sources of tension within and between nations, their values and customs.

The basic point is that the past governs the present, so the systematic study of the past is a necessity. No historian would claim that history provides clear answers, only that without history no answers would be possible. However, there is one very vital conclusion to be drawn from this justification for history: it is that the historian, like the scientist, is concerned with establishing well-substantiated knowledge, based on a systematic methodology, about specific topics, not with general speculation about the major issues of human existence.

I want to spend a second or two on the question of *myth*. The characteristic of myth is that, while containing some element, usually highly attenuated, of faithfulness to what actually happened in the past, it

is also highly distorted or exaggerated, almost invariably with a view to supporting one particular nation or community or religion or point of view. Myths exploit the past in order to serve some current national, political or religious purpose, or, at the very least, they fool people into believing something that simply isn't true. The distinguished French historian Marc Ferro (in a book translated as *The Use and Abuse of History: or how the past is taught*, published in 1984) discussed the way in which myths are perpetuated not just among white former colonialist countries but also in black Africa, India, the West Indies, and the different branches of Islam. As he pointed out, there can be no true freedom and no peace between nations as long as we are in thrall to myths.

It is a vital function of history – part of what makes it a social necessity – to challenge myths. Protestants and Catholics in Northern Ireland long subscribed to different myths, thus keeping old animosities very alive. I have heard many people assert that while Britain is a class-ridden society, France is not *because France had the French Revolution*. This is a complete myth. If you study the subject carefully, France today is just as divided by class as Britain is. Politicians preach the virtues of the 'traditional family', but once you examine the question you find that beliefs about the 'traditional family' are riddled with myths. The social value of history is that it enables us to challenge myths.

Now I am going to summarize Sections 1 and 2 in diagrammatic fashion. A simple way to define history is as follows:

History = sources + expertise (that is, the expertise historians apply to sources).

Tongue-in-cheek, and with a blackboard handy, I sometimes write this up as H = S + E! Combining everything in the two sections about the past, sources, myths and history, we have Figure 8.1.

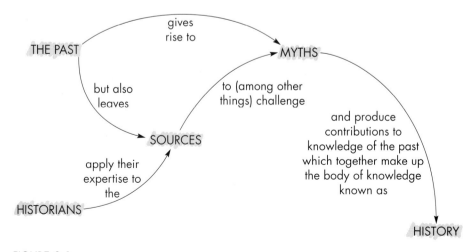

FIGURE 8.1

Now you personally, as a student, could probably think of many more immediate justifications for the study of history – that it is enjoyable, that it stretches the mind, etc. – but for the moment I simply want to concentrate on one which is particularly relevant to this interdisciplinary foundation course and to this block.

EXERCISE

In this block you will shortly be learning about the philosopher Rousseau and the artists David and Friedrich. Have you any idea what essential function history performs in such studies? (This is a difficult question so don't waste time over it.)

DISCUSSION

To appreciate fully and understand such figures you need to know about the society in which they lived, the events they lived through – 'the historical context', as we sometimes call it. It is the task of history, no simple one by any means, to provide the historical context. This is a central point in history's relationship to other disciplines in the humanities. No surprise at all if you did not think of it.

3 PRIMARY AND SECONDARY SOURCES

Because I am concerned with the basic principles of historical study, I shall be choosing my examples from various periods and topics. But in order to provide some unity, I shall focus on (a) the history of the British family (a central topic in social history), (b) the origins, course and aftermath of the French Revolution (a major historical event and essential to your study of Rousseau, David and Friedrich), and (c) the 1960s, a very evocative and controversial period which will form the basis of the final substantive block in our course.

To explain the differences between primary and secondary sources, I am going to take the most traditional of these three topics, the French Revolution. Think for a moment about what you would do if you wanted to find out a bit about the French Revolution. You might look it up in an encyclopaedia. But if you were truly serious in your quest for knowledge about the French Revolution, you would, I am pretty sure, look it up in one or more books. Where do the authors of these books get their knowledge from? The answer may well be 'from other books'. But if you got a really detailed, specialized book on the French Revolution or some

aspect of it, then you would find the author drawing upon materials actually belonging to the time of the French Revolution itself – speeches by revolutionary politicians, letters and diaries written by the various people involved, decrees and laws passed by the revolutionary government. Such things are the real, basic 'raw material' of history. They are what we call *primary sources* – sources which came into existence within the actual period being studied. The books written up later by historians, drawing upon those primary sources, are *secondary sources*. It is perfectly proper for you simply to use an encyclopaedia or perhaps even a simple textbook. These, as I say, will have drawn on other, more detailed books by historians, that is to say, *secondary sources*. But a true work of historical research, while making use of *secondary sources* in evolving a research strategy (as described in TV8), will fundamentally be based on *primary sources*. In the serious study of history, the distinction between *secondary sources* (books and articles by historians) and *primary sources* (materials originating within the period being studied) is absolutely crucial.

Four clarifying points need to be made:

1 With regard to secondary sources we really have to make a further broad distinction between research-based specialist work, which will usually appear in the form of articles in learned historical journals or as specialist books, and more general works with the character of textbooks and the function of summarizing and synthesizing the specialist work. You need to understand not just the distinction between primary and secondary sources, but also that there are different types and levels of secondary source. These range from the most highly specialized research-based work, through high-quality textbooks which incorporate some personal research as well as summarize the work of others, to the simpler textbooks, and then on to the many types of popular and non-academic history, encyclopaedias and so on.

2 Because a source comes in the form of a printed book, that does not necessarily mean it is secondary. A book which originates within the period being studied is a primary source – it might be a description of family life, a work of political philosophy, an analysis of popular music or a 'conduct book' such as we see in TV8. If produced within the period studied, it's a primary source. *Rule number one: look at the date!*

3 Primary sources in their original form are usually only to be found in specialist libraries, such as the British Library, or record offices, such as the Lichfield Record Office (both in TV8 – though the British Library has now moved to a new building). However, it is usual to provide students with specially edited (and, if necessary, translated) collections of primary sources, and I do want here to stress the value of selected primary sources in the teaching and learning of history.

While you will always need the textbooks and other secondary works, you will also find that actually reading the words of, or looking at the artefacts created by, the people of the past society you are studying can give you a more direct and vivid understanding of that society than any secondary account. To sum up: primary sources are indispensable for research and the production of historical knowledge, but selected and edited (and, if necessary, translated) they are also vital in the teaching and learning of history.

4 Although research would not be worthy of the name if not largely conducted in the primary sources, researchers do have to use secondary sources as well. To embark upon a piece of historical research you need to have a thorough knowledge of the field, and that can only be acquired by reading the books (the secondary sources) written by other historical experts. Reading other historians' books in the same field will give you pointers as to sources to study and the archives in which they can be found, as well as to issues and problems to be addressed. They will save you from duplicating work which has already been done and will give you a clear idea of what work needs to be done, or perhaps re-done. They will be indispensable in developing your initial *strategy*.

Not all secondary sources are equally worth reading, and my hope is that, after all four history units, you will be in a strong position to make choices fairly quickly. Of course, you can't really know what is in a book until you read it. But here is just a very simple preliminary step.

EXERCISE

Say you had the choice between two books on the French Revolution (which everyone agrees broke out in 1789 – there is less agreement about when it 'finished'), one published in 1855, the other in 1998. Which, for your purposes as a history student, would be likely to be the more worth reading? Give reasons (always the important point!).

DISCUSSION

The 1998 book, because it ought to reflect the most recent research. I have had students get this one wrong, arguing that 1855 is better because nearer to the French Revolution. That is to confuse the qualities of primary and secondary sources. Primary sources are the more valued the closer they are to the events or topics being studied. But a book published in 1855 could not be a primary source for the French Revolution, and an out-of-date secondary source is of low value.

EXERCISE

Here is a list mixing up primary and secondary sources. Indicate which are primary (P), which secondary (S). Indicate which relate to the French Revolution (including its origins) (R), to the family (F), to the 1960s (60), or to none of these (0). The last source listed is a particularly tricky, but particularly illuminating, one. You'll need to give a brief word of explanation for your decisions on this one. Before you start I suggest you reread the first two of the clarifying points I set out a moment ago, and particularly note 'rule number one'. If you feel you can distinguish between the more specialized secondary sources and the more textbook-like ones, do that as well, but don't waste too much time on that since bare titles are not terribly illuminating. Sorting out the primaries and the secondaries is the thing.

1 W. Doyle, *The Oxford History of the French Revolution*, Oxford, 1989.

2 A. Goodwin, 'Calonne, the Assembly of French Notables of 1787 and the Origins of the *Révolte Nobiliaire*', *English Historical Review*, volume 61, 1946.

3 P.R. Hanson, *Provincial Politics in the French Revolution: Caen and Limoges, 1789–1794*, Baton Rouge, 1989.

4 P. Jones, *The Peasantry in the French Revolution*, Cambridge, 1988.

5 J. Necker, *A Treatise on the Administration of the Finances of France*, London, 1785.

6 A letter dated 13 November 1462 from Margaret Paston to her husband John.

7 R. O'Day, *The Family and Family Relationships, 1500–1900: England, France and the United States of America*, London, 1994.

8 L. Stone, *The Family, Sex and Marriage in England 1500–1800*, London, 1977.

9 Margaret Stacey, *Tradition and Change: A Study of Banbury*, Oxford, 1960 (a sociological study).

10 The diary of Thomas Turner, 1754–65.

11 Decree of the *Parlement* of Paris, 5 December 1788.

12 Charles Dickens, *A Tale of Two Cities*, London, 1859.

DISCUSSION

1 S R. Straightforwardly, a historian's later account. If you got that wrong you'll have to read through this section again. The title suggests a general overall study; in fact, this is a very high quality textbook drawing both on the author's specialist researches in primary sources and an enormous range of articles and books by other historians.

2 S R. Learned article by a historian – a highly specialized piece of work, appearing in what is in fact the most traditional and austere of British historical journals. Though dating back to 1946, that's still a long time after the French Revolution. Because the article is so highly specialized it is still considered of value today – the phrase 'revolt of the nobility' (*révolte nobiliaire*) is widely used to describe events just before the outbreak of the Revolution; Calonne was King Louis XVI's chief finance minister.

3 S R. Straightforward again. A highly specialized secondary source confined to two French towns over a five-year period.

4 S R. Another highly specialized secondary source confined to studying the peasantry during the Revolution.

5 P R. The date, within the period of the origins of the French Revolution, gives this away. Necker was the finance minister to Louis XVI prior to being disgraced and replaced by Calonne. It was not unusual for contemporary French works (this one set out the dire financial problems of the then French government) to be published in London.

6 P F. If you got this wrong you probably need to read the whole section through again.

7 S F. General (covers three countries) rather than highly specialized work. Another high-quality textbook.

8 S F. High-quality secondary source.

9 P 60. Slightly trickier perhaps, and my sympathies if you got it wrong. But as a sociological study from within the 1960s, this must count as a primary source for the period.

10 P F. As with 6, though I can't blame you if, from the dates, you thought it was related to the origins of the French Revolution. Actually, as an English diary, it's very useful on family relationships.

11 P R. As with 5.

12 P 0. As I warned you, the one students most usually get wrong. Published in 1859, this can't be a primary source for the period of the French Revolution. People are often tempted to see this novel about the French Revolution as a secondary source for the French Revolution. But a novel is a novel is a novel (that is, a deliberately created work of the imagination): a historical novel, no matter how carefully researched, is (like a historical film) always a primary source for the time period in which it was written. If *A Tale of Two Cities* is a primary source for anything, it is for attitudes and values in the mid-nineteenth century, particularly with respect to fear of revolution or the power of the mob. It's a primary source, but not for any of our three main topics.

EXERCISE

How would you describe the following (all relating to the period of the French Revolution and its origins): primary or secondary?

1 Jean-Jacques Rousseau, *The Confessions*, written between 1759 and 1770, first part published 1782, second part 1789.

2 Jacques-Louis David, *The Oath of the Horatii*, painting, 1784–5.

3 J.-L. David, *The Death of Marat*, painting, 1793.

4 J.-J. Rousseau, *The Social Contract*, 1762.

5 *Analytical, Critical and Philosophical Commentaries on Paintings Exhibited at the Salon* (official art gallery), 1791.

6 *Memoirs* of Mme de Genlis, who lived from 1737 to 1830, published in printed and edited format in Paris in 1857.

DISCUSSION

They are all primary sources (they originate from within the period being studied). 1–4 are philosophical or artistic works. 5 contains contemporary critical comments on the works of David and others. Memoirs as a direct account, unmediated by a historian, by someone who lived during the period studied are regarded as primary sources, though they do have to be treated with especial caution as they are usually written up later. For the true researcher the printed and edited version mentioned here would only be a start, and recourse would have to be made to the original manuscript.

AGSG, ch.2, sect.3.5, 'What if you get stuck?'

Please do be sure that you understand the distinction between *primary* and *secondary* sources before proceeding.

4 THE PAST HAS GONE FOR GOOD

Most of us have little difficulty in believing in a past that actually happened, in believing that past societies had a real existence. The special problem of historical study is that these societies, by definition, no longer have a real existence; the past is gone for good. For all the literature, weighty and trivial, about defying time, time capsules and travel in time, there is no escape from the passing of time and from human mortality.

Think about this one (but if it throws you, just go straight to my discussion). Have the Sixties 'gone for good'? How about 'yesterday'? Not the song, just, well, the day before today.

DISCUSSION

Doesn't do to dwell on it too long, does it? ... or we'll all be breaking down in floods of tears (which partly explains, incidentally, the appeal both of the Beatles song and of reading history – what I would call the 'poetic appeal' of history, as distinct from the more utilitarian one embodied in the notion of history as social necessity). Anyway, even if many people try to behave as though they haven't, I think we have to recognize that the Sixties have gone for good. We have the songs, the films, the TV programmes, the clothes, the first Open University building, the Acts of Parliament making divorce easier, lowering the age of adulthood to eighteen, legalizing abortion and homosexual behaviour between consenting adults (and the debates on these matters in Parliament and in the press); we have, in the National Library of Scotland, the minutes of the experimental Traverse theatre, and in the Modern Records Centre at Warwick we have letters from ordinary people to their local MPs: just see how rich is the range and variety of primary sources. But, yes (to answer the question), the Sixties have gone for good. So has yesterday, though yesterday's newspapers still exist, and someone else will just be receiving that letter you wrote and now wish you hadn't.

To drive home the point, I'm going to extremes here. Historians aren't usually concerned with single days. The, as it were, 'basic unit of study' is more likely to be a decade, a century, a generation, or a particular topic or institution over a period of time, such as 'industrialization' or 'the family'.

Now, obviously, the family, as an institution or social practice, exists today.

The family, I have just said, certainly exists today. Think very carefully (and remember that we are discussing history): what is it, relating to the family, that has gone for good?

DISCUSSION

What has gone is the family in past periods – the Romano-British family, the medieval family, the Victorian family. Stop and ponder very carefully what I am saying here: the past itself, though it leaves memories, relics and traces (the sources), has gone for good – you cannot apprehend it directly and you cannot visit it.

EXERCISE

So, what is it, relating to the family, that still survives? Before answering, read back through my discussion of the previous question.

DISCUSSION

The sources survive – as I've just remarked. TV8 will provide you with examples, but let me list some here: Roman funeral inscriptions, parish registers of births, marriages and deaths, family letters (like the Paston one I mentioned in a previous exercise), diaries (like the Turner one in the same exercise), family portraits, family photographs, census data, personal memoirs.

The novelist L.P. Hartley produced the famous remark, 'The past is another country ...', which has subsequently been rather misused by other writers. Although illuminating on one aspect of the past, the statement is utterly misleading on the main aspect, which we have just been addressing. The remark is misleading in that, as I've just put it, you cannot visit the past (there are no boats or jets to the past such as you could take to 'other countries'). The illuminating point made is that, like foreign countries, the past is different (and, indeed, that was the very point Hartley was making in the remainder of the quotation). As will be explained in the next unit, we have to try to see people who lived in the past in terms of their own time, and get away from expecting them to think and behave in exactly the way we do. Some of the attitudes and behaviour of the 1960s already seem quaint – though 'quaint' is a word we should avoid, our task being to understand. The classicism of eighteenth-century intellectuals may now seem strange, but we have to try to understand the hold it had over them.

The ineluctable fact that the past has gone for good has inescapable consequences for the way in which knowledge of the past – that is, history – is produced. Since past societies are no longer real, historians cannot, as is sometimes said by fashionable **postmodernists**, 'represent' or 'reconstruct' them. The reality historians engage with consists of the only things we have: the primary sources. You can see them, feel them, sometimes even smell them. Forget 'represent', forget 'reconstruct'; it is out of these sources that historians produce knowledge about particular aspects of the past.

5 SEARCHING OUT THE SOURCES AND WORKING OUT A STRATEGY

There is a notion in some quarters that history is about the different interpretations historians produce based on an easily accessible common pool of 'data' or 'facts'. Actually, in considerable measure, history is about getting round the relevant libraries and archives, following up leads which take you to still other libraries and archives: leg work, in short.

EXERCISE

1 In my brief list of some sources for the Sixties, I mentioned at least three geographical locations. Note down what these were, and if you can think of any other places implied in my list, include them too.

2 In discussing the history of the family, I mentioned one absolutely central type of source, specific examples of which, almost by definition, are scattered round the country. What type of source is that?

3 If you were doing research on some aspect of the French Revolution, where would you have to go?

DISCUSSION

1 Milton Keynes (the Open University), Edinburgh (National Library of Scotland), University of Warwick (Modern Records Centre). For Acts of Parliament and parliamentary debates, and for newspapers, you'd need a major library, such as the British Library in London, the National Library of Wales in Aberystwyth, or one of the older university libraries. Despite the availability of videos, you might still have to go to the National Film Archive. For clothes you'd have to seek out a fashion and design museum.

2 Parish registers of births, marriages and deaths. Some are in the original parishes; most are collected in local record offices – but still you have to travel to get to them.

3 I hope at least you said Paris; bonus marks if you said archives in the French provinces. For the crucial point I want to introduce here is that it was only when historians went out and combed the French provinces for sources that we got a fully rounded account of the French Revolution, not one confined to events in Paris.

In travelling around searching out primary sources, historians do not simply operate arbitrarily or haphazardly. But nor do they set out with some predetermined theory which, at all costs, they intend to 'prove'.

Historians set out with a *strategy*. From reading all the secondary sources relevant to the topic they are interested in, they derive a sense of what questions need answering, and at least a provisional inventory of the archives they will need to visit. Of course, new questions keep cropping up; new sets of sources have to be investigated. But historians address limited, manageable sections of the past. Aided by the work of others, by professional societies and journals, by librarians and catalogues, they first establish a clear, rational strategy – just as scientists do.

6 THE IMMENSE VARIETY OF PRIMARY SOURCES

There is an immense variety of primary sources – that's becoming pretty clear, isn't it? I particularly want you to be aware of the significance of 'non-traditional' sources such as physical artefacts, films, works of art, and so on, any sources which are not written or printed, or which are works of the imagination. But I do have to be careful not to exaggerate. For a large number of historical investigations, traditional written sources are paramount. Still, many people are unaware of how varied written sources are. One of the aspects of the 'searching out' functions of the historian, and one of the characteristics of the most outstanding historians, is the faculty for thinking of the way knowledge can be extended by the deployment of new or unusual sources. For example, one of the other major advances in the study of the origins of the French Revolution has been through turning to sources related to the French publishing industry in the eighteenth century – and using computers to analyse them. We are now in a much stronger position to assess the influence of such writers as Rousseau, for example.

Different types of source have different strengths and different weaknesses (depending ultimately upon what particular topic you are studying). Here I shall just make certain broad contrasts, and draw attention to the special value of, and conversely the special problems inherent in, certain sources.

1 The contrast between public and private sources. The simple contrast here is between sources which were intended to be seen or read by substantial numbers of people (such as Roman Imperial inscriptions, Acts of Parliament, newspapers) and sources generated purely for the use of one person or certain specified persons (such as diaries, letters, secret diplomatic documents).

We cannot say that one sort is automatically more reliable than the other. We could make the initial presumption that someone writing in their own diary or to a close friend would be unlikely to tell deliberate lies. Conversely, some types of public document may be

deliberately designed to mislead, and here my distinction concerning 'documents of record' (see 2 below) is important. On the other hand, the fact that a document is public and 'open' may create pressures for it to be accurate (I'd say that, for example, of a report by a reputable journalist in a reputable newspaper).

2 The contrast between 'documents of record' and what I shall call 'discursive sources'. A 'document of record' is one which by its very existence records that some event took place – it is not someone else's account, but, as it were, it embodies the event itself. Prime examples are Acts of Parliament, peace treaties, charters (like Magna Carta), and minutes of meetings. An Act of Parliament itself embodies the event of a law being passed, as a peace treaty embodies the event of a peace treaty being concluded: both may be full of waffle and hypocrisy, and they may indeed never be implemented, but they still record something that definitely happened. The actual existence of Magna Carta (in several copies) does tell us that the issuing of Magna Carta actually took place. Minutes (of cabinet meetings or, say, the local marriage guidance council annual general meetings) can be uninformative or even misleading, but provided they are not fakes (and that goes for everything) they are records that the meetings did take place. Discursive sources – somebody else's report that a meeting took place or description of the signing of a treaty – will have their own uses, but are not the best and most direct sources for the events themselves.

3 Here I want to take together three categories of source once rather neglected but now much used by social historians. These are: (a) books advising on social behaviour and etiquette, sometimes known as 'conduct books' (referred to in TV8); (b) studies of customs and folklore; (c) guides, handbooks, directories and other works of reference.

The last category can be given a high rating for potential accuracy, since customers wouldn't buy them if they weren't reliable. The second one should be accurate, though there is always the danger of the enthusiast being tempted to romanticize. The first category offers most problems – are the authors writing about behaviour as it actually is, or are they describing some ideal?

4 Similar problems can come up with laws, legal decisions, sermons and other moralistic texts such as religious treatises. We have to try to find out how far laws and legal decisions are actually carried out, not just assume that they record something that has happened or will happen; similarly we have to check whether sermons and treatises refer to things actually happening or things the authors devoutly wish would happen. On the other hand, there may be a fair presumption that activities frequently condemned in sermons are actually happening.

5 One important source you might not think of, but which can have amazing uses, is wills (also referred to in TV8). Wills may be the best way of establishing how rich a person was. They can also be used to infer how much, or how little, affection existed between married couples and between parents and children. Much work with primary sources – this is a general point – is done by indirect inference.

6 For some years now 'oral history' – recording people's memories before they die – has been very fashionable. Very useful (but only, of course, for recent history), particularly with respect to ordinary people who usually do not leave written records. Of course, it is very subject to the fallibility of the human memory. We have, and can still generate, oral history for the Sixties, but none for the French Revolution or almost all of the long history of the family. Some people do leave autobiographies or memoirs. Though these are almost always written up late in life and subject to all the problems of memory, afterthought and hindsight, we do count them as primary sources. Biographies, however, unless actually written from direct knowledge during the subject's own lifetime, we consider to be secondary sources.

7 There is much talk of 'statistical sources'. In fact, statistics can be extracted from many different types of source: parish registers, census returns, estate records, government reports, etc. What is critical is the method of analysis; computers make it possible to use much larger and more representative quantities of data. But if the figures were dubious in the original document, no amount of processing through a computer will make them any more reliable.

8 There is glamour in film, archaeology, 'history on the ground' (surviving buildings, streets, etc.), posters and furniture. Historians can learn much from all of them. But we must always be aware of the difference between the teaching/learning function on the one hand, and the genuine research one on the other. Non-traditional sources can be awfully good for driving a point home vividly, but it is often the case that our knowledge of that point originally came from more humdrum written sources.

9 Historians should make use of poems, paintings, novels, works of music. They can often tell us much about attitudes, values, standards of taste, and cultural achievements. But we do always have to remember that such sources are deliberately works of the imagination in a way in which other sources are not.

EXERCISE

Look at the reproduction of David's *Oath in the Tennis Court*, 1790–1 (Plate 126 in the *Illustration Book*), a sketch for a painting which was never proceeded with. On the morning of 20 June 1789, in the early

stages of the Revolution, deputies to the newly revived Estates General (the nearest French equivalent to the British Parliament), finding the doors closed against them, assembled in a nearby indoor court designed for the game of 'royal tennis' and took an oath never to disperse until France had been granted a constitution.

1 How useful a source for that event do you think this drawing is? Is it as useful as a photograph would be, say?

2 Is there anything else which you think it a particularly useful source for?

DISCUSSION

1 Well, it's not really very like a photograph is it? – unless the photographer had had the opportunity to pose everyone taking part, unlikely in a sudden and impetuous historical event. Photographers can pose small groups of protagonists and can choose their angles so as to frame a particular composition, but I really can't believe any photographer could have achieved this effect. Think about it if your inclination is to disagree with me. Clearly the artist himself has carefully posed the participants to drive home the heroic and historic nature of the event, but as an accurate record of how it actually was this is scarcely of much use. Perhaps we get some sense of what it was like to be inside a 'tennis court', but that's about it. If you'd always thought the oath was taken on the equivalent of your local public courts, at least this is a corrective. Note, anyway, that the drawing was composed some two years after the event.

2 'Heroic' and 'historic' are key words here. A source like this is not strong on actual physical evidence, but it is excellent for attitudes in 1791. I mentioned at the beginning that David was a kind of official painter for the revolutionary regime, so this is good evidence of how that regime was now glorifying the early events of the Revolution and, as it were, wrapping them up in the respectable imagery of classicism (as you will see in Unit 12, this drawing is severely 'classical' in its studiously balanced composition).

7 THE FRAGMENTARY AND OPAQUE CHARACTER OF PRIMARY SOURCES AND THE IMPLICATIONS OF THEIR FALLIBILITY FOR THE PRODUCTION OF HISTORY

In commenting on some of the different types of source I have suggested that nearly all have drawbacks of some sort. Some sources are extremely difficult to decipher and some even are badly damaged (see Figures 8.2 and 8.3). For some topics there is an overabundance of sources – too much to analyse efficiently. More usually there is a paucity of sources relating to the questions on which we dearly want answers. The crucial thing to remember about primary sources is that they were brought into being by people in past societies for their own purposes, not to make life easier for historians. Even where the sources are adequate and manageable in quantity, they still present considerable problems of analysis and interpretation. Many of the conclusions historians draw have to be made indirectly or by inference; sometimes it is hard to draw any definite conclusions at all. It is easy to become swamped in miscellaneous

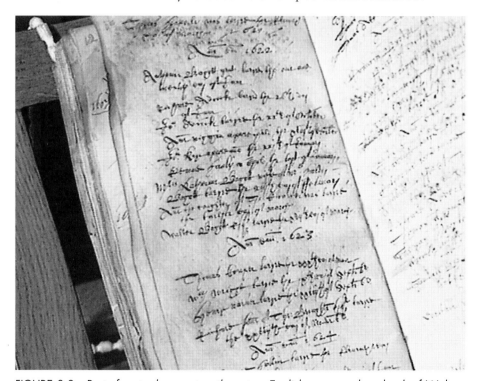

FIGURE 8.2 *Part of an early seventeenth-century English commonplace book of Walter Bagot, Blithefield, Staffordshire, shown in TV8. Water damage is evident from staining on the paper and bleeding of ink from the left-hand page to the right-hand one, which make it difficult to read the text. Blithefield Hall, Staffordshire. (Photograph: Trevor White, OUPC)*

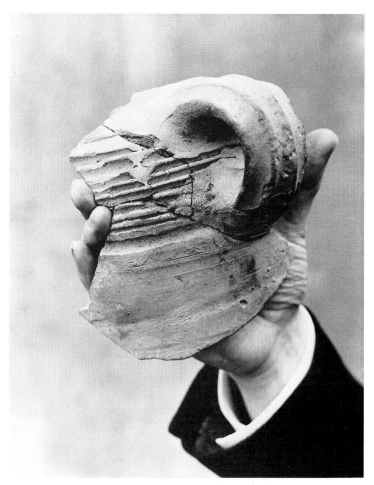

FIGURE 8.3 *This pot from the eastern Mediterranean was found in fragments in a layer of soil in London deposited after the fifth century* CE. *Taken in conjunction with its provenance (where it was found), this source suggests that trade between London and the eastern Mediterranean continued after the fifth century into the so-called 'Dark Ages'. Museum of London. (Photograph: Open University)*

information, with the sources themselves not necessarily being very helpful in suggesting interconnections and explanatory relationships.

Much reflection and intellectual effort is called for, therefore, and much scope ensues for differences of interpretation between different historians. Some historians are anxious to present bold, clear patterns, while others prefer to accumulate masses of detail; some historians draw heavily upon concepts developed in the social sciences, while others prefer to use concepts of their own. Lawrence Stone, in the book I included in my list of primary and secondary sources, *The Family, Sex and Marriage in England 1500–1800* (1977), invented the concept of 'affective individualism' to pin down what he saw as a major change taking place in family life in the three centuries he was concerned with. This was the change from, to put it crudely, marriage as essentially a business arrangement to marriage as a matter of personal choice and

affection (that is, affective individualism). While most other historians of the family recognized that there were elements of truth in Stone's boldly stated arguments, many felt that he exaggerated the nature of the change and overstated the case that it took place within certain definite dates (basically, he claimed, after 1640). That sort of disagreement is fairly common among historians and can arise, as we shall see in a moment, from a number of causes. But, and this is the point of this section, fundamentally it arises from the unsatisfactory nature of primary sources when it comes to settling matters of that sort.

For long years the focal point of argument over the French Revolution was the question of whether or not the Revolution marked the overthrow of the feudal aristocracy by the rising middle class (or **bourgeoisie**). In this case the thorough exploitation of new sources has led to a pretty complete rejection of this rather simplistic analysis (based on **Marxism**). The dominant class before the Revolution is revealed as a mixture of aristocratic and bourgeois elements, with no evidence of any sharp conflict between the two. The actual revolution, quite manifestly, was precipitated by the devastating economic crisis facing the monarchist government. But on the specifics of this much room for debate remains, simply – to return to my main point – because such economic statistics as can be found in the sources are so imperfect. Clearly the Revolution was a massive event, but pinning down its precise significance in specific areas is not something on which the sources provide unambiguous evidence. Some historians maintain the traditional position of identifying massive changes in the way society was organized and governed; others concentrate purely on the impetus given to political ideals of representation and democracy; others again stress continuity as between the old regime and the new.

Combining knowledge and expertise, historians can produce a remarkable amount from the most intractable and inscrutable sources. They learn, as I sometimes like to put it, to 'squeeze the last drop' out of their sources. But perhaps occasionally, understandably, they squeeze out drops that aren't actually there. There are always areas in which the evidence from the sources is insecure, ambivalent or even in conflict. Historians have to do their best, striving always to present accounts which are intellectually coherent; different historians will 'do their best' in different ways.

8 SUBJECTIVITY IN HISTORY

What we have come back to is the human factor. History, remember, is not the past; it is the knowledge of the past produced by fallible human beings, historians. There is bound to be a personal, 'subjective' element in history ('subjective' is the opposite of 'objective'; 'objective' means 'unbiased, strictly in accordance with the evidence and uninfluenced by

any social or personal factors or prejudices'). Human elements come into the sciences as well (and, of course, disagreements between scientists are certainly far from unknown). But what I have been stressing in the previous section is that there is a special reason why history should be more subjective than most of the natural sciences: in history, because of the intractable and imperfect nature of the sources, 'the evidence' is often not in itself conclusive.

However, you may very well feel that there are far more straightforward reasons for historians to disagree with each other, that there are obvious personal attitudes which affect the way historians write their history.

EXERCISE

What sorts of personal attitude might be likely to affect the accounts given by different historians? Give as many precise examples of 'personal attitudes' as you can.

DISCUSSION

The obvious answer that the question invites is something like: political, religious and ideological attitudes. As precise examples one could then list: conservative, Marxist, liberal, monarchist, social democratic, republican, feminist, Catholic, Protestant. The exact labels you used don't matter, but I trust you were thinking along these lines.

Actually I think it is too simplistic to draw correlations between political beliefs and the kind of history produced. For many historical topics political belief is practically irrelevant, as it is for most problems in the natural sciences. However, that said, there is the crucial point that, unlike the sciences, history is concerned with human actions, human beliefs, human values. Thus some kind of personal or political engagement is practically impossible to avoid. Much depends on the particular topic being studied.

One of our three topics (the family, the French Revolution, the Sixties) is one on which feminists, as feminists (as professional historians they might well have other strong interests), could be expected to have strong views. That topic, you might guess, is the family. Indeed the concept of patriarchy (that is, domination of the family by the male and the organization of the family – as well of the rest of society – in the interests of men), a concept pioneered by feminists (following Karl Marx and his collaborator Friedrich Engels), figures prominently in all studies of the family. Many feminists see the family as an instrument of the oppression of women. However, other feminists have concentrated on bringing out the vital managerial role women have always had to play within the family. So actually it would be wrong to think that all feminists will have

one particular approach to historical issues, just as it would be wrong to think that there will always be one conservative approach, one Marxist approach, etc.

Too much attention can be given to differences of approach. There are basic principles of historical study – which I am setting out in these units – and these set firm limits on the extent to which historians can simply indulge their own personal attitudes. What we should concentrate on is the remarkable amount of secure knowledge historians have produced, while always being aware that there are important areas where there can be no real certainty.

But historians are no angels. While too much attention does tend to be given to political views, not enough attention is given to the way in which career pressures can lead historians to exaggerate a particular interpretation (the more to stress the originality of their position) or line themselves up as supporters of a particular side in some great historical debate – these tendencies are not unknown in the sciences.

My final word on the question of subjectivity in history is that we should pay less attention to historians as individuals and more to the bodies of knowledge produced by the labour of many thousands of historians. We should remember, above all, that the works of historians, even the most famous, are merely contributions to knowledge, and are subject to debate among professional colleagues, and to qualification and correction. Readers do not have to believe everything they read in a history book – with a little effort that which is securely established (this is why scholarly books have footnotes) can be separated out from that which is merely speculative or polemical. Let me advance the Marwick 20 per cent rule: at least 80 per cent of what a scholarly historian writes is likely to be soundly based – but always be ready to reject up to 20 per cent, which can be due to bees in the bonnet, playing to the gallery, humble error, or various other reasons already identified. And there are, after all, textbooks which set out honestly to summarize for us what is securely known. In these introductory units I will be forced to dwell on the names of a rather limited number of historians – Lawrence Stone and Peter Laslett, for instance – not because I think they are all that important as individuals, but because they represent two rather distinct approaches (followed by hundreds of others) to historical study. We should think of history as a profession, not as the product of isolated geniuses. In history there are no Rembrandts, no Shakespeares, no Beethovens. The work of historians is constantly being revised, modified, updated: on the whole we don't go in for revising Rembrandt or updating Beethoven. (Of course, messing around with great creative figures to suit contemporary taste has gone on throughout the centuries; still, what Shakespeare or Beethoven actually wrote remains a matter of serious concern. In thirty years I doubt if anyone will care tuppence what Peter Laslett or Lawrence Stone actually wrote; their well-substantiated contributions will pass into the textbooks, while the rest will be forgotten.)

It is always worth going back to the fundamental question of 'why study history?' and the answer 'because societies need history'. Historians are paid by society. If all historians could actually say is, 'sorry, we all have our own opinions, and we don't agree on anything', they'd be failing in their basic duties. You, as a student or as an intelligent citizen, are entitled to demand that historians provide you with a clear, coherent, well-substantiated account of, say, the French Revolution. Quite an effort will be required from you as well, of course. But with two or three top quality textbooks (and some selected primary sources) you can get a clear idea of what is securely known along with where and *why* there are disagreements. History properly presented (and intelligently and energetically entered into by you) will give you the means to make choices for yourself where there genuinely is, for good reasons, disagreement among historians. To this day the French Revolution is a live issue in French politics and in political philosophy generally. Where there are big differences in the history books, these relate to the really big issues, which almost go beyond the competence of history to settle (though without the work of historians we couldn't even begin to discuss them). Historians are in broad agreement about the immediate origins of the Revolution, about its course (usually taken as running up to 1799 when Napoleon was declared 'First Consul', 1802 when he became 'Consul for Life', or 1804 when he was crowned emperor) and about the different social and political groups involved (though, in the nature of the sources, there is variation in the assessment of precise roles and motivations). The big disagreements are over the more profound 'causes' of the Revolution and over its 'consequences': did it, for example, make possible industrialized/'capitalist' Europe, or was it in fact a serious interruption in developments already taking place in that direction? Historians also disagree over the horrific bloodshed and hideous cruelty which unquestionably accompanied the Revolution: is this to be condemned, or excused as 'inevitable' or even 'just'? But, when we come to it, I shall hope to show you that even on these enormous issues the writings of historians (if not those of popularizers and political fanatics) are reasoned and evidence-based, and that while historians do, for career or personal reasons, often identify themselves with a particular school or approach, their actual writing is characterized more by agreement than disagreement. We shall see!

9 IS HISTORY CULTURALLY DETERMINED?

This section offers a very brief treatment of an issue which, as you will come to find out as you proceed with your university career, lies at the heart of many debates over the nature of history and the other humanities subjects.

Are we all irredeemably products of the culture (that is, the society and period) in which we live (defined by some as 'bourgeois culture')? Is it true that the dominant ideas of our culture determine everything we do, whether it is reacting to a member of the opposite sex, painting a work of art, writing a piece of history or, indeed, contributing to scientific knowledge?

Historians recognize that we are all culturally *influenced* but deny that their work (that is, history) is culturally *determined*. Historians argue that, far from being prisoners of their own culture, they are, by the very nature of what it is they study, particularly well qualified to understand the influences operating on them and, therefore, escape from them. Their claim is that, in the nature of what they do, historians are studying past societies and the way in which people in these societies were affected by the culture in which they lived. Historians, in other words, are experts on cultural influences. Accordingly, they are very aware of the danger of becoming prisoners of the dominant ideas of their own society. Historians recognize that they can never escape from these entirely, but believe that they are well equipped to make a good try. Historians further maintain that they have principles and methods which, in their own way, are just as rigorous and systematic as those of the sciences (it is my purpose in these units to set out these principles and methods). Thus they can produce knowledge which has an objective basis, though because of the imperfect nature of the sources there will always be gaps in that knowledge and disagreements over it.

10 THE PLACE OF CONTROVERSY IN HISTORY

AGSG, ch.6, sect.7, 'Beliefs and theories'

Historians do disagree with each other, for reasons we have just been working through. So do scientists. Controversy and debate are essential components of the intellectual world, where we always have to be aware that many matters are not firmly fixed or conclusively settled. I want you to take seriously, and be able to present in your own words, the arguments about history in these units, but I also want you to be open to the arguments of those who disagree with me. Obviously, if my

arguments are open to debate, so too are the arguments of those who maintain that all knowledge is culturally determined or constructed.

Here I want to focus briefly on controversy in history. There are controversies over the family, the French Revolution, the Sixties and – to choose some examples you'd encounter in further history courses – the origins of the Second World War, the social consequences of the First World War, the powers of Louis XIV, the role of nationalism in nineteenth-century Europe. I want to make two points:

1 It is important not to become obsessed with controversy and disagreement among historians. There are (in my view) far too many books with titles such as *The Debate over the French Revolution*, *The Controversy over the Origins of World War I*. One should never forget the very real achievements of historians in illuminating often obscure and complex topics which none the less, as I have already argued, are of vital interest to society today.

2 But having said that, controversy and debate – if treated in an open and constructive way and *not* as an end in itself – can serve valuable purposes in the advance of historical knowledge.

EXERCISE

This isn't easy, but can you think what these purposes might be?

DISCUSSION

1 Controversy can open up new lines of enquiry. Historians who have researched deeply into some problem can become blinded to the existence of wider perspectives and alternative lines of enquiry while delving ever deeper into the subject. If the articles and books produced by them are then attacked boldly by colleagues, they will be forced to defend themselves and give consideration to alternative interpretations. Out of all this the total sum of historical knowledge may be increased considerably.

2 It can lead to new synthesis (that is, a combination of the best from two or more opposing interpretations). The sharp exposure of conflicting views can make it possible for another historian (perhaps the writer of one of the high-quality general surveys or textbooks I mentioned earlier) to bring together the best of the conflicting interpretations, and again make an advance in historical knowledge.

11 TECHNICAL TERMS, CONCEPTUAL TERMS, COLLECTIVE NOUNS AND CLICHÉS

The writing of history requires the utmost precision in the handling of language. Easily said but very hard work to achieve. Nothing is easier than to slip into a weary cliché ('sick as a parrot', 'over the moon', 'don't take sources at face value', 'written sources are bread and butter to the historian', 'Rousseau made the intellectual ammunition, the French revolutionaries fired it'), flog old metaphors which explain nothing ('wars are catalysts of change'), use a fancy word because it sounds trendy even if we're not quite clear exactly what it means ('discourse', 'ideology'), or, most common in history, use some vague concept whose scope and meaning is far from clear – the classic instance being 'public opinion' (everybody's opinion, the opinion of a few newspaper proprietors, or what?). I'll be going into this crucial question of how we use language in historical writing more thoroughly in Units 25 and 26. My contention is that in writing history it is essential to be precise and explicit, as it is in scientific writing. This, in my view, is one of the ways in which a work of history differs totally from a novel or a poem: a creative writer may quite deliberately exploit the ambiguities and resonances of language, but a historian should make special efforts to be as clear and explicit as possible, and to separate out unambiguously what is securely established from what is basically speculation. For the moment I just want to make some brief points about four types of problem you encounter the moment you start reading any history at all: technical terms, conceptual terms, collective nouns and clichés. By clichés I mean words or phrases we slip into so readily that we have ceased to consider whether they really are the best words for what we want to say, and whether indeed they actually do say anything precise.

Technical terms

AGSG, ch.2, sect.2.3, 'Academic language'

Some technical terms belong to the past societies we are studying, while some are coined later by historians. In writing about past societies there are times when we simply cannot avoid using the terms people in the past used, even if these terms no longer exist today. And if they no longer mean anything to us today, we have to be very exact in knowing what they meant to people in the past. Obvious examples are 'serf', 'peasant', 'yeoman' – all country-dwellers of some sort – and 'burghers', 'burgesses' – both townsfolk of some sort. Quite frankly, we'll get nowhere in studying the French Revolution if we are not familiar with the names and functions of the main political institutions, and with the different kinds of tax and their strange names. At the time of the Revolution there were thirteen *parlements* across France, including one

in Paris which had jurisdiction over about one-third of the French population. *Parlements*, unlike the British Parliament, did not pass legislation, but were responsible for confirming acts and decrees of the king's government and for making judicial decisions. The Estates General, famously brought back into being at the time of the Revolution, was a medieval body, a little more akin to the British Parliament; it was divided not into two 'houses' but into three 'estates', each representative of one of the three orders or estates into which medieval France was held to be divided: the clergy (the 'first estate'), the nobility, and the 'third estate' – the remaining 95 per cent of the French population (save that women didn't really count). The basic French direct tax (another technical term – a tax levelled directly on income or property) was the *taille* (pronounced 'tie'), levied as frequently, and at as high a rate, as the king's government thought it could get away with. There were loads of indirect taxes (taxes that you pay every time you buy some commodity or service, like VAT today) – including the hated *gabelle* levied on that absolute necessity, salt.

'Citizen' is a key technical term for the Revolution. All full members (that is, *not* servants, *not* slaves) of the ancient Roman Republic were 'citizens'. Seeing themselves as re-establishing the liberties of ancient Rome, the French revolutionaries took this term to themselves, together with many classical symbols.

Good examples of technical terms invented later by social scientists and adopted by historians are 'nuclear family' (husband, wife and children) and 'extended family' (the former plus other relatives and perhaps even retainers). To describe the violence which broke out in the French countryside in the autumn of 1789, in which the peasants themselves feared they were being attacked by brigands hired by the nobles, historians have coined the term 'the Great Fear'.

Conceptual terms

We need concepts to help organize our thoughts, to describe what we perceive as happening in human and social relationships and activities but for which no ordinary words exist, and to bring the intellectual, thinking element into our writing of history.

EXERCISE

Can you think of any such concepts we have already encountered?

DISCUSSION

'Affective individualism' and 'patriarchy'. You might also have referred to the concept of the 'bourgeoisie' (as in the bourgeoisie allegedly overthrowing the aristocracy in the French Revolution).

We hit rough seas at once. Is the 'bourgeoisie' a concept, or is it an actual entity with a real existence in the sense that, for instance, we could tot up all those in France in 1788 who belonged to the bourgeoisie? 'Bourgeois' and 'bourgeoisie' are obviously French words; they were used by the French in the eighteenth century and are still used by the French today. Actually their meaning in eighteenth-century France was pretty precise: a bourgeois was not a noble, so that gives us the boundary 'at the top', as it were; and a bourgeois did not work with his hands, so that gives us the boundary at the bottom. Trouble can arise when this French word is applied to other countries, such as Britain, or in more recent periods when its usage has become much vaguer. So if you encounter the word 'bourgeoisie', try to establish how it is being used; if you use it yourself, be sure how you are using it. If as part of a broadly Marxist approach (no ban on that), be sure that you understand all the assumptions involved within that approach. One could define certain conceptual terms as being labels which describe something that we recognize does exist but which, in a particular usage, carry with them a load of theoretical assumptions.

Conceptual terms may either:

1 be borrowed – most usually from some grand theory, such as Marxism, or from the social sciences (where 'extended family' and 'nuclear family' come from);

2 be invented by historians as part of the interpretation or hypothesis they are trying to put over. Stone's 'affective individualism' is a good example of this.

Technical terms you can't avoid; you just have to get them right. Conceptual terms, treat with caution. That men have often oppressed women is abundantly clear from the sources, but that does not necessarily mean it is true that something called 'patriarchy', with all the theoretical assumptions embedded in that term, actually existed. The term may indeed be legitimate, but you must think things through very carefully before you decide to use it. Stone thought that envisaging what he called 'affective individualism' clarified an important point about the development of the family. Marx thought that envisaging the bourgeoisie and the proletariat as he defined them clarified central points about the development of humanity. He may have been right. Equally he may have been wrong. All concepts demand constant scrutiny.

Collective nouns

Many of the trickiest technical terms, conceptual terms and indeed clichés are labels for collections or *classes* of individuals: bourgeoisie, nobility, middle class, sansculottes. (This last French term literally means 'without breeches'; as a group it included town-dwellers of varying social status who, as a deliberate political gesture, wore workmen's trousers rather than gentlemanly breeches. Sansculottes were important in the French Revolution – see Figure 9.2 on p.76.) 'Class' itself is a tricky word. All societies, in some way or another, divide up into distinctive social groups, some wealthier and more powerful than others. What I want to signal here is that one of the most difficult tasks facing historians is 'mapping out' past societies into such groups (bourgeoisie, working class, etc.). Should one try to use the terms people in the past themselves used, should one use the clear-cut but rather abstract terms of Marxist theory, or what? Much historical controversy arises from this process of 'mapping out' being done in different ways.

Clichés

I've concentrated on the hard stuff, but don't forget my opening phrases. We may laugh at 'sick as a parrot', but we should all try to avoid slipping into less obvious clichés.

12 THE FAMILY FROM ROMAN BRITAIN TO THE PRESENT: MYTHS, SOURCES AND ISSUES

Ideally this concluding section to Unit 8 should be studied in conjunction with TV8. As mentioned at the beginning of this unit, I'd suggest two alternative approaches, depending on your circumstances:

1 View the programme, work through this section, view the programme again.

2 Read quickly through this section missing out the exercises and my discussions, view the programme, work carefully through this section doing the exercises.

In Section 2 I remarked that beliefs about the traditional family are riddled with myths. There is, I think, one great central myth about the family, and then a number of lesser ones, some perhaps in conflict with each other.

In doing the exercises in this section, I want you to draw both on things I have been saying about the family throughout this unit and on material contained in TV8.

EXERCISE

1 What secondary sources could you turn to in studying the history of the British family?

2 List some of the *printed* primary sources that could be used. Try to indicate, in general, the strengths and weaknesses of each type of primary source.

3 List as many *other* kinds of source for the family as you can think of. Again indicate strengths and weaknesses.

DISCUSSION

1 R. O'Day, *The Family and Family Relationships*, L. Stone, *The Family, Sex and Marriage*, Peter Laslett, *The World We Have Lost* (mentioned in the unit and in TV8). There was also the article in the historical journal, *Social History*, 'The emergence of the modern life cycle in Britain' by Michael Anderson, mentioned in TV8. (It is in such articles, incidentally, that history most strikingly shows its resemblance to the sciences.)

2 Conduct books (mentioned in the unit and in TV8). They tell you about contemporary ideas about the family (strength), but they are quite likely to be describing what the authors thought the family ought to be like rather than what the family was really like (weakness). Another kind of printed primary source mentioned in the unit is the autobiography. Not all autobiographies discuss family life, of course; the main technical weakness is that autobiographies are usually written up after the events dealt with have passed, and may be spoiled by bad memory, deliberate evasion, etc. On the other hand (strength), autobiographies may be the only source we have for certain people and their families (if no private papers have survived, for example). The working-class autobiographies which began to appear throughout the nineteenth century are valuable – though often elusive and reticent – sources for working-class family life.

There is an enormous array of other sorts of printed primary source, many not directly related to the family. Published volumes of census statistics are enormously valuable, their 'weaknesses' being the absence of emotional content and the other things they leave out (some mentioned in TV8). Acts of Parliament – for example, the Divorce Reform Act of 1969 or the Family Law Reform Act of 1968, which reduced the age of majority to 18 – relating to the family are 'documents of record' (great strength), but they don't tell us whether

they are actually carried out or not (weakness). Reports of government investigations, sociological investigations, etc. could be very useful. You'd really need specific detail on each one to check out strengths and weaknesses (I go into this in Unit 9).

3 Going chronologically through the sources discussed in TV8 and adding in a few others already mentioned in the unit, you could come up with:

 – Roman funeral inscriptions: very valuable if you know how to interpret them and have information from other types of source, but can be misleading (easy to jump to the wrong conclusions about who carved figures are, what they are doing, etc.).

 – Parish registers: indispensable but the information is very bare – no detail about lives of individual families.

 – Commonplace books: depend, of course, on what the owner chooses to put in them (potential weakness) but can confirm fascinating information – about attitudes to children other than eldest sons, for instance.

 – Family letters and diaries. None in TV8 but the same sort of comment would apply to them.

 – Portraits: add an extra dimension but may be highly stylized rather than faithful likenesses.

 – Handwritten census enumeration returns (as seen in TV8): invaluable statistical information but many gaps.

 – Film: depends on the film, but in the case of *The Family Way* was written by someone who was himself working class, and does give direct evidence of 1960s housing, etc. However, film is concerned with deeper human truths rather than historical ones, and probably its writer (Bill Naughton) was thinking as much of his own family in the 1920s and 1930s as of families in the 1960s. Another source might be novels about family life – but, as with feature films, remember that novels are always *deliberately* works of fiction.

Myths

The big myth is of the 'traditional' family having been highly stable, undisturbed by such disruptions as divorce. In fact it could very readily be disrupted by the death of either the husband or the wife.

A lesser myth is that for much of the past the family was a *purely* economic unit; TV8 gives examples of families based on affection and love (no doubt they were economic units as well – TV8 brings out how the census enumerators' returns fail to record working-class wives' contributions to the family income). Linked to this myth is another one,

that families were concerned only about the eldest son – charged, according to the myth, with perpetuating the family's fortunes. TV8 gives examples of concern both for younger sons and for daughters.

Then there is the myth – possibly derived from Shakespeare's *Romeo and Juliet* – as to age at marriage for females. TV8 (following on the celebrated work of Peter Laslett and the Cambridge Population Group) indicates that the marriage age for females was usually in the early twenties.

The most complicated myth is the one that there has been a *universal* change from the large 'extended' family of the past to the smaller 'nuclear' one of the present. One problem was that there was confusion between 'family' (consisting of close blood relatives) and 'household' (including servants, retainers, young house-guests from other families, usually in some kind of 'apprenticeship' relationship, etc.). Again it was Peter Laslett who attacked the myth of the extended family in *The World We Have Lost* (1965). And while extended *households* were common among the very wealthy, they were non-existent among the poor.

Of course, there have been important changes in the family over the centuries, particularly with respect to the roles of women and of children. I shall now conclude with a couple of paragraphs by one of Laslett's most distinguished disciples, Keith Wrightson, taken from a long essay on 'The family' in *The Illustrated Dictionary of British History*, followed – of course! – by a few more questions.

> Within marriage women were, at least until very recent times, legally inferior, subject to a sexual double standard and expected to be subordinate to their spouses. Actual behaviour, however, must be distinguished from legal and moralistic prescriptions. Early diaries and letters indicate strong companionate elements in the marriages of people of middling rank, with couples sharing productive, decision-making and leisure activities. Peasant women and the wives of workers in domestic industry also shared fully in family production. Confinement to housekeeping was a later product of industries which offered no female employment and removed work from the household (though the Industrial Revolution gave many women factory work). It would be unwise to make too sharp a dichotomy between 'traditional patriarchal' and 'modern companionate' marriage. Both situations have a long history as the poles of an enduring continuum in marital relations.
>
> Similarly, social change can be shown to have altered the conditions of children's lives more than the nature of attitudes towards them. Before the 19th century children were expected to work and were employed at home or put into service at an early age. Nevertheless, this situation was not incompatible with parental recognition of the individuality and care for the welfare of their offspring. Child-rearing in the past, though not conforming to modern practices, was certainly less severe than is commonly alleged and there is substantial evidence that parent–child relations were warm and affectionate. The abolition of child labour and introduction of compulsory

education have prolonged effective childhood, while economic and social change have afforded greater opportunities for the overt demonstration of parental care.

(Wrightson, 1980, p.110)

EXERCISE

1 (a) What is meant by 'a sexual double standard'? (b) Does it still exist?

2 'Legal and moralistic prescriptions'. What types of source and problems inherent in them (I've already discussed these) are being referred to here?

3 How impressed are you by Wrightson's arguments about attitudes towards children?

DISCUSSION

1 (a) Behaviour condoned in a man (for example, premarital sex or having a sexual partner on the side) is treated as unacceptable in a woman. (b) You are almost certain to have your own strong views on this; all I ask is that you force yourself to think very hard about the evidence. I am a historian both of the Sixties and of contemporary society; both in the Sixties and today one can find plenty of people around with grossly outdated attitudes, but I believe that an overwhelming body of evidence (women's magazines, films, newspapers, opinion polls, surveys – particularly the massive *Sexual Behaviour in Britain* funded by the Wellcome Foundation and published by Penguin in 1994) shows that the double standard is not salient today. You may well have been tempted to bring in the many inequalities still suffered by women today (in the distribution of income and power, for example). But my question was purely about the 'sexual double standard'. Another lesson: in all academic work stick strictly to the question. Of course, I still may be wrong (as on so many other things). But I want you to see that the proper approach for historians in trying to resolve controversial issues is to seek out the sources and see what can be derived from them.

2 Well, conduct books for a start. But also laws and legal decisions, sermons and religious treatises. In each case we must not jump to the conclusion that what is said in such sources is actually carried out or corresponds with 'actual behaviour'.

3 You may not have felt this at all, but personally I thought Wrightson was overstretching his case that the nature of parents' attitudes towards children in the past did not differ from those of later parents, and therefore he was not very persuasive. As good historians will always do, he states the circumstances honestly (children were

expected to work, etc.). But, it seems to me, that brings out just how different parental attitudes were then (even though it remains a myth that parents in the past had *no* affection for their children).

You'll find this a lot in historical study. You don't have to accept the particular emphasis Wrightson gives his material. The material itself is accurate and in many ways coincides with parts of Stone's interpretation (save that Stone, for his part, overstates his own case). It is a central contention of mine that the real disagreement between historians is often much less than, for professional reasons, they represent it as being. With that thought in mind, we shall move to the next unit and some detailed study of the sources for, and the issues entailed in, the French Revolution.

GLOSSARY

bourgeoisie is a term whose precise meaning depends very much on the context in which it is used. In eighteenth-century France the bourgeoisie included those who were neither members of the nobility nor artisans/workers. **Marx** and his followers defined the bourgeoisie as the dominant entrepreneurial class of capitalism. In the twentieth century it has been used more loosely to include the 'middle class' generally.

Marx/Marxism Karl Marx (1818–83) argued that events and circumstances in the past move in a series of stages, or epochs, each terminated by revolution. In France, he said, the French Revolution ended the feudal epoch dominated by the aristocracy, and replaced it with the capitalist epoch dominated by the '**bourgeoisie**'. According to Marx, the 'proletariat' (working class) would soon overthrow the bourgeoisie.

postmodernism is a theory that began in France in the 1960s with the writings of Michel Foucault, Roland Barthes and Jacques Derrida, and was embraced by Anglo-American academics in the 1970s. According to postmodernism, we and our world are permeated by a hidden, impersonal structure of language which is contaminated with 'bourgeois' values. Postmodernist historians argue that history is inextricably linked to the historian; it is a constructed narrative similar to literature. Hayden White, Professor of Comparative Literature at Stanford University, described works of history as 'verbal fictions, the contents of which are as much invented as found'. According to this view, history is a way of ordering the world rather than a way of producing knowledge of the past.

REFERENCES

FERRO, M. (1984) *The Use and Abuse of History: or how the past is taught*, London, Routledge and Kegan Paul.

LASLETT, P. (1965) *The World We Have Lost*, London, Methuen.

STONE, L. (1977) *The Family, Sex and Marriage in England 1500–1800*, London, Weidenfeld and Nicolson.

WRIGHTSON, K. (1980) 'The family' in A. Marwick (ed.) *The Illustrated Dictionary of British History*, London, Thames & Hudson.

1 BASIC QUESTIONS TO BE ASKED OF ANY PRIMARY SOURCE

It was necessary in the previous unit to run through the general issues raised by historical study. Now I want to get you involved in tasks resembling those historians themselves carry out. Since you will be working on preselected, printed, translated excerpts from primary sources, there will be a heavy element of artificiality. The systematic list of questions set out below is designed to make you think, step-by-step, about the problems involved in making use of primary sources. I am not claiming that every professional historian explicitly and systematically goes through these questions; in many cases, he or she will already know the answers.

Theoretically the first point a historian must establish about any primary source is its authenticity. If we have a letter purporting to be written by David or by Louis XVI, we need to be sure it was written by him and not forged by someone else. If we have a bust of Rousseau purporting to have been sculpted in 1789 out of stone from the walls of the Bastille, we want to be sure it wasn't, say, carved out of rubble on a building site in Milton Keynes in 1995. Authenticity is often established through the provenance of the source (its place of origin). The problem of authenticity is not one I shall trouble you with in exercises and assignments, but it is important to be aware of its existence.

Historians do not, in fact, deduce or infer their evidence from single sources but from comparing and contrasting a whole range of sources. And they never start on the primary sources without having a good deal of knowledge already about a period and topic. So historians will always study any source in relation to their wider knowledge and to the other relevant sources. In later history courses we shall expect to see you demonstrate such contextual knowledge, but we recognize that, at this level, you are hardly being provided with sufficient contextual knowledge to make that point worth labouring here. So here is a restricted list of questions I would like to see you apply to all the primary sources we provide you with:

1 What date is it? How close is its date to the date of the events described? How does this date relate to other important dates you are aware of? What, in short, is the significance of the date? Some documents and visual sources such as buildings and physical artefacts raise considerable problems of dating. But all the sources we ask you to work on will be firmly dated.

2 What kind of source is it? A private letter, an official report, or what? I have already indicated that different types of source have different strengths and weaknesses (depending always, of course, on what they are being used for).

3 How did the source come into existence in the first place, and for what purpose? What person or group of persons created the source? What basic attitudes, prejudices, vested interests would they be likely to have? A committed revolutionary listing grievances against the monarchy might be inclined to exaggerate. A servant of the king describing the condition of the people might be inclined to put an optimistic or unsympathetic gloss on things. For whom is the document intended, and to whom is it addressed? A courtier seeking a position of influence with the king, and describing the king's achievements, might well be unduly flattering.

4 How far is the originator of the source really in a good position to provide reliable information on the particular topic the historian is interested in? There are many accounts of the exciting events of 1789, but we would usually prefer those of persons who actually took part in them, or were present at them, to accounts based only on hearsay. Some of the Enlightenment philosophers wrote sympathetically about the condition of the people, but we would always want to know how much direct knowledge they really had. A poor parish priest might be a better source for the conditions of ordinary people in his village.

5 What did the source mean to contemporaries? Eventually the historian will go on to deduce or infer conclusions relevant to his or her own line of research, but first it is vital to be sure of understanding the source as contemporaries would have understood it. This is not necessarily easy if the language is archaic or the source is full of obscure references or technical terms. With certain sources there are the problems of deciphering inscriptions, translating strange languages, or making out unfamiliar handwriting. We shall not inflict any of these problems on you. However, in the extracts we give you, you should be able to identify the technical terms and the allusions which would need to be explained, even if you do not yourself have the detailed knowledge required to provide the explanations. Sums of money usually have to be explained: no point reading that something cost 1,000 *livres* if you have no idea what that sum meant in terms, say, of the average weekly earnings of an ordinary worker. Statistics will have to be set in context (a town of 10,000 inhabitants – is that large or small?). Events referred to in the source may have to be explained. Allusions to the Bible are not unlikely in eighteenth-century documents, as also are allusions to the classics (the force of classicism again); all such allusions have to be sorted out before we can be sure we have got the full meaning of the document as contemporaries would have understood it.

6 Then we have the question of how this source relates to knowledge obtained from other sources both primary and secondary – that is, to 'context'. Although, as already mentioned, your contextual knowledge is going to be minimal at this stage, I cannot put it too strongly that in the real practice of history, one can do very little with primary sources unless one already has very considerable contextual knowledge.

To give you some sort of framework for various exercises on primary sources, I have provided (*Resource Book 2*, A1) a very bare outline of the main events and developments in the French Revolution, together with some of Napoleon's actions particularly relevant to your later study of Friedrich. I will give you a rather fuller account later, together with some discussion of the period between 1750 and the outbreak of the Revolution. First, however, some preliminary information about France in the late eighteenth century, and about the social groups and political institutions involved in the Revolution, is essential.

(i) Short of an elaborate modern apparatus of terror (one thinks of Hitler or Stalin) it is very difficult for any ruler to rule 'absolutely'. Governments in some sense have to have the 'consent' of their subjects, or at least the more powerful ones. Governments also have to have 'legitimacy': that is, people should feel that the government actually has the right to govern. Throughout eighteenth-century Europe it was widely accepted, in large countries at least, that monarchy was both the most legitimate and the most effective form of government (for achieving tranquillity – prized by all – at home, and glory – prized by some – abroad). Monarchy was revered. It was part of Rousseau's importance that he believed none of this. There was also reverence for 'Ancient Law', which guaranteed certain freedoms and privileges to certain sections of the population, thus setting limits on the power of the king. In France there was no parliament of the British type. The king chose his own ministers. There was usually one chief minister, who if unsuccessful would be disgraced and exiled, to be replaced by someone else. The stakes were high. What kings needed above all was cash (especially if engaged in foreign war), which had to be raised through taxation (the only other main source was loans). The French taxation system in the eighteenth century was complex and cumbersome: tax levels and new taxes had constantly to be promulgated and agreed.

(ii) In a large and sprawling society like France, made up of various social groups, different developments could be going on at the same time, not necessarily connected with each other in origins. Thus representatives of the nobles and of the bourgeoisie might be arguing over the principles of taxation in some formal assembly, while elsewhere harvest failure might result in peasants rampaging across the countryside and bread riots in the towns. Actually for most of the eighteenth century France had been remarkably free of serious

popular disturbances. It was a central feature of the revolutionary period itself that popular disturbances of different kinds began to put pressure on, and interact with, the assemblies in which (mainly) bourgeois figures made their demands against the old regime. The very fact of such demands being made – of there being a revolution in progress – then began to stimulate further popular action, to involve social groups which hitherto had little political consciousness.

(iii) Some commentators have even suggested that there were several revolutions, in the sense both of different revolutions going on at different levels of society and of the original revolution – which resulted in something akin to a British limited monarchy – being followed by a series of ever more drastic revolutions. That is an over-elaborate formulation, but you do have to be aware that the revolutionary period spread over several years, that there was a colossal interaction between different sorts of development and event, and thus that the Revolution took on a momentum of its own not necessarily related to the causes of the original outbreak. In other words, it is impossible to envisage a simple model: CAUSES→ REVOLUTION→CONSEQUENCES. Earlier and continuing revolutionary developments themselves became the 'causes' of further revolutionary developments. It is dangerous to think of the Revolution (or 'revolutions') proceeding in a single direction; at times the tendency seemed to be towards greater radicalism, greater 'extremes' – but then there could be 'reaction', or perhaps revulsion against bloodshed, or simply desire for order and stability.

(iv) It is impossible to ignore the significance of events themselves, as distinct from long-term forces – I am thinking of, for example, the storming of the Bastille on 14 July 1789, the West Indian slave revolt of 14 August 1791, or the outbreak of European war on 20 April 1792. Nor can we ignore contingency (or 'accident') – for example, disastrous harvests.

(v) Formerly, medieval France had been divided into three 'orders' or 'estates': the clergy, the nobility, and the rest (amounting to 95 per cent of the population). The reality in the eighteenth century was very different. Many of the old-established nobility (known as the 'Nobility of the Sword') were extremely powerful, but others were impoverished and of only local importance. There was a newer and usually very rich and powerful nobility (the 'Nobility of the Robe') of those who held important offices in the service of the Crown (many of these could be bought). The bourgeoisie, sometimes also very rich and powerful, were neither noble nor worked with their hands. The ambition of most of the bourgeoisie was to join the nobility. Below the bourgeoisie in the towns were craftsmen, artisans and other workers; in the countryside those designated as 'peasants' might be small farmers, but were mainly landless labourers who often had to do other kinds of work apart from agriculture. The clergy at the top

(bishops, abbots, etc.) were noble, whereas the parish clergy were little removed from the peasants.

(vi) Historically, the three 'orders' or 'estates' of society had been represented in a body analogous to the English Parliament called the Estates General. No Estates General had met since 1614. Some of the regions of France had Estates of their own, usually unimportant, though sometimes they could become centres of opposition to royal policies. The *parlements*, of which there was a major one in Paris and twelve others in the provinces, were essentially judicial bodies, but they also normally exercised the function of 'registering' royal legislation, thus confirming its legitimacy.

EXERCISE

Now turn to 'Chronology showing key events of the Revolution' (A1) in *Resource Book 2*, reading quickly through this and keeping it for reference. We will return to it later in this unit.

EXERCISE

Carefully read the following primary source, and then work through the six questions to be asked about primary sources I listed at the beginning of this section, seeing how far you can provide answers to them.

Count de Germiny's account to the National Assembly, 20 August 1789

On 29 July 1789, a group of brigands from elsewhere, together with my vassals and those of Vrigni, the next parish to mine, two hundred in all, came to my *château* at Sassy, parish of Saint Christopher, near Argentan, and, after breaking the locks on the cupboards containing my title deeds, they seized the registers which could be so necessary to me, took them away, or burned them in the woods near my *château*; my guard was unable to offer any resistance, being the only warden in this area, where I myself do not reside. These wretched people had the tocsin rung in neighbouring parishes in order to swell their numbers. I am all the more sad about this loss because I have never let my vassals feel the odious weight of ancient feudalism, of which I am sure they could be redeemed in present circumstances; but who will ever be able to certify and prove the damage that they have inflicted on my property? I appeal to your discretion to bring in some law whereby the National Assembly can reimburse me for my loss, above all for the use of common land, as useful to my parishioners as to my own estate, whose title deeds they burned. I will not take steps against those whom I know to have been with the brigands who, not content with burning my papers, have killed all my pigeons. But I expect full justice in the spirit of equity which guides you, and which gives me the greatest confidence.

(quoted in Wright, 1974, p.107)

DISCUSSION

1 What date is it? Has the date any special significance? Well, this is the first summer of the Revolution, the summer of the 'Great Fear' in the countryside.

2 What type of source is it? As a formal complaint to an official body it is a document of record in that it definitely records a complaint is being made. How accurate it is with regard to the actual complaint made is another matter, though one would be inclined to feel that given the formal nature of the source it would be broadly accurate.

3 Who created the source? For what purpose? What biases might we expect? The author is a nobleman whose purpose is to persuade the National Assembly to pass a law enabling him to be reimbursed for the damage he claims he has suffered. Despite the point I have just made about formal accuracy, one would none the less expect the count to express as strong a case as possible in his search for compensation. It might be in his own interest to try to make out that it was not really his own vassals who were causing the trouble, so we might want to look a little cautiously at his claims about 'brigands', in particular, and also about vassals from the next parish.

4 Is the author of the source in a good position to provide reliable information? It's his property, so in general he ought to be able to give an accurate account. But he does reveal that he himself is not a resident in the area where the trouble took place, so he must be relying to some extent on another source of information, presumably from his warden. As the warden was not able to put up any effective defence, he might be inclined to exaggerate about the numbers, about there being 'brigands', etc. Still, I would come back to the point about this being a formal complaint to an official body – I would expect the count to be pretty punctilious in what he says.

5 What did the document mean to contemporaries? What particular problems of interpretation are there? Let me work through the document identifying phrases which need explaining. The implication of using the word 'brigands' is to suggest that we are here dealing with professional criminals, not just ordinary peasants. 'Vassals' are peasants who are not completely free but owe feudal duties to their lord. We have a number of place names in the first sentence, and it is a good basic rule always to find out what exact geographical location we are concerned with (different types of action take place in different parts of France). 'Château' is not necessarily a fortified castle, but can simply mean something like a manor house. 'Title deeds' and 'registers': these are the written documents which prove the count has legal right to certain lands and to certain feudal duties (including taxes and so on). 'Tocsin' is a peal of church bells used to arouse the alarm – it had already become a

regular symbol of the revolutionary mobs in Paris and elsewhere. 'Odious weight of ancient feudalism' is an important and rich phrase. Over time feudal duties had changed and in some places were more onerous than others – Germiny is claiming that he is relatively generous in what he demanded from his vassals, and he is indicating that he is in favour of ancient dues being abolished ('redeemed'). 'Present circumstances' are the current conditions of revolutionary upheaval. 'Common land': this was land to which everyone in the parish, not just the lord, had equal rights (for grazing, gathering wood, etc.). 'Killed all my pigeons': the keeping of pigeons in order to conduct pigeon-shoots was common among the nobility, and much hated by the peasants since the pigeons fed on their crops.

6 How does this source fit into the contextual knowledge we already have? We have noted the date and that that fits this into the period of the 'Great Fear'. I did mention the matter of 'brigands' in my brief account in the chronology (they stirred fear among peasants as well as among lords).

I hope that you can now see how the six questions can be related directly to the document, and can appreciate the importance of going systematically through the document in this way, before we proceed to deciding exactly what reliable information it gives us.

2 WITTING TESTIMONY AND UNWITTING TESTIMONY

These phrases were actually invented by me more than a quarter of a century ago: they do, I believe, refer to an absolutely crucial, though never utterly cut-and-dried, distinction in what is contained in primary sources. 'Witting' means 'deliberate' or 'intentional'; 'unwitting' means 'unaware' or 'unintentional'. 'Testimony' means 'evidence'. Thus 'witting testimony' is the deliberate message of a document or other source; the 'unwitting testimony' is the unintentional evidence that it also contains. (Actually, it is the writer or creator of the document or source who is intentional or unintentional, not the testimony itself, but transferring the adjective from the person to the testimony is perfectly acceptable in ordinary English usage.) Witting testimony, then, is the information that the person who originally compiled or created the document or source intended to convey.

In the document we have just been looking at, the testimony the Count de Germiny wishes to convey is that he has suffered at the hands of brigands and peasants and he hopes to gain compensation through the National Assembly. He refers specifically to the breaking of locks on

cupboards, and the seizing and burning of registers of title deeds. His earlier point that there were brigands and vassals from another parish is amplified when he refers to the tocsin being rung in several parishes in order to produce much larger numbers than would have been provided by his vassals alone. He specifically mentions that the title deeds expressing his own claims upon common land have been burned. Finally, not only have his papers been burned, but all his pigeons have been killed. The other deliberate message in the document is that he is not a wicked upholder of ancient feudalism, but indeed is a believer in such feudalism being abolished. The count also seems to be trying to emphasize his decency by bringing in the question of common land, relevant to the vassals as well as to himself. And he says he is not going to take direct action against his peasants even though they were acting with brigands. That, then, is a summary of the witting testimony: very important but really not much more than a paraphrase of the text itself.

However, for the historian, de Germiny reveals other things: (i) of which he is not conscious, (ii) of which he is partially conscious but of whose historical significance he is quite unaware, and (iii) which are so obvious to him that he just mentions them in passing. The title deeds and registers form a good example of (iii). We as historians learn how important these are to him (he takes that for granted). Evidently these written documents are essential for him to back up his feudal claims (he cannot do this just on the basis of power and prestige alone), and, what is more, the vassals themselves know this. So we have clear (though *unwitting*) testimony to the importance in this society of certain types of legal documentation. We also learn how important to him his pigeon-shooting is (and, by implication, how hated by the peasants).

Completely unwittingly he gives away the fact that he is a non-resident landlord or that, at the very least, he has two residences. Equally, since he gives this away unthinkingly, there was obviously not thought to be anything unusual or reprehensible about a noble living in this relatively lavish way. See how you can keep digging deeper into a document to bring out things about prevailing values and assumptions.

In his opening sentence (this is an example of (ii)), the count is not intending to make the historical point about whom the brigands were collaborating with; but he would seem, without deliberately intending it, to be giving evidence against the common view among peasants that the brigands were actually working on behalf of the nobility against the peasants. It is also clear – and this is perhaps one of the single most important historical points in the document – that the count has absolute confidence the National Assembly will listen to him sympathetically. In other words, he does not see any clash of interest (personal or class) between himself as a member of the nobility and the National Assembly (traditionally represented as 'bourgeois'). He clearly feels that it will value property rights just as much as he does.

To sum up. There is important direct – witting – testimony in this document. But I hope you can also see that for some of the most important concerns of the historian, it is the unwitting testimony which matters.

EXERCISE

There is one rather important thing about what actually happened which the document does not tell us. I wonder if you can spot what it is. If not, go straight to my discussion.

DISCUSSION

We don't know whether the count was successful in his appeal. The fact that he asked for a law which will gain him reimbursement does not mean such a law was actually passed. In fact, what happened – as stated in the chronology – was that pressure from the peasant activism of the 'Great Fear' forced the National Assembly in August to abolish all feudal privileges. So, though this is not contained in the document (but would form the part of the full context which a historian would need to have), it is an important point that this nobleman, though confident of the support of the Assembly, did actually fail in his appeal.

3 UNDERSTANDING THE PAST 'FROM THE INSIDE'

Some of the things you learned about the family in past ages may have astonished you: large numbers of dependants and retainers all living with a wealthy family in the same household, or attitudes to wives or daughters and to children. There is little point in getting upset or censorious about behaviour and attitudes in the past (though we may well find knowledge of them helpful in our reflections on similar issues today – this is a basic purpose of historical study). As historians we have to understand the mind set, mental outlook or belief system of people in past societies (*mentalities* – yet another technical term! – is the word historians use). This point is a general one and applies to all historical study, even of a period as recent as the 1960s. Shortly you will be reading the 'Petition of the women of the Third Estate', which is very illuminating with regard to their mentality or general outlook: they do not seek the jobs – still less 'the authority' – of men; they are religiously moralistic about prostitution, and they are utterly monarchist.

Here I want to mention three aspects of the mentalities of Western Europeans throughout the centuries which both tend to astonish the modern mind and are particularly relevant to our study of eighteenth-century France:

1 the continuing influence of the classical tradition (for detail on this important point, read now A17 by Michael Bartholomew and Antony Lentin and A18 by Colin Cunningham in *Resource Book 2*);

2 the centrality of Christian belief and practice;

3 a belief in the supernatural (I am avoiding the word 'superstition' because, although accurate enough, it does suggest criticism of past attitudes and therefore a failure to understand people on their own terms).

4 HANDLING PRIMARY SOURCES

We are now ready both to analyse primary sources and to extract information from them. In the following exercises we are going to imagine that we are writing a study of some aspect of the French Revolution and that we have a specific source in front of us which we wish to analyse and then make use of. The purpose of the exercises is to get you to concentrate on the actual words and phrases of the source in front of you, but to make this possible it is necessary to give you certain basic contextual information. This kind of exercise is fundamental to what I am trying to demonstrate in Units 8 and 9, and is the kind of exercise you are asked to do in the TMA associated with them. The audio-cassette has been designed to help here, so please have it to hand and I will tell you when to switch on. The next exercise is set out in the same format as the TMA.

EXERCISE

Read carefully the following passage, which is an extract from a petition addressed to the National Constituent Assembly drawn up by members of two radical republican clubs, the Social Circle and the Cordeliers Club. (The authors were mainly bourgeois figures, including the lawyer Danton, later a notorious enthusiast for the Terror.) It was published in the *Social Circle* newspaper on 16 July 1791.

Basic contextual information: after attempting to flee the country in June, leaving behind a denunciation of the Revolution, the king had been suspended from exercising his royal powers by the National Constituent Assembly. The decree of 15 July confirmed the Assembly's acceptance of the inviolability of the king's person and of the theory that the king had been abducted against his will, but stated that he would not be reinstated

until he had accepted the new constitution currently being drafted. This petition of 16 July was in protest against the decree, the drafters hoping to collect mass signatures at a demonstration on the Champs de Mars on 17 July. About 6,000 signatures had been collected before the demonstration was suppressed in the 'Massacre of Champs de Mars'.

> The undersigned Frenchmen, members of the sovereign people, considering that in matters relative to the safety of the people it has a right to express its will to enlighten and guide its mandatories:
>
> That no more important question has ever arisen than that of the king's desertion;
>
> That the decree of 15 July contains no provision relative to Louis XVI; ...
>
> That Louis XVI, after having accepted royal duties and having sworn to defend the Constitution, has deserted the post entrusted to him, has protested against that very Constitution in a declaration written and signed in his own hand ...
>
> That his perjury, his desertion, his protest, to say nothing of all the other criminal acts which have preceded, accompanied, and succeeded them, entail formal abdication of the constitutional crown entrusted to him;
>
> That the National Assembly has so judged in assuming the executive power, suspending the powers of the king, and holding him in custody; ...
>
> Formally and particularly demand that the National Assembly receive, in the name of the nation, the abdication made on 21 June by Louis XVI of the crown delegated to him, and provide for his replacement by constitutional means;
>
> Declaring that the undersigned will never recognize Louis XVI as their king, unless the majority of the nation expresses a desire contrary to that of the present petition.
>
> *(Stewart, 1965, pp.218–19)*

Imagine you are writing a study of 'The attitudes of the French people towards monarchy and constitutional government during the French Revolution', and you want to use this source. In the form of a brief essay of not more than 600 words (not notes – an essay will provide good practice for your TMA), discuss the following:

(i) What kind of primary source is this, and what strengths and weaknesses does it have as a source for 'The attitudes of the French people towards monarchy and constitutional government during the French Revolution'?

(ii) What particular words and phrases in the document require elucidation or special comment before you can make use of it?

(iii) What can you learn from it with respect to your study, distinguishing between the witting and unwitting testimony?

Notes on how to approach this exercise

In answering these questions you will need to bring in what you have learned from Sections 1 and 2 of this unit. Here are some hints.

'What kind of source' is question 2 in Section 1 (p.47), which you may need to refer back to. In establishing strengths and weaknesses you need to work your way systematically through the other questions:

1 Significance and relevance of the date of the source.

3 (I've just referred to question 2.) Who created the source and what particular interests were they likely to have?

4 Are the creators of the source in a good position to provide reliable information on the particular topic you are interested in?

For question (ii) in this exercise, you need to refer to question 5: it is vital to be sure of understanding the source as contemporaries would have understood it, and to tease out all obscure references, technical terms, etc. Single out everything that requires elucidation or explanation, even if you yourself are not capable of providing that explanation, or even if the contextual information has already provided an explanation. The purpose of the exercise here is to see if you are able to indicate all the words and phrases a historian would have to elucidate before proceeding any further.

For question (iii) the minimal contextual information you have should be helpful, though Section 2, explaining the difference between witting and unwitting testimony, is important. There it is explained that unwitting testimony is information contained in the source (a) of which the creators of the source are not conscious at all, (b) of which the creators are partially conscious but of whose historical significance they are quite unaware, or (c) which are so obvious to the creators of the source that they are really just mentioning them in passing. Unwitting testimony can be of great significance to the historian, revealing values, assumptions, conventions, etc.

DISCUSSION

When you have finished your essay, but *only* then, switch on the cassette (AC4, Side 1, Band 1) and listen to my suggested answers combined with my explanation of the thought processes you should be going through in doing this kind of exercise.

EXERCISE

Read carefully the following passage, which is an extract from one of the formal statements of grievances (technically known as *cahiers de doléances* – a different one is discussed in TV9) which the districts were

invited to send in to the Estates General early in 1789. This one is from the village of Pleurs in the legal district (*bailliage*) of Sézanne.

> Afflicted by so many misfortunes and suffering from poverty, the people of the countryside have become listless; they have fallen into a state of numbness, a kind of apathy, which is the most dangerous of all complaints and the most disastrous for the prosperity of a country. The population is suffering. They are afraid to get married, for marriage only holds the prospect of further hardships; they would immediately be taxed, asked for the *corvées*, for labour services and contributions of all kinds. They fear a situation where their family would be a burden on them, since they can only anticipate their children being poor and wretched.
>
> Oh petty tyrants placed at the heart of the provinces to hold sway over their destinies! Oh proprietors of seigneurial estates who demand the most crippling and servile exactions! Oh rich citizens who own property for the moment! Be so good as to leave for a time your palaces and châteaux, leave your towns where you have created new problems, where you are offered with both hands everything that indulgence and luxury can invent to stimulate your blunted senses, your satiated spirits; be so good as to glance at those unfortunate men whose muscles are only occupied in working for you! What do you see in our villages, in our fields? A few enfeebled men, whose pale faces are withered by poverty and shame, their wives lamenting their fecundity, each child wearing rags.
>
> Among them, however, you will find several who are happy; these seem to be men of a different kind; they are in fact privileged men like you, nourished on the food of the people; they live amid abundance and each day is pure and serene for them. Such a striking comparison has served to deepen the misery of the labourer, if he is at all sensitive.
>
> *(quoted in Wright, 1974, p.105)*

Imagine you are writing a study of 'Conditions and attitudes in the French countryside in early 1789', and you want to use this source. In the form of a brief essay (not notes), discuss the following questions:

(i) What kind of primary source is this, and what limitations and strengths does it have as a source for your study?

(ii) What particular words and phrases in the document require elucidation or special comment before you can make use of it?

(iii) What can you learn from it with respect to your study, distinguishing between the witting and unwitting testimony?

DISCUSSION

This is a very special (and famous) kind of source, a statement of complaints which the district was specifically asked to send in for the first meeting of the Estates General. It is a formal complaint to a formal institution so we would expect it to maintain certain standards of accuracy. At the same time we would not expect the complainants to

understate their complaints. These formal documents were drawn up at meetings of the local parish so we would expect them to express what the peasants really felt, though the actual drafting would have to be done by someone educated, the most likely person being the priest. This is a 'strong' document, therefore, giving peasant grievances more or less 'straight from the horse's mouth', as it were. The style is declamatory and rhetorical, but that is not unusual in an eighteenth-century document. The basic points do come through pretty clearly. However, there are some general comments ('the most dangerous for the prosperity of a country', etc.) which go beyond factual reporting and move into the realm of opinion – these we have to treat particularly cautiously. 'They are afraid to get married' may be true, but really we would require hard corroborating evidence (statistics of marriage rates, for example). Apart from that, the basic weakness is that this is only one source and we do not know how representative it is – we would need to compare and contrast it with other sources. We cannot be sure from the document whether these extremely bad conditions are something very recent and therefore potentially threatening (as seems to be the sense of the document), or whether they are really quite normal and therefore can be expected to be endured as in the past.

With regard to that point but moving on to the question of elucidation, it would be useful to be sure of the geographical location of Pleurs and Sézanne. *Corvées* is a technical term that would have to be explained (compulsory service on building roads or a payment instead); you would also need to have detail on the 'labour services' and 'contributions'. It is not absolutely clear who are the people referred to in the first three sentences of the second paragraph: *probably* – but we would have to check this – 'petty tyrants' are the government officials, the *intendants*; the 'proprietors' are nobles; and those in the third sentence members of the bourgeoisie. The next sentence is easy to misread, so be sure you have got the correct sense: the document is saying come out of your palaces (*not* go away from them) and look closely at the misery all around. Just who, exactly, are being referred to in the final paragraph is not absolutely clear. Presumably all of those addressed in the third paragraph are members of the Estates General, the intended recipient of this formal document; thus those referred to in the final paragraph are the many privileged who are not actually members of the Estates General and are continuing to live among the people – either the lesser bourgeoisie or (my interpretation) wealthy artisans who, by the definitions of the time, ranked below the bourgeoisie.

Wittingly, the document is telling us that conditions for ordinary people in the countryside are appalling – people are listless, apathetic, afraid to get married and raise children. Men are enfeebled by work and withered by poverty, and children are in rags. The misery of the worker is made even worse by the obvious contrast between the rich and the poor. The document defines the situation as 'dangerous' and 'disastrous for the

prosperity' of the country. We cannot be certain whether everything said wittingly is absolutely true or not, but without doubt what is said wittingly is of great historical importance. What is also very important historically is that formal channels have now been opened through which the peasants can express their grievances (this is not overtly expressed in the document because the writers of the document know that is what is taking place – I classify this as 'unwitting testimony'). The effects of the complaints on the Estates General may not have been great, but the very fact of having them expressed raised peasant expectations, which when unmet led to the peasant risings and the 'Great Fear'. We learn that as far as the poor are concerned, nobility, bourgeoisie and (probably) wealthy artisans can all be lumped together as one oppressive class. (Is this perhaps the real social divide, not the Marxist one between nobles and bourgeoisie mentioned in Unit 8?) You see how we have to keep digging deeper and deeper into the document – that is, we have to seek out the unwitting testimony. Overall, in its witting and unwitting testimony, the document tells us about peasant grievances, and it also tells us that these grievances are being voiced in a formal way.

5 FACTS IN HISTORY

You could say, 'the French Revolution is a historical fact'. However, it is obvious that something as complex, and spread over so many years, must contain a vast number of other historical facts, such as that the Bastille was stormed on 14 July 1789 or that Louis XVI was guillotined on 21 January 1793. Historical events certainly cannot be reduced to single 'atoms' or single 'building bricks'. Historians are interested in many other things than events – states of mind, living conditions, evidence of links between one circumstance and another – to which the word 'fact' scarcely seems appropriate. From all this I personally conclude that earnest discussions about historical facts are a waste of time. The question one asks is not, 'is it a fact?', but 'is there reliable evidence for it in the sources?'

This extremely short section is included because the question of 'historical facts' crops up again and again. It is short because a short answer is all that is needed: one no longer wastes time in the sciences discussing the nature of scientific facts; so, in history, there is no point in discussing the nature of historical facts! I hope the shortness of this section will do something to compensate for the length of the next one.

6 ESSENTIAL CONTEXTUAL KNOWLEDGE OF THE FRENCH REVOLUTION

This section will take you the longest to complete, so you may need to divide your time into a series of study sessions to fit the eight phases of French history given here. See AGSG, ch.2, sects 3.2 and 3.3, 'Reading speeds' and 'Study sessions'

This section is very long not because it is more important than the others, but rather because it unavoidably contains a lot of information. Its purpose is to fulfil the second aim of these units: 'to discuss some of the main aspects of the origins, course and aftermath of the French Revolution ...'

Let me first say something about recent writing on the French Revolution. My point in Section 1 (p.49) about the importance of contingency is perhaps one that particularly distinguishes recent historical writing; seeing clearly that there is much which is not determined by 'historical laws' is part of the general move away from Marxism. An ultra-traditional Marxist interpretation would see the French Revolution as both inevitable and necessary: inevitable because the burgeoning bourgeoisie could no longer be held down by the reactionary aristocracy, and necessary to clear the way for bourgeois industrial/capitalist society. Nobody believes that exactly any more, and indeed much of the detailed archive work which has provided a much more complex, and much more convincing, picture of the Revolution was carried out by scholars who were themselves Marxists. To give some sense of how the historical context is produced and to forge links with TV9, I'm going to pick out four current British historians. Three are best known for their excellent textbooks (of very different types), one for a massive tome deliberately created for the 200th anniversary of the Revolution and, as intended, an immense best-seller.

William Doyle (Professor of History at Bristol University) established himself through scholarly work in the provincial archives, particularly on the *parlement* at Bordeaux (as I remark at the beginning of TV9, this is the sort of precise topic most historians work on). His later *Origins of the French Revolution* (1980, revised 1988) and *Oxford History of the French Revolution* (1989) are excellent textbooks in the non-Marxist tradition. Doyle sees himself as belonging to those who brought about a collapse in what he perceives as a previous Marxist 'consensus' (wrongly in my view – there have always been non-Marxist histories of the French Revolution). Bill Doyle shares his expertise with us in TV9.

Gwynne Lewis (Professor of History at Warwick University) established himself with a study of coal mining in the provincial region of the Bas-Cevennes and the arrival there of capitalist methods in the late eighteenth century. In his brief textbook, *The French Revolution: rethinking the debate* (1993), he identifies two distinct approaches: what he calls 'the revisionist approach' (which includes Doyle) and what he calls not the Marxist approach but, in full recognition that that approach no longer

carries credibility, the 'marxisant' approach (French, pronounced 'marx-eez-ong', meaning 'inclining towards Marxism'). As I see it, recognition is implicitly being given that differences are of emphasis rather than kind, though Lewis clearly enjoys an adversarial atmosphere in which he rejoices in his own strong left-wing political commitment and makes jokes about those who don't share it. Most revealingly he describes Doyle's *Oxford History* as 'revisionist in tone rather than content'. In other words, he himself doesn't find much to disagree with in the content. This is my fundamental caution: be sure that much vaunted disagreements genuinely are about content (what really counts) and not simply (because there are political or other reasons for exaggerating them) differences in 'tone'.

Simon Schama (Professor of History at Harvard University) did his earliest work, much of it intricately statistical, on the Dutch Republic at the time of the French Revolution. Later, making detailed use of paintings as sources, he published a highly original study of the Dutch Republic at its height in the seventeenth century. His *Citizens: a chronicle of the French Revolution* (1989) is long and lavishly illustrated because his publishers saw it as a prime commercial investment in celebration of the 200th anniversary of 1789 (as was stressed in Unit 8, Section 8, history is an activity of ordinary human beings with normal appetites for fame and fortune). Again Schama did very interesting work in using paintings, drawings, designs, etc. as basic source materials. He also made particularly extensive use of the many memoirs, autobiographies and published letters from the time – anything yielding personal detail and anecdote. He set out deliberately to give the reader a sense of immediacy, a sense of precisely what it was like to live through the Revolution; accordingly, the reader is taken in and out through the lives of lesser people and greater ones. Given these aims, he devised with great skill a structure for his book which would communicate them with maximum efficiency. He called his book a 'chronicle', partly to distance himself from those (Marxists in particular) who had sought to analyse the deeper origins and nature of the Revolution, and partly to show that he was in touch with fashionable postmodernist ideas about history being 'narrative' in much the same sense that novels are 'narrative'. But he did in fact draw heavily and knowledgeably on the most recent specialist works by professional historians. He differs from Doyle, and very obviously from Lewis, in expressing anti-Marxist views in very positive terms. He maintains that France was moving towards capitalism anyway, and that the Revolution was an interruption of that development. He finds the massacres and bloodshed inexcusable. He argues that the one significant outcome of the Revolution was a new phase of more intensive war based on national citizen armies. But where Schama's book really differs from the two textbooks is in its colour and detail, and in that it is manifestly aimed at a wide readership; in content and approach there is no real conflict with Doyle.

Colin Jones (Professor at Exeter University at an unusually young age, subsequently joining Gwynne Lewis as Professor of History at Warwick) did a remarkable study of hospitals in eighteenth-century France using hitherto untouched archive materials from throughout France. (He was able both to challenge and, in some cases, to confirm the speculations on this subject of the French philosopher Michel Foucault.) Jones is also the author of the infinitely useful *Longman Companion to the French Revolution* (1988); he too appears in TV9.

Phases of French history, c.1750–1815

You are *not* expected to memorize this information: it is provided as basic context for exercises on primary sources. Read it through carefully, and then use it *for reference*. In presenting you with my summary of Enlightenment France and the French Revolution, I shall try to *structure* my material in such a way that it will *communicate* what I think is important in the most effective way possible. (Structuring is a central issue in Units 25 and 26.)

French society, 1750–86

EXERCISE

To begin, read the historical outline of France in the eighteenth century by Clive Emsley (*Resource Book 2*, A19).

Remember what I have already said about the importance of classicism among the educated, religion among all classes, and the strong belief in the supernatural among the poor (and quite a few educated people as well).

To these I want to add a further element, which I can only describe as the *brutality* and *cruelty* of life. Use of such terms entails perjorative value judgments which may seem at odds with the idea of seeing the past 'from the inside'. However, historians simply cannot avoid value-loaded words – we have (in discussing the French Revolution) to call a massacre 'a massacre'.

Brutality and cruelty were abundantly apparent in all societies, but one is not being jingoistic in noting that, for example, the French judicial system was a good deal more brutal at this time than the English (I do mean 'English', not 'British'). Torture was regularly used for the extraction of confessions, and the death penalty was often exacted in a particularly cruel fashion (breaking on the wheel, for instance). More generally, near-starvation conditions throughout the country meant that, for the many, life could not unjustly be described as 'nasty, brutish and short', though, as it happened, eighteenth-century France was unusually free of total

famines. The Enlightenment philosophers did speak out against brutishness in all its aspects.

I also want to refer to the sense of social hierarchy and profound belief in monarchy deeply ingrained in practically everyone at this time (and, after the interlude of the French Revolution, for many years to come – when nationalities began to demand their own nation states in the nineteenth century, the first thing they tried to find themselves was a monarch). Most Enlightenment philosophers continued to believe that the division of society into ranks was perfectly proper, and that monarchy would provide the most secure and legitimate form of government. Against ideas of the automatic legitimacy of monarchy, Rousseau proposed the notions of the 'social contract' (between rulers and ruled, which rulers have to obey) and the 'general will' (the will of the people as against that of a mere monarch). In Units 10 and 11 you will explore Rousseau's ideas in greater depth.

EXERCISE

Finally, what of women? Well, here I triumphantly kill two birds with one stone. I have spoken of the crucial importance of primary sources both in research and in teaching and learning. For an immediate, and yet immensely rich, understanding of the position of women, you could not do better than read A3 in *Resource Book 2*, 'Petition of the women of the Third Estate to the king, 1 January 1789'. I have not provided any feedback this time (though I expect you to read this document in accordance with the critical principles you are learning), but will want you later in this unit to reflect on what happened to women during the Revolution. Do not read further until you have read and understood the petition. ■

How sophisticated and well educated the leading figures who drafted the petition were! Schooling (I don't say 'education'), if intended only to enable you to understand religious services, could also enable you to understand political tracts and newspapers. These women knew what was going on; they knew that, to use a feeble but useful cliché, France was on the move. That is what had stirred them into action.

So, a positive point to end my survey of French society, 1750–86. From the researches in particular of one of France's best-known historians of today, François Furet (rhymes – nearly – with hoo-ray), a kind of French Peter Laslett (rigorous in his insistence on the primacy of statistical analysis, contemptuous of impressionistic, 'literary' history and, above all, of Marxism and postmodernism), we know about the great expansion in publishing, printing and the reading public in eighteenth-century France. We have also known for much longer that the minister responsible for censorship (generally severe in France), Malesherbes, was himself a true Enlightenment figure and believed in letting people read what they

wanted. So the Enlightenment works of Rousseau, Voltaire, etc. were not only written, but (what doesn't necessarily follow) they were widely *read.*

The pre-revolutionary crisis, August 1786–December 1788

On 20 August 1786 Calonne, comptroller-general of the royal finances, told Louis XVI that a complete collapse in the nation's finances was imminent. France had achieved glory, and glorious revenge on an old enemy, by supporting the Americans in their successful revolutionary war against Britain, but the cost had been enormous. From the sources left by eighteenth-century accountants it is impossible to establish exact figures, but almost all historians are agreed as to the reality of the crisis, though Schama claims that the king could have found a way out as kings had done in the past – for instance, when they had simply gone bankrupt and refused to pay off existing debts. Neither Calonne and the king nor any one else at the time thought that an option: by this stage in economic development, if you didn't pay your debts you'd find it difficult to raise future loans. Calonne was also clear that there was no scope for increasing taxes. He put his analysis down in writing (*Resource Book 2, A2*).

EXERCISE

Read A2, an extract from Calonne's reform programme, and then write down answers to the following questions:

1 It took months for Louis XVI to be convinced that Calonne's analysis was correct, and that what he called for at the end of the extract was essential. Does Calonne convince you? Or was he perhaps just making it all up? Give reasons. (This is just a variation on the standard questions about reliability, bias, etc.)

2 What, in essence, is Calonne saying needs to be done? How would you characterize his conclusion (timid, sweeping, crazy, etc.)?

DISCUSSION

1 I can see no reason why Calonne should want to make it up. Such an analysis certainly wouldn't be popular with his royal master, so he is doing himself no favours. As comptroller-general, Calonne presumably ought to know the situation better than anyone.

2 He says there is a need for an end to the lack of uniformity (the 'disaccord', the 'incoherence') throughout the kingdom, and to the 'abuses' which make it impossible to govern the kingdom well. The conclusion certainly is very sweeping; dare one call it 'revolutionary'? His analysis is revolutionary in that it would offend established

interests (the implication that the rich should pay their fair share of taxation, for instance). On the other hand, both the analysis and conclusion weren't new, being very much in keeping with the sorts of thing Rousseau and other Enlightenment philosophers had been saying for decades.

Sweeping changes in the organization of the monarchy and in the basis of taxation could not simply be decreed by the king; there had to be some means of securing consent for them (at least from the mighty), of establishing their legitimacy. Calonne hit on the wheeze of summoning a special 'Assembly of Notables', powerful men carefully selected by the government yet who could be represented as speaking for all the major interests throughout the kingdom. The 144 Notables included 7 princes, 14 bishops and 36 titled noblemen (a total of 57 genuine nobles of ancient stock); 12 high officials of the king (either members of the central Council of State or *intendants*, the king's representatives in the regions), 38 magistrates, and 12 representatives of regional estates or assemblies (a total of 62 of bourgeois origins who, because of the office they held, automatically became members of the lesser nobility); 25 mayors and civic dignitaries (classic examples of the successful bourgeois not yet ennobled). Not a very revolutionary-looking body! It assembled on 22 February 1787 in Versailles. The Notables did agree that in future the nobles would have to bear a fairer share of the tax burden, but the bishops resisted the application of the same principle to the Church, and the magistrates argued that for the whole sweeping range of proposals the consent of a more legitimate body than this specially convened assembly would be required. They had in mind the Estates General, which had last met in 1614. Among the educated and politically informed and perhaps even beyond, the idea grew that, if France was to be reformed and the crisis resolved, then the solution lay in the rare and majestic operation of the summoning of an Estates General (see Figure 9.1).

Calonne's failure to get his way with the Assembly of Notables was bitterly criticized by his ambitious rival for the king's favour, Brienne. First Calonne was dismissed from his post, then on 30 April 1787 Brienne became first minister. It is on the basis of the programme of the Brienne ministry that the claim can be made that already, before the Revolution, the French monarchy was embarked on ambitious reform (and so, by implication, that the Revolution was 'unnecessary'). The programme included legal reform and the abolition of judicial torture, religious toleration and granting of full civil status to Protestants, central control and audit of taxation, and the establishment of genuinely elective provincial assemblies. But Brienne was no more successful than Calonne in winning the support of the Assembly of Notables. This was dismissed on 25 May while Brienne went ahead anyway. The normal routine for legislation was for it to be 'registered' by the *Parlement* of Paris and the

CLERGÉ NOBLESSE TIERS-ÉTAT

Costume de Cérémonie de Messieurs les Députés des 3 Ordres aux États Généraux .

A Paris chez Basset Md d'Estampes et Fabricant de Papiers Peint rue St Jacques au coin de celle des Mathurins .

FIGURE 9.1 *Pre-revolutionary print published by Basset in Paris showing ceremonial dress of deputies of the three orders in the Estates General. A member of the clergy is shown on the left, the nobility in the middle and the Third Estate on the right. Musée Carnavalet, Paris. (Photograph: Bulloz)*

twelve other provincial *parlements*. But now the *parlements* declared that such far-reaching legislation really needed the approval of a truly national body, and joined in the clamour for an Estates General. In fact, through the unsuccessful ruse of the Assembly of Notables, the monarchy had already conceded the point that its programme needed the validation of some sort of national body. Although the *Parlement* of Paris was an unelected body of magistrates who automatically enjoyed noble status, it came to assume a certain symbolic importance.

Then, not for the last time in this complex series of events, international developments impinged on French ones. A Prussian invasion of the Netherlands seemed likely. Normally the French would demonstrate their great power status on the European scene by going to the aid of the Dutch 'Patriots'. But a bankrupt government could not risk being embroiled in a European war. If national prestige was to be preserved, the government had to get its reforms (particularly those aimed at improving tax returns) implemented. Louis and Brienne alternated between threatening and cajoling the Paris *Parlement*. On 19 September 1787 the king himself was present at a day-long sitting at which he hoped to have new loans approved. At the end of the session Louis refused to allow a vote to be taken, insisting that the loans simply be registered 'because I wish it'. That opened up bitter conflict with the

opposition, the lead being taken by the distinctly un-bourgeois Duke of Orleans. The government now suspended the *parlements*, simply going ahead with the forcible registration of its reforms.

From May 1788 there was agitation of various sorts at many levels of society. So prominent were the unauthorized assemblies of nobles which organized petitions in support of the *parlements* that some historians have referred to this period as that of 'the revolt of the nobility'. Probably at least as important is the massive onslaught of political pamphlets calling for a summoning of the Estates General and frequently deploying the language of Rousseau – the 'general will' had been defied, the 'social contract' broken.

Meanwhile the government was not escaping from its financial crisis, and by August the final disaster Calonne had warned of appeared to have arrived. Again there have been disputes among historians as to whether the government really was bankrupt; Brienne certainly seemed to think it was. Probably the point is academic. Brienne decided that the only way of restoring royal credit was to announce that an Estates General would indeed be convened on 1 May 1789. Then he quietly resigned, ensuring that Necker, the former finance minister (in disgrace with the king but widely popular), replaced him. Royal government now seemed to go into suspension, awaiting the convocation of the Estates General. There was intense manoeuvring between the politically conscious groups – nobles and bourgeois together, nobles and bourgeois separately – over what form the Estates General would take and which group would control it. At this point we can give one tentative (and incomplete) answer to the question, 'Why did the French Revolution happen?' That answer is: 'By the end of 1788 royal government had collapsed.'

From Estates General to National Assembly to Constituent Assembly, January–June 1789

The *Parlement* of Paris returned in triumph to the Palace of Justice, as Necker cancelled all the reforms that had been carried through without its consent. Apparently sharing the widespread view that salvation lay with the summoning of the Estates General, Necker advanced the date to 1 January 1789 (this decision being duly registered by the Paris *Parlement*). He also legalized the Paris political clubs, first formed in the spring of 1787 but banned by Brienne. While the *parlements* stepped up the general level of agitation, Necker sought an answer to the question of what form the Estates General should take by convening a second Assembly of Notables. The major questions, debated in clubs and assemblies in Paris and throughout the country, concerned: how each of the three orders should elect its representatives, whether the Third Estate (representing 95 per cent of the population) should have double the representation of the other two, and whether (if that were agreed) the estates should meet together as one assembly on a one-representative-

one-vote basis, as against each estate meeting separately and arriving at its own decision.

No clear answers emerged and so, in the early months of 1789, the complex processes of actually electing representatives went ahead as basic issues of principle continued to be debated. In theory the Third Estate electorate was a wide one extending to peasants and artisans; however, they seemed happy to leave the actual choosing of individual representatives to local assemblies dominated by bourgeois figures. (Note the 'gentlemanly' breeches worn by the Third Estate deputy in Figure 9.1 – he is obviously not a peasant or artisan.) Sometimes nobles were chosen. When finally the Estates General did convene on 4 May, 43 per cent of the Third Estate consisted of officials of the lesser (non-noble) courts, 25 per cent of lawyers, possibly up to 19 per cent of landowners (noble and non-noble); the 76 merchants, 8 manufacturers and 1 banker totalled only 13 per cent. The Third Estate was bourgeois in the eighteenth-century French sense; it was not bursting with capitalists, but it certainly excluded peasants and workers.

One other important procedure took place simultaneously with the choosing of representatives: each order, in every part of the country, was invited to draw up lists of grievances for debate when the Estates General finally convened. These lists of grievances (*cahiers de doléances*), reposing in the archives and (some of them) converted into printed volumes of documents, have long formed a central source for the study of the French Revolution.

In accordance with tradition the Estates General did in fact convene in its three separate components, despite the arguments raised against this within the Third Estate as well as among many of the non-noble clergy and some nobles. On 10 June the Third Estate passed, by 493 votes to 41, a resolution calling on all three estates to meet as one body, and resolving to carry on as such a body if the other two estates refused to join it. On 17 June the Third Estate did exactly this: joined by nineteen clergy it constituted itself a National Assembly, and immediately asserted sovereign rights over taxation – in effect, it was setting itself up as an equivalent of the British House of Commons. The king was spurred into action and decided that the next session of the Estates General, on 23 June, would be a 'Royal Session' at which he would propose a programme. The Third Estate was not informed that until then the hall in which it had been meeting would be closed. Turning up as usual on 20 June the members were outraged and full of suspicion. Where did they go? Well, the tennis court of course (as we saw in Unit 8 and Plate 126 in the *Illustration Book*). Here they took the famous oath never to disperse until they had given France a constitution.

Necker wanted the king to accept the new situation, thus involving the Estates General in the reform and taxation programme. When the king insisted on annulling the resolutions of 10 and 17 June, Necker resigned.

The Third Estate reaffirmed the Tennis Court Oath, and was joined by most of the remaining clergy and forty-seven of its supporters in the noble estate. The king swung round, insisting Necker come back and instructing all nobles and clergy to join the Third Estate in forming a genuine National Assembly. France was now a limited (or 'parliamentary') monarchy and on the way to becoming a constitutional one, as the National Assembly stressed by renaming itself the 'National Constituent Assembly', a body whose essential task was to draw up a constitution. The problem was that it looked as though the king was going to try to use the army to reverse all the concessions he had made.

Famine and popular involvement in the Revolution, July–August 1789

By the end of June 1789 you could say, if you wanted to put it that way, that 'bourgeois revolution' had been attained. The king was still there of course, and although, meeting separately in their own estate, the nobles had readily given up their remaining tax exemptions, many of their privileges and 'feudal rights' remained in being. There was very real danger that the king might forcibly overthrow this 'bourgeois revolution'. There is little disagreement among historians that what changed all three of these circumstances was the rather different actions of, on the one hand, the peasantry and, on the other, the townsfolk, particularly in Paris. The debates and issues surrounding the elections for, and meeting of, the Estates General undoubtedly did have an effect on both groups in making them aware of the possibilities of change, and perhaps even in arousing hopes that their world of grinding poverty was about to come to an end. But without doubt the catastrophic harvest of 1788, which produced (a) starvation, (b) loss of income, and (c) unemployment (wine-making, silo-making, grain-milling, and lots of other trades people no longer had the money to pay for), was an important goad to action. How important? Many historians have been reluctant to accept the historical significance of something as arbitrary as a bad harvest. Undoubtedly all the developments I have just been discussing are important too: the point to focus on, I think – and it is a point of wide validity in historical study – is the concurrence of these various social and human acts with this 'act of nature'.

The people of Paris were very conscious of being at the centre of national events, and rich businessmen were united with poor artisans in demonstrating, first, on behalf of the Paris *Parlement* in its confrontations with the king, even though it was an utterly unrepresentative body of ennobled officials, and then in support of the Third Estate. The cafés in the Palais Royal, private property of the Duke of Orleans, became a meeting place of the better-off and more intellectual sort, a hotbed of pro-Third Estate agitation. The first bread riots in 1789 were really separate from these activities. But as hunger spread, the king's obvious hopes of reversing the constitutional changes were identified as all of a

piece with a policy of starving the people, whereas Necker, whom the king finally dismissed on 8 July, had always been seen as a champion of traditional regulation and subsidy. News of Necker's dismissal broke on Sunday 12 July, a convenient day on which to start a demonstration; this one, of 5,000 to 6,000 people, involved both the Palais Royal revolutionaries and the bread rioters. The king had already been moving troops into Paris as part of his plans to curb both rioters and the Third Estate. There was an immediate clash with two results: the troops were withdrawn and the Parisians decided to arm themselves more effectively. Here is William Doyle's account of what happened next:

> Thus began the insurrection which culminated in the taking of the Bastille on 14 July. Primarily it was a search for arms. Throughout the 13th, every place in the city where arms were known, or even suspected, to be stored was ransacked. The Bastille was merely the last, and the most formidable, depot that the rebels reached, and it was only taken by storm because its terrified garrison made a half-hearted attempt at resistance. Only later did it come to seem especially significant that an apparently impregnable royal fortress and a sinister state prison where victims of tyranny had often languished, should have fallen to popular assault. It is, indeed, unlikely that it would have fallen had the efforts of the besiegers not been co-ordinated by mutinous members of the French Guards, professional soldiers who knew what they were doing. But the insurrection was also a food riot. During the night of 12/13 July, 40 out of the 54 gates in the new customs wall were attacked and burned, and at certain points the wall itself was demolished. A later investigation of those known to have taken part in these attacks showed them to be people who were hard hit by the higher prices of wine, foodstuffs, and firewood which resulted from the *octrois* [duties on goods entering Paris, always unpopular in times of high bread prices]: they were shopkeepers, petty tradesmen and wage-earners. The abbey of Saint-Lazare was also looted after rumours spread that grain was stored there. Now they had armed themselves, it was too much to expect the people of Paris not to take direct action on their most pressing problem, that of feeding themselves.

> *(Doyle, 1988, pp.188–9)*

Prosperous citizens were themselves a little afraid of bread rioters, though they might be happy to use them for their own political ends. On 13 July those citizens who had participated in choosing the deputies for the Third Estate set up a communal committee, the 'Paris Commune'; this body, basically of the same social composition as the Third Estate, was to become very important in its own right. It set up its own citizens' militia. On 16 July Louis was advised that he could not totally rely on the loyalty of his troops, who tended to sympathize with impoverished bread rioters though not necessarily with wealthier citizens. Thus he abandoned his plans to overawe the National Constituent Assembly by force, and he recognized Lafayette as commander of the National Guard (the militia of the newly formed Paris Commune).

Peasants had the opportunity in early 1789 to have their grievances included in the *cahiers de doléances*, and seem to have believed that remedy therefore was at hand. Starvation and dashed expectations are probably enough to account for the insurrections of the spring of 1789. Rumours of the delays at Versailles and of the king's plans led to a belief that aristocrats were about to reassert all their old powers. With news of the 12 July rising in Paris, there began the peasant rampage known as the 'Great Fear' (many of the peasants were motivated by a fear that the aristocrats were deliberately setting 'brigands' against them). While also searching out grain hordes, the peasants were particularly interested in getting hold of, and destroying, documents which gave their holder the rights to feudal dues; often whole castles were burned down as well.

Safe from the king's army, members of the National Constituent Assembly proceeded with their main business, producing on 4 August their 'Declaration of the rights of man and the citizen' (*Resource Book 2*, A4). That same night the Assembly felt bound to respond to the anarchy and violence in the countryside; the peasants must be appeased or everything gained so far would be in jeopardy. For a quick grasp of the atmosphere in the Assembly – and a key insight into how certain things happened during the Revolution (provided, of course, you accept this aristocrat as a reliable witness), read the account by the Marquis de Ferrières of the debates of the night of 4–5 August in his letter to a neighbour in the provinces (*Resource Book 2*, A5). Doyle calls Ferrières 'a moderate sceptical nobleman'.

The 'Rights of man' (the beginning of a constitution) had been asserted (as planned). Feudalism had been abolished (under unexpected pressure from the peasantry). The first phase of Revolution itself was completed. On 24 August the king formally promulgated the Civil Constitution of the Clergy, which controlled the powers of the Church and provided for the clergy to be elected just like other public officials.

From constitutional monarchy to republic, September 1789– January 1793

Could the Revolution have stopped with constitutional monarchy on a model not wildly different from the British one? Almost immediately two factors made this very nearly impossible: the continuing reluctance of the king to accept the new legislation (and his new, diminished role) and the determination of the various activist groups in Paris (such as the Cordeliers Club, the Jacobin Club and the Social Circle) to ensure that the Revolution continued in directions they approved of. A little later a further factor emerged: the refusal of many clergy to accept the Civil Constitution. The king sought to strengthen his position by summoning the thoroughly loyal and highly disciplined Flanders Regiment to Versailles. Then, against a background of banquets and the drinking of loyalist toasts, he announced his reservations about, first, the decrees

abolishing feudalism and then the very 'Declaration of the rights of man' itself. The politically sophisticated were outraged, while rumours spread among ordinary people that the king's forces were about to impose a blockade on food supplies. On the morning of 4 October women assembled in the various markets, then led a procession to the Town Hall. Later, a vast assemblage of people set off for Versailles with whatever weapons they could muster. It became clear that the king had no alternative but to obey the wish of the crowd, and not only assent to the legislation but also move to Paris and take up residence in the Tuileries Palace. Shortly the Constituent Assembly followed, establishing itself in the nearby premises of a riding school. Bread riots continued till November, when cheaper supplies began to become available, bringing to an end these 'October Days', whose upshot had been the bringing of the king away from the home of kings, Versailles, and under the direct surveillance of the people of Paris.

The Constituent Assembly addressed itself to the basic task of further elaborating the constitution. In particular, it had to settle the basis for voting rights and to produce a new local government map which, among other things, would give legal recognition to the spontaneous establishment of municipal institutions during the summer of 1789, and would replace the medley of regional governments with a uniform system of 'departments'.

A month or so before the move to Paris of the Constituent Assembly, a new extreme radical newspaper, *L'Ami du Peuple* (*The Friend of the People*), was founded by the conspiratorial Jean Paul Marat (Doyle calls him 'a charlatan adventurer'). Shortly after the move, the radical leaders of the Assembly established a political club called the 'Society of the Friends of the Constitution'. Because this club began meeting in a former monastery near the Assembly which had belonged to the Jacobin order of monks, its members were labelled (originally with comic mockery as they were irreligious radicals) 'the Jacobins'. Similar clubs were formed in the great cities and in remote townships and affiliated themselves to the Paris Jacobins. The provincial Jacobins were those leisured, educated people who had formed the various discussion groups of the Enlightenment, now taking on the sharper purpose of safeguarding the Revolution and maintaining its momentum. Steadily Maximilian Robespierre, a member of the Assembly, emerged as the leading Paris Jacobin.

The pre-Revolution crisis had been one of a bankrupt, or near-bankrupt, state. The problem remained. Necker proposed a limited issue of paper money. Against that the radical nobleman Mirabeau proposed the issue of interest-bearing bonds (*assignats*) secured on the nation's lands. Reissued several times, *assignats* became a form of paper money, trust in which became a token of revolutionary loyalty. Necker resigned on 3 September 1790. At the same time, land taken from the Church and from *émigrés* began to be sold off, with peasants among the purchasers.

Around the same time the new local authorities, vociferously supported by 'patriots' (extreme supporters of the Revolution) and Jacobins, began to protest to the Assembly about those clergy who were resisting the Civil Constitution. After two days of debate over what was a highly contentious issue, the Assembly voted on 27 November to dismiss forthwith all clerics who did not totally accept the new dispensation and, in its most seriously divisive act so far, imposed on all clergy an oath of loyalty to nation, king, law and constitution. Well over 40 per cent of the clergy refused to take the oath. Generally those refusing had the support of their own parishioners. Thus a geographical split can be perceived between those parts of the country still committed to the ongoing Revolution and those now beginning to have very serious doubts. A number of insurrections were plotted, the most serious being frustrated in Lyon in December 1790, while at the same time protests against unemployment and rising prices merged into attacks on clergy who had refused to take the oath.

Though the king had fulfilled his role as constitutional monarch in promulgating the Civil Constitution, he remained unreconciled to it or to any of the other revolutionary legislation. What he was bent on was flight, followed by denunciation of the Revolution. On 20 and 21 June 1791 there took place his famous 'flight to Varennes' (the town where the royal party was stopped). The king was brought back to Paris, and the proclamation denouncing the Revolution that he had left behind was made widely known. The upshot inevitably was a further strengthening of radical sentiment among the various popular movements.

But it also resulted in a further division of opinion. The overwhelming majority of the Assembly, busily engaged on elaborating a constitution for a constitutional monarchy, wished to retain the monarchy and to restrain radical, republican sentiment. It therefore, producing the convenient fiction that the king had been kidnapped against his will, simply announced that he had meantime been suspended from his duties but that the monarchy would continue. A popular demonstration against the continuance of the monarchy of perhaps 50,000 people, and in support of the petition I discussed on the audio-cassette, gathered on the Champ de Mars in Paris; a couple of suspected royalists were lynched. In restoring order, Lafayette and the National Guard shot and killed possibly fifty people. In this 'Massacre of the Champ de Mars', it seemed, the republican movement had been crushed. On 13 September the king, restored to full power as a constitutional monarch, approved the new constitution. On 30 September the Constituent Assembly was dissolved; in accordance with a resolution espoused by Robespierre, none of its members could stand for the Legislative Assembly which was to replace it.

The Constituent Assembly was essentially the Estates General by another name. The Legislative Assembly was (as Robespierre intended) a new body – no nobles, no clerics, and almost entirely composed of younger

men who had come to the fore during the revolutionary agitations and discussions since 1789. But they were prosperous men: the Constituent Assembly had seen to it that the popular forces whose external pressure had often been critical would not actually be represented within the Assembly. The vote was confined to men over twenty-five paying the equivalent of three days' unskilled labour in taxes – these voters, defined as 'active citizens', numbered about 4.3 million in 1790. These 'active citizens' then chose 'electors', one for every hundred of their number. These 'electors' had to be paying taxes to the value of ten days' labour – only about 50,000 active citizens met this requirement. Then the electors met in departmental assemblies to choose the actual deputies, who had to be landowners paying at least a 'silver mark' in taxes, the equivalent of 54 days' labour.

The Legislative Assembly had two major concerns: the upholders of traditional Catholicism (mainly the priests who refused to take the oath of loyalty to the Civil Constitution, but also the papal enclave at Avignon which the Assembly decided to take over by force) and the *émigrés* (the opponents of the Revolution who had fled the country and were constantly plotting a royalist invasion – the Declaration of Pillnitz of August 1791, between the rulers of Austria and Prussia, guaranteed them the support of these two monarchs). Punitive decrees were promulgated against both. The king, as was his right under the new constitution, vetoed both decrees.

However, the potential confrontation between king and Assembly became swallowed up in another set of events which was to have critical effects on the way the Revolution developed – events springing from France's changing relationship with foreign powers. For entirely different reasons, various groups in France looked forward to involvement in foreign war: extremist deputies thought it would consolidate the Revolution and encourage risings throughout Europe; Lafayette saw opportunities for extending his own military powers; the king thought war and foreign victories would sweep away the Revolution. The basic excuse for war was that foreign powers, and particularly the Austrian Empire, were aiding and abetting the *émigrés*. By mid-April 1792 the Austrian army was mobilizing, so on 20 April France – king and Assembly apparently joined in delirious unity – declared war on Austria.

Meanwhile, starting on 14 August 1791 a slave rebellion, stimulated of course by revolutionary doctrines, had broken out in the West Indian sugar plantations of Saint-Dominique. A mighty event in itself, this had the effect of producing a sugar shortage in France from January 1792 onwards. Women again led the mobs which surged through Paris. Paris had enough grain – but only because it had drawn in supplies from the surrounding countryside. There were grain riots in northern France, and protests and demonstrations everywhere as the fall in value of French money (the *assignats* and the traditional *livres*) produced sharp price

rises. As the war began, peasant attacks on all the remaining vestiges of feudalism resumed.

Early defeats for the French forces created fear and suspicion in Paris. In theory, France was being run as a constitutional monarchy. In the middle of June the king dismissed his anti-clerical, pro-war ministers (usually known, along with their supporters, as the Girondins – many of them came from the Gironde region in south-west France). This was the occasion for the invasion on 20 June of the Tuileries Palace by 10,000 to 20,000 armed demonstrators calling themselves 'sansculottes' (see Figure 9.2). The king responded bravely and there was no immediate outcome, but the sansculottes had signalled their arrival as yet another important extra-parliamentary force. One of the, as it were, self-fuelling features of the Revolution was the annual celebration of the major events so far, such as the Tennis Court Oath and, above all, the Fall of the Bastille. In advance of 14 July 1792 battalions of provincial National Guards (known as *fédérés*) began to pour into Paris, those from Marseilles singing the battle hymn originally written for the outbreak of war in April. Sansculottes, *fédérés* and Jacobins were all talking of storming the Tuileries and establishing a republic. Danton was emerging as a leader of this tendency; membership of the Paris 'sections' (or constituencies) was

FIGURE 9.2 *Anonymous contemporary popular prints showing Parisian male and female sansculottes of the second invasion of the Tuileries on 10 August. Note the 'uniform' of working-class clothes. They also wear the hat of liberty, which was an important visual badge of revolutionary patriotism. Bibliothèque Nationale, Paris. (Photograph: Bulloz (male) and Giraudon (female))*

greatly expanded beyond 'active citizens', and debate, discussion and co-ordination with the *fédérés* in a central committee became a permanent feature. On 28 July news reached Paris that the Austrians had invaded north-east France and that the Duke of Brunswick had threatened Paris with 'exemplary and forever memorable violence' if they took any action against the king. War and revolution became interlinked in a profoundly significant way as the Assembly authorized distribution of arms to all citizens.

One could almost represent the French Revolution as a series of concentric circles. At first the outer circles (peasants, popular movements in the towns) are no more than pressure groups upon the inner circles, but steadily they become more and more directly involved in the action. The two critical 'external' circumstances affecting this process are harvest failure with its accompanying dearth, and – crucially important from this time on – foreign war. So you might represent the French Revolution diagrammatically as shown in Figure 9.3.

FIGURE 9.3

On 10 August power moved decisively from the innermost ring to the second from the centre. The forces of the Central Committee, in effect representing the Paris Commune, mounted the second invasion of the Tuileries, faced by 2,000 National Guards and 900 Swiss Guards. The former immediately defected to the Commune, while 600 of the latter were hacked to death. The Assembly declared the monarchy suspended; it also announced that 'to assure the sovereignty of the people' a new Convention based on universal suffrage (but excluding servants, the unemployed and, of course, women) would be convened. The monarchy in effect was at an end (unless restored by foreign invasion). The king was imprisoned in the Temple, a medieval fortress, while over half the members of the Assembly quietly disappeared. The remainder of less than 300 deputies were under the domination of the Commune, who in the 'First Terror' proceeded to wreak revenge on all they saw as enemies while, during the same period, elections for the Convention took place. On 21 August 1792 the new invention, the guillotine, was first used on a political prisoner. Paranoia and suspicion there were aplenty, but they

were greatly increased by news that the Prussians had invaded French territory. Danton instituted a systematic search on 30–31 August for arms and suspects, resulting in 3,000 further arrests. In the 'September massacres' between 2 and 7 September, well over 1,000 prisoners were done to death. The leading figure in calling for the massacres was Marat, hitherto considered too unbalanced and bloodthirsty to command much support. The ordinary artisans and shopkeepers who carried them out seem to have been motivated in part by a fear of leaving the Paris prisons full of those they considered dangerous enemies while they themselves marched off to the front to resist the Prussians. And resist they did. On 20 September the defeat of the Prussians at Valmy indicated that the new citizen armies, fired up with patriotic and revolutionary fervour, would outfight the static armies of the eighteenth-century absolute monarchs.

The Prussians were prepared to offer peace. But on the day of Valmy the Convention (still dominated by lawyers but now actually containing a few artisans) met; the following day it declared France a republic. The Prussians broke off negotiations. It was decided to put Louis on trial before the Convention itself, beginning on 11 December. The Girondins argued that any sentence must be subject to confirmation by the people as a whole in a referendum: their hope was that the provinces might reject the death sentence so obviously wanted by the Parisians. On 14 January 1793 the Convention focused on the question: 'Is Louis Capet guilty of conspiracy against public liberty and of attacks upon the general security of the State?'

On the first vote taken the next day, 693 deputies voted 'guilty', none for acquittal. On the question of confirmation by referendum, the Girondins secured 283 votes to 424 against. A further day and night passed as the Convention discussed and voted upon the actual penalty: 361 voted for immediate execution, 72 for death in principle but with varying delaying conditions, 288 for a variety of forms of imprisonment. Even after the sentence was communicated to Louis on 17 January many deputies called for a reprieve. The vote was close: 310 for a reprieve, 380 for carrying out the sentence. Louis was guillotined on 21 January.

War, counter-revolution and terror, February 1793–July 1794

The narrow majorities I have just cited demonstrate how strong reverence for monarchy still was, and the sharp polarization of opinion within France. Against many kinds of resentment in the provinces, the Paris groups, that is the Jacobins, the patriots and – a new extreme one – the *enragés* ('angry brigade' would be a good translation), were establishing control. International war increasingly influenced domestic developments: as over-confident revolutionaries saw themselves bringing revolution to the whole of Europe, Britain organized a coalition of European powers against the threat of both revolution and potential French dominance of the continent. French victories in 1792 were followed by defeats in 1793. Continuing dearth and near-famine

provoked further agitation and violence among the general populace. Resistance to Paris-dominated revolution entailed open civil war in several parts of France. Struggles for power, the determination of the Jacobins and their associates to 'complete' the Revolution by creating a completely new society, fear of foreign armies, fear of counter-revolution at home, fear of starvation – all combined to produce a period of intensified terror in both Paris and the provinces which devoured members of ousted revolutionary factions, many kinds of moderates, the utterly innocent, as well as out-and-out opponents of the revolutionary regimes (with the stakes so high, people were forced into taking up extreme positions on one side or the other). Almost anyone could be ensnared by the Law of Suspects (17 September 1793), which, among many other provisions, called for the arrest of anyone who 'either by their conduct, their contacts, their words or their writings, showed themselves to be supporters of tyranny, of federalism, or to be enemies of liberty' and of former nobles 'who have not constantly manifested their attachment to the revolution'. Anyone saying 'monsieur' instead of 'citizen' immediately fell under suspicion. Between September 1793 and July 1794 there were about 16,000 executions (including at the beginning, on 17 October 1793, the unbending Queen Marie-Antoinette and towards the end, in July 1794, the uncompromising revolutionary Robespierre). Almost 2,000 of these took place in Lyon between October and April during the brutal repression of counter-revolution there.

For the exact sequence of events between February 1793 and July 1794, look again at the chronology in *Resource Book 2* (A1). To highlight certain critical developments I'm going to ask you to consider an important document.

EXERCISE

Now read A13 in *Resource Book 2*, the decree establishing the *levée en masse* (mass conscription).

1 I would term this a document of record. Why?

2 What critical development in European, as well as French, history does this document signal? Quote particularly significant phrases from the text. Which of the three historians I cited lays special emphasis on this development? For clues go back to the beginning of this section: once you've found your historian, you've found your answer.

DISCUSSION

1 Quite unambiguously this sets out what is now the law with regard to conscription of persons and resources. It is not a description of the law, it *is* the law.

2 The historian is Schama, and he identifies 'a new phase of more intensive war based on national citizen armies' (see p.62). This is what is signalled here. With regard to significant phrases, it is noteworthy that married men are exempted from fighting. Very important are the involvement of women – though in feminine occupations; the employment of old men in propaganda; the deliberate policy of setting up factories (a 'war economy'); the sense of nothing being wasted (the extraction of saltpetre from cellar floors most notably). Power is being concentrated in the Committee of Public Safety, itself originally a response to the threatening military situation.

Perhaps you noted other things. I simply want to get over the general principle of combing thoroughly through the sources, teasing out the significance of individual phrases.

What one might term the culmination of the implementation of revolutionary principles came in October to December 1793 with the new revolutionary calendar (starting with 'Year One'), the replacement of Christianity by 'Reason', and the open adoption of the description 'Revolutionary Government'. Power was further centralized into the Committee of Public Safety and General Security dominated by Robespierre and his followers; then, allegedly because they created disorder and distraction, the Parisian extremist groups (*enragés*, sansculottes, etc.) were eliminated (March/April 1794). Rousseau's supreme importance was given powerful recognition in April and June; the Festival of the Supreme Being at the same time marked a slight withdrawal from the extreme anti-Christian position. Festivals on the classical model were a regular feature; David was their designer. As the movement towards the restoration of stability intensified, Robespierre himself became a victim of it.

The 'Thermidorean reaction', the Directory, the Consulate and the Empire, August 1794–1804

Quickly glance through the outline of events from August 1794 to 1804 in the chronology (A1). This is a sketchy outline (only eighteen entries for ten years) compared with my earlier blow-by-blow (as it were) accounts. The excitement is over; the revolutionary aspects of the Revolution have come to an end. The glamour now attaches to Napoleon's military victories and to the titanic struggle with Britain.

EXERCISE

1 What general trend is apparent?

2 Three fundamentals of the Revolution during the period 1789–94 have clearly been overthrown by 1804 – what are these?

DISCUSSION

1 A trend towards the concentration of power in the hands of one man – Napoleon.

2 (i) Government by National Assembly or Convention; (ii) integration of the Church with civil authority and dechristianization; (iii) the abolition of hereditary rule.

I hope these are clear to you. Overall what I am getting at is that there is a 'winding down' of the Revolution, a steady concentration of power in fewer hands, ending up with something not totally different from the 'despotism' or 'tyranny' originally identified by Rousseau and anathema to all revolutionaries.

Once more I believe that the way to a richer and more direct sense of these trends is to give you a couple of extracts from the primary sources to study.

EXERCISE

Read A15, 'proclamation of the Council of Five Hundred, 10 November 1799'; and A16, 'proclamation of the Consuls to the French people, 15 December 1799'.

1 Refer to the chronology in *Resource Book 2* (A1). Take each of these documents of record in turn, and quoting exact words from the document, say which event the document records.

2 Each document claims that the Revolution and subsequent events have created problems which the new arrangements will resolve. What are these problems? What is each new arrangement intended to bring?

3 Do these documents mark the abandonment of revolutionary principles? Comment particularly on the final short paragraph of A16.

DISCUSSION

1 A15: the establishment, following the coup led by Napoleon against the Directory, of a provisional government (pending the promulgation of yet another constitution) – 'In order to arrive more promptly at a definitive and complete reorganization of public institutions, a *provisional government has been established*' (emphasis added).

 A16: the drawing up of a new constitution which is proclaimed to the French people – 'Frenchmen! A Constitution is presented to you!'

That was intended to be quite a simple exercise. I hope you found it so. I am again making the point that for teaching and learning, rather than just a second-hand narration, things are clearer if we have the actual primary sources.

2 Attacks of 'seditious men' resulting in a 'succession of revolutions', 'instability', 'disorders', 'conspirators and malevolent persons' (A15).

'Uncertainties', failure 'to guarantee the rights of citizens and the interests of the State' (A16).

In a word, 'stability' is what each new arrangement is promising.

3 What is striking is that each document claims to be preserving revolutionary principles, though whether they actually do so, given the retreat from government by Assembly, the concentration of power in fewer hands, and the emergence of a First Consul (who soon became a hereditary emperor), is very open to question. The proclamations claim they will: 'give substantial guarantees to the liberty of citizens, to the sovereignty of the people, to the independence of the constitutional powers, and … to the Republic' (A15); fulfil 'the true principles of representative government', and 'the sacred rights of property, equality, and liberty', and establish the Revolution 'upon the principles which began it' (A16). The final sentence is claiming to have terminated 'uncertainties' and re-established the principles upon which the Revolution began. Thus the Revolution 'is ended' in the sense of being 'completed'. Others might claim that the Revolution was 'ended' in the sense of its basic principles having been destroyed.

The Napoleonic Empire and nationalist reactions to it

The political map of Europe at the end of the eighteenth century and in the early nineteenth century was very different from the political map of Europe today (see Figure 9.4). The idea of the nation state – a country where the political boundaries coincide with the boundaries of nationality, a country within whose boundaries practically everyone belongs to the same national culture and speaks the same national language – had scarcely yet been formulated. Territories were very much seen as the possessions of monarchs or emperors. Various territories scattered across what is now Germany (as well as much of Eastern Europe) belonged to what was called the Holy Roman Empire, ruled from Vienna by the Austrian Habsburg family; other German-speaking territories belonged to the Kingdom of Prussia; and one, Pomerania (home of the artist Friedrich), belonged to the Kingdom of Sweden. The major continental powers, apart from France, were the Holy Roman Empire, Prussia and Russia.

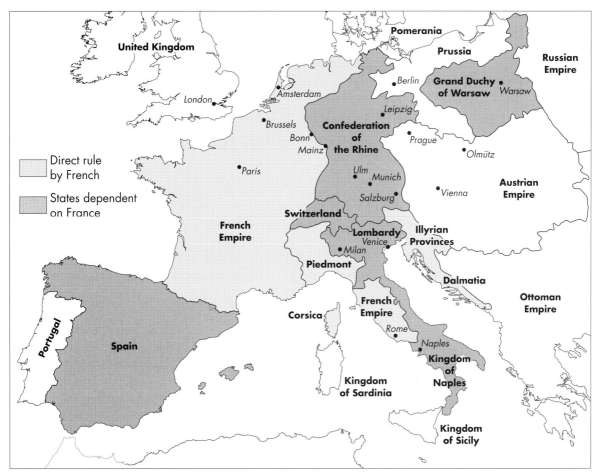

FIGURE 9.4 *Europe in 1810 at the height of Napoleon's power*

Ideas of the rights of monarchy and empire were given a terrific jolt by the French Revolution. Ideas of liberty and democracy spread across Europe. The victories of the French revolutionary armies were victories not for a French monarch but for the French nation. And then, more and more, as French conquests multiplied under Napoleon, the French came to be seen as illegitimate invaders and conquerors. This was particularly so in the German-speaking territories. Those on the west side of the Rhine were totally absorbed into France between 1801 and 1804; in 1806 the remainder of the western German lands were grouped into the Confederation of the Rhine under French control, while in the meantime Napoleon had abolished the Holy Roman Empire so that what was now the Austrian Empire was confined to Central and Eastern Europe.

Thus the effects of the French Revolution and the Napoleonic aftermath on people in other European countries came in the form of, first, an 'earthquake', then a very severe 'after-shock':

1 The earthquake: the Revolution fostered ideas of liberty and democracy (featured in the manifestos issued by the French armies as

they marched across Europe) and, less strongly and more indirectly, of nationality.

2 The after-shock: Napoleon's conquests produced strong reactions; equipped with the new ideas, people in the territories conquered by Napoleon used these ideas in their struggles against him.

Nationalism

Elements of what could reasonably be called nationalism (consciousness of, and pride in, belonging to a particular 'nation' – the desire to see all people in that nation united in one self-governing country or *nation state*) have appeared in most centuries. But only in the nineteenth century did nationalism begin to become a major historical force through a complex convergence of circumstances no historian can really explain fully. These include: the accelerated growth of vernacular languages (German, Polish, etc., rather than Latin – this development had started centuries earlier) and of literacy and education, often leading to the discovery of national literature, music, myths and traditions – thus nationalism and Romanticism (the reaction against classicism, discussed in Unit 12) were often closely inter-related; the emergence of a prosperous non-aristocratic or 'bourgeois' class not committed to older monarchical or imperial loyalties, but which could see fulfillment for itself in the notion of nationhood (positions of power, more opportunities for trade); the sudden successes (even if only temporary) of independence movements which had been engaged in age-old struggles against imperial oppressors (e.g. the 'Patriots' in the Netherlands fighting against their Austrian ruler); the revival of religious fervour. The German-speaking people were scattered across many separate territories. A few figures were beginning to fantasize about a union of German peoples. The French Revolution had some effects, but much more potent was the effect of Napoleon's conquests. At first people in the small German states were basically *anti*-Napoleon. That forced them into thinking about what it was they were *pro*. So the concept of German nationalism began to form.

It is important not to exaggerate any of this. As you will see in Unit 12, Friedrich was affected by all of these trends – religious fervour, Romanticism, the principles of democracy and self-government, budding German nationalism – but he continued to see himself as a loyal subject of the king of Sweden (I should, however, add that Gustav IV of Sweden was a committed enemy of Napoleon).

David was seen as the official painter of the Revolution, then of the Napoleonic Empire, and he was a leading proponent of Neoclassicism. Friedrich was involved in the nationalist and democratic protest against Napoleon, and he was a Romantic. But he wasn't a public figure like David. Linking him to his historical context is an even more complex matter than it is with David.

Conclusion

This highly condensed account of Enlightenment France, the French Revolution and its Napoleonic aftermath is one which, give or take the odd point of emphasis, most historians would accept. But when we come to a really big question like the consequences of the Revolution, then, as I have already said, there is much scope for disagreement. The issue is of great significance with regard to the way in which history is produced, but it is not really relevant to the study of Rousseau, David and Friedrich (except in so far as the Revolution led to the Napoleonic conquests), so I shall be very brief.

One consideration is how far ahead we look. Do we sum up the situation as it was at the time of the establishment of the Directory, or do we range ahead across a century or more? Revolutionary and counter-revolutionary actions culminated in imperial government under Napoleon. Napoleon was defeated at Waterloo in 1815 and the Bourbon monarchy restored (though not every aspect of the Old Regime could be restored). There were further revolutions in 1830 (establishing a more limited form of monarchy) and in 1848 (establishing a republic which, however, shortly gave way once more to an empire); in 1870, following the defeat by Prussia of the second French Empire, the Third Republic was established on something like the principles of 1791.

But let us briefly turn back to the Revolution itself.

EXERCISE

Again read through the chronology (A1) in *Resource Book 2*. Rather different types of underprivileged people can be perceived, and would appear to be enjoying some improvements, at least while the Revolution is on. Who are they?

DISCUSSION

Women and black slaves. Slaves appear both as rebels and then as the beneficiaries of the abolition of slavery. Women appear as the leaders of riots (mainly, actually, as housewives seeking essential products for their families). But some women (as we saw from the 1789 petition in *Resource Book 2*) are putting forward formal political and social claims. Such remarks, however, have to be set within the general framework of increasing misery and dearth presented in TV9.

You will see in *Resource Book 2* an extract from *The Rights of Woman* (A8) written by Olympe de Gouges (1749–93), celebrated writer of plays and pamphlets who was the daughter of a butcher. This document is presented in the form of an appeal to Marie-Antoinette, though in fact it was printed and quite widely circulated. The document firmly records

that certain thoughts about the rights of women were being expressed and certain claims were being made, though it does not indicate whether the claims were actually recognized (at the height of revolutionary reform new laws were passed with respect to marriage and divorce – see A10). Apart from primary sources, I have also provided two secondary articles about women in the French Revolution (A20 and A21). These articles are fine examples of work produced by one of the new approaches to history which I have already mentioned (though whether they should be called 'feminist history' or 'women's history' I leave it to you to decide – and I want you to be aware that male historians have been studying the role of women in the Revolution since at least 1854, when Jules Michelet published *The Women of the Revolution*).

The Revolution simply cannot be presented as a neat, systematic event which came about because 'historical circumstances were right' for the bourgeoisie to revolt against the nobility, and whose consequence was that the bourgeoisie took over from the nobility 'as the ruling class', as the traditional Marxist interpretation would have it. The Revolution is probably best seen as a period of turmoil in which developments within the revolutionary period itself, both internal and external, produced further developments and reactions. In such periods of upheaval the underprivileged are stimulated into asserting their own rights, and are presented with unprecedented opportunities for taking on new roles and pressing new claims. (The two periods are very different, but some of the same points can be made in respect to the other period of upheaval we will be studying at the end of the course, the 1960s). However, for the overwhelming majority of the French people – as the range of evidence cited in TV9 indicates – the main consequence of the Revolution was to produce disruption, dearth and unnecessary misery. At the same time, some redistribution of wealth and power did take place, though again it is difficult to present this redistribution as falling neatly along class lines. *Some* peasants did quite well overall. Without doubt, the confiscation of the lands of the Church and of *émigrés* and their subsequent sale enabled those peasants who had accumulated some savings to set themselves up as independent proprietors (land was cheap and peasants were in favour with revolutionary governments). Though never anything like a 'ruling class', this 'peasantry' was to be a vital element in France until the aftermath of World War II.

I would myself stress two other points. The French Revolution was above all about political ideas. Whatever the setbacks, the restorations, the reactions, a European tradition of republicanism and political rights had come into existence. This tradition was henceforth to be a powerful force in both French and European politics. Though Napoleon ruled as a ruthless monarch, he did keep the new representative institutions in existence, and he did have his titles in 1802 and 1804 ratified by plebiscite – however artificial these may have been. The notion of popular demonstrations in the streets, and even of revolution, became an

established fact of French politics: the events of May 1968 when students took to the streets of Paris were seen by many at the time as the outbreak of a new French Revolution. Secondly, perhaps almost as much because of the pressures of war and the organizational genius of Napoleon as because of the Revolution itself, France did begin to take on the lineaments of the modern state. The registering of births, marriages and deaths is but one sign of this, and one genuinely belonging to the Revolution itself.

You have read enough for one week. But perhaps you will have the chance to read A22, 'The new France' by François Furet and Denis Richet, which, you will need to be aware, sums up the situation as it was in 1798. This chapter is typical of the so-called 'new social history' which came to the fore in the 1960s: note the strong emphasis on statistics as well as the concern with such issues as contraception. It is a rich and stimulating text, though I believe it to be unsound in some places and even absurd in others (remember the Marwick 20 per cent rule from Unit 8, p.32). Undoubtedly there is some truth in the attribution of a falling birth-rate to contraception, but it is also true that 1,300,000 French males were killed in the Revolutionary and Napoleonic Wars, and that the consequent low male/female ratio was an important factor in the falling birth-rate. The apparent equation between female emancipation and 'homage ... to feminine beauty' seems particularly absurd – though the daring fashions and behaviour of the Directory and early Napoleonic period do again stir in my mind comparisons with the 1960s.

7 HISTORY: DEFINITION, AIMS, ACHIEVEMENTS AND VALUE

The objective for this final section of Unit 9 (it's really an objective for the entire two units) reads as follows. You should now:

> Be in a position to write several sentences defining history, its aims and achievements, and its value as a training in the handling of evidence of many kinds.

EXERCISE

Try your hand now at writing a few sentences along these lines.

DISCUSSION

How well and how enthusiastically you do this really depends on how successful these two units have been. We certainly have not progressed very far with training in the handling of evidence, but I was hoping that you might make the point that, in a world where we are deluged with information, disinformation and misinformation, training of the kind I have been hinting at is indeed valuable. With regard to definition, aims and achievements, you will find my answers within these units. I do hope, at any rate, that I have succeeded in providing some essential contextual information as you turn now to Rousseau, and then to David and Friedrich.

REFERENCES

DOYLE, W. (1988, 2nd edn) *Origins of the French Revolution*, Oxford University Press.

DOYLE, W. (1989) *The Oxford History of the French Revolution*, Oxford University Press.

JONES, C. (1988) *Longman Companion to the French Revolution*, Harlow, Longman.

LEWIS, G. (1993) *The French Revolution: rethinking the debate*, London, Routledge.

SCHAMA, S. (1989) *Citizens: a chronicle of the French Revolution*, London, Viking.

STEWART, J.H. (1965, 5th edn) *A Documentary Survey of the French Revolution*, New York, Macmillan.

WRIGHT, D.G. (1974) *Revolution and Terror in France 1789–1795*, Harlow, Longman.

UNITS 10 AND 11 ROUSSEAU AND DEMOCRACY

Written for the course team by Derek Matravers

Contents

STUDY COMPONENTS				
Weeks of study	Texts	TV	AC	Set books
2	*Resource Book 2*	TV10 TV11	AC4, Band 2	–

Aims and objectives

The aims of these units are:

1 to examine philosophical techniques and arguments through looking at the problem of the legitimacy of government;

2 to discuss (a) the solution to this problem provided by Jean-Jacques Rousseau and (b) a modern solution to this problem.

The following objectives list what you should be able to do once you have reached the end of each part:

Part 1

1 Understand the problem of legitimacy and see why philosophy is the appropriate subject to solve it.

2 Write down an argument, in the form of premises and a conclusion, as to why 'might' does not equal 'right'.

3 State Rousseau's solution to the problem of legitimacy.

4 State the crucial steps of Rousseau's argument for his solution.

Part 2

1 Understand why Rousseau draws a link between the way people are governed and their individual virtue, and form your own views on this link.

2 Describe the method that Rousseau favours for discovering the 'general will'.

3 State why some have taken Rousseau's philosophy as being an argument for intolerance.

4 Compare two views of Rousseau: one which takes him to be intolerant, the other of which does not.

Part 3

1 Provide a defence of democracy as an alternative to Rousseau's solution to the problem of how to run a state.

2 Demonstrate how democracy does preserve some sense of Rousseau's demand that the people govern themselves.

3 Understand the problem posed for minorities in a democracy, and state three reasons why minorities might remain in a democratic system.

A note on the structure of the units

AGSG, ch.2, sect.3.2, 'Reading speed'

For the next two weeks we are going to look at the political ideas of the eighteenth-century philosopher Jean-Jacques Rousseau, his influence on the French Revolution and on the development of modern democracies. There are three parts to these units of roughly equal length. These are broken down into sections, each of which revolves around one particular point. During your study of these units make sure you read slowly, giving yourself plenty of time to think. Philosophy is about argument, and arguments cannot be rushed. To quote from Unit 4, 'to study philosophy you have to engage in philosophical argument' and that is what you should be doing (Block 1, p.145). Thinking through some of the points in political philosophy which came to the fore during the French Revolution will, I hope, prove a rewarding experience. While working through these units you should divide your time carefully and take care not to rush any section. Remember that you also have two television programmes, an audio-cassette and a TMA to think about. There are also two optional readings in *Resource Book 2*.

When I introduce a key concept, or reintroduce a concept you will have met in Unit 4, I will put it in **bold**. These concepts are also explained in the glossary at the end of these units. You will also find, throughout these units, text surrounded by a box. These contain discussions and further illustrations of points in the text, and while you do not have to read them to follow the argument, I hope you will find them interesting. Please note that the translation of *The Social Contract* I have used in these units is from Cress, Donald A. (ed.) (1987) *Jean-Jacques Rousseau: Basic Political Writings*, Indianapolis, Hackett. As many other editions of *The Social Contract* are available, I have provided book and chapter references throughout.

PART 1 ROUSSEAU'S ARGUMENT

1 REASON TO REVOLT

During the early stages of the French Revolution the Jacobin rabble-rouser, Jean Paul Marat, ignited the passions of Parisians by reading from a political text to large crowds on street corners. The text was *The Social Contract* by Jean-Jacques Rousseau, and it was frequently quoted and referred to during the years of the Revolution. Indeed, much of the debate in the National Convention centred on discussion of Rousseau's ideas which, the revolutionaries thought, described a way of running the country based on reason and clear moral principle, rather than on tradition and superstition. This illustrates one of the points stressed in the conclusion of Unit 9, that 'the French Revolution was above all about political ideas' (p.86).

FIGURE 10/11.1 *Allan Ramsay,* Jean-Jacques Rousseau, *1766, oil on canvas, 75 x 64.8 cm. National Gallery of Scotland.*

Philosophy

What has the study of the best way to run a state to do with **philosophy**? Remember the description of philosophy that was given in Unit 4:

> The analysis of reasons and arguments is a particular province of philosophy ... In fact, inasmuch as philosophy has a distinctive method it is this: the construction, criticism and analysis of arguments. Philosophical skills are applicable in any area where arguments are important, not just in the realms of abstract speculation.

> *(Block 1, p.146)*

In these two units we are going to put this into practice by looking at the arguments presented by Jean-Jacques Rousseau in *The Social Contract*. What are the ideas behind the slogans coined by Rousseau? Are there sound arguments for Rousseau's conclusions?

There is a problem for anyone who teaches about a great philosopher who is dead, such as Rousseau. How can we ask these questions about Rousseau's work unless we are clear about what he said? In other words, before we can look philosophically at Rousseau's argument, we must try to *understand* it. That is why the objectives for Part 1 point toward *understanding* Rousseau's argument rather than criticizing it. (In Part 2 we will look more closely at the argument to see if it is flawed in any way, and in Part 3 we will look at how Rousseau's argument can be applied to the kind of democratic politics we have today.) As you read Part 1, you will probably find that there are problems inherent in Rousseau's argument. You may even think you have misunderstood the argument, because what you take to be problems are not being dealt with. What I suggest you do is write your thoughts down and read on. Only one point can be dealt with at a time, and the problems you have noted may be raised later in the units. At the end of Part 1, look over any notes you have made. Make sure you give reasons for any claims you make (remember, philosophy is about **argument**, not **assertion**). Writing down what you think is right and wrong, and backing up your ideas with reasons, are the best ways of being thoroughly philosophical! If your problems are not raised in these units, then discuss them with someone else doing the course, or with your tutor.

AGSG, ch.2, sect.3.5, 'What if you get stuck?'

In philosophy, as in any other subject, you can sometimes simply get stuck. If this happens, you need patience. Go back over what you have read. Look up any words you do not understand in a dictionary or in the glossary. Try to write the argument in your own words. Explain what you are studying to a friend or family member. I have deliberately kept these units short in order to leave time for you to work things out. Also, of course, you should ask your tutor.

Summary

1 Philosophy is important in the study of areas such as politics, because it can look at the arguments to make sure we are getting them right.

2 If you disagree with any points in Rousseau's argument, note them down and try to find reasons for your views. They may be discussed later.

3 If you get stuck, be patient. Go over the points again, look up unfamiliar words, discuss the points with someone, ask your tutor.

Rousseau and the French Revolution

If you look back at the Chronology of the Revolution in *Resource Book 2*, A1, you will see that in August 1789 the National Constituent Assembly published the 'Declaration of the rights of man and the citizen'. The first paragraph of the Declaration begins as follows: 'Men are born, and always continue, free and equal in respect of their rights. Civil distinctions, therefore, can be founded only on public utility.'

Consider this proclamation one sentence at a time: 'Men are born, and always continue, free and equal in respect of their rights.' What does this mean? If we read the masculine pronoun as covering both men and women, it means that people have equal rights when they are born and continue to have equal rights until they die. What does a 'right' mean? **Rights** tell us what we are allowed to do, or what others are allowed to do to us, both as people and as members of society. This covers many things from the 'right to life' to the 'right to strike'. People differ in their view about what rights we actually have. There is general agreement that we have a right to life, but disagreement as to whether we have a right to strike. We need not decide here what rights we have. The claim of the Declaration is only that, whatever rights we have, we have them equally.

Because the idea of equal rights is so familiar these days, this claim is bound to have lost some of the force it had for the revolutionaries. To them, it was a rejection of the claim that one particular person, the king, had more rights than anyone else. In particular, it was a rejection of the claim that the king, just because he was the king, had the right to rule. It is not hard to imagine the devastating effect this idea must have had on the minds of those people living with a system of government in which they were on the bottom and the king on top. If the claim about equal rights were true, the king had no *right* to be up there; he was just another person.

Civil distinctions, such as who is to be put in charge of what, are dealt with in the second sentence of the Declaration: 'Civil distinctions, therefore, can be founded only on public utility.' Such distinctions should not be founded on anything other than whether or not it would actually be of use to the public. For example, it would make sense to put

someone who was a brilliant military tactician in charge of the army and someone who was a brilliant administrator in charge of the civil service. It would not make sense for anyone to be put in charge of anything, or more particularly made a king, simply because their father was.

Women played an important role in the French Revolution, as you learned in Unit 9. However, both Rousseau and the writers of the Declaration use the term 'man'. It would need a unit or more to discuss the treatment of women in the eighteenth century. For now, I would like to make three points:

1 The way women are regarded has changed so much over time that it seems a mistake for us to blame eighteenth-century writers for their attitudes without taking the historical facts into account.

2 Having said that, Rousseau's attitude to women was strange even for the eighteenth century. This surfaces in his writing, particularly in Book 5 of *Émile* (1762), his book on education. There he states that women should be passive and weak, while men should be active and strong!

3 In these units we are not examining Rousseau's attitude; we are examining his argument. Even if he uses 'man' and 'master', we need not think of them as specifically male terms. It does not make any difference to the argument we shall be considering.

Rousseau's *Social Contract* was published in 1762, which was some years before the French Revolution began. The first chapter begins with the ringing slogan, 'Man is born free, and everywhere he is in chains' (Rousseau: Cress (ed.), 1987, bk1, ch.1, p.141). This is so similar to the first paragraph of the Declaration, it is difficult to resist the thought that this was the source of the revolutionaries' ideas.

Rousseau's comments about the king would also have received a sympathetic hearing, 'In certain families', he says, 'crowns have been made hereditary ... which prevents all dispute when kings die ... the risk of having children, monsters, or imbeciles for leaders has been preferred to having to argue over the choice of good kings' (Rousseau: Cress (ed.), 1987, bk3, ch.6, p.185). It would not have been difficult to convince the poor of Paris that their troubles were the result of taking this risk. Two hundred years later, revolutionaries were still quoting Rousseau. Che Guevara, the Argentinian communist revolutionary and guerrilla leader of the 1950s and 1960s, was reputed to have carried *The Social Contract* with him on his campaigns, along with his copy of *Das Kapital* by Karl Marx.

In looking at Rousseau's argument, I will be using certain words which will be familiar, such as 'authority', 'state' and 'government', but it is as well to state exactly what is meant by them. As you will have seen in Unit 4, in understanding arguments the more exact one can be the better. Do not worry about whether the ideas are acceptable or not at the

moment; I am only introducing the terms. The important thing is the role they have in Rousseau's argument. When we examine the argument, you will be able to look back at this discussion, or consult the glossary if you need to clarify any points. According to Rousseau, a person (or institution, such as the state or government) has **authority** if they are able to command others to do things. Authority is **legitimate** if the person (or institution) possesses the *right* to command others. In our society, a police-officer has legitimate authority to stop traffic, while someone with a gun has only the authority – the power – to do so. We will examine Rousseau's argument about the difference between legitimate authority and power shortly.

What Rousseau means by a **state** (sometimes called a 'civil state') is a number of people who are subject to a set of laws which governs their conduct. The laws are enforced by the imposition of penalties. Much of Rousseau's discussion in *The Social Contract* is concerned to establish whether or not the authority of the state is legitimate. Britain is a state: it consists of a number of people, a set of laws devised by Parliament, and the police and criminal justice system to enforce them. Do not take 'state' to mean something sinister and secretive. Rousseau did not mean us to think of it in the way we might think of 'police state'. I could have used the word 'society' or even 'association'. For the sake of simplicity, I adopted the term which occurs most often in Rousseau's text. A **government** is that group of people whose task it is to formulate the laws. In Britain, as in all countries, the number of people in the government is small compared to the number of people in the state.

One of Rousseau's ideas which inspired the revolutionaries was that, to be legitimate, the authority the state has over the people must come from the people themselves, and not from a single person such as the king. The source of the state's authority is known as the **sovereign**: in a republic the people are sovereign while in a **monarchy** the king or queen is sovereign. This use of the term may surprise you; British people use the word 'sovereign' to refer to the ruling monarch. This is because Britain is still a kind of monarchy – known as a **constitutional monarchy**. If Britain were a republic, then the people would be sovereign. Rousseau, as I have said, was a republican and so believed the people should be sovereign.

The problem of legitimacy

Let us go back to Rousseau's claim that, 'Man is born free, and everywhere he is in chains.' It is easy to think that, as chains are a bad thing and freedom a good thing, Rousseau must mean that we start out free, are somehow enslaved, and that we should now be trying to escape our chains. You can see this is not what he means as you read the rest of the paragraph, 'Man is born free, and everywhere he is in chains ... How did this change take place? I have no idea. What can render it legitimate?

I believe I can answer this question' (Rousseau: Cress (ed.), 1987, bk1, ch.1, p.141).

Rousseau asks two questions. The first asks how the change from freedom to chains took place. Although it is not obvious from the above quotation, this question asks for a historical account of the change that took people from living as hunter-gatherers to living in regulated societies. Although Rousseau had tried to answer this question in an earlier work, *Discourse on the Origin of Inequality* (1754), here he dismisses that historical inquiry, claiming he has no idea how to answer it. This is because what he is really interested in is the second question: what would render the change legitimate? In other words, is there any way in which we can *justify* living in a society? If a hunter-gatherer came up to us and asked what was so good about living in a society, what would we be able to say? Rousseau thinks he has an answer to this.

What Rousseau means by being 'in chains' is 'living in society'. He does not want us to escape our chains by escaping living in society, but rather to consider how it can be right for us to live in the chains of society when our natural state is to be free. The answer he will give is that, if the society is properly run, the chains it puts on us are not really chains at all.

> Some translations of *The Social Contract*, including the Penguin translation, begin, 'Man was born free ...' rather than 'Man is born free ...'. Although I do not think it matters much which translation is used, you should appreciate that subtle differences do occur from one translation to another. While it is true that the alternative, 'was' rather than 'is', has more of a suggestion of some idyllic time in which people actually were born free – a time Rousseau discussed in *Discourse on the Origin of Inequality* (1754) – the philosophical argument concerns the situation of people at *all* times. For this reason I prefer the Hackett translation used throughout these units.

Let us abandon the colourful metaphor of people in chains and consider the problem. The claim is that in thinking about the relation between ourselves and society we are pulled in two directions at once. On the one hand, there is the belief that nobody has a natural authority over us; we are all free and equal beings. On the other hand, living together would be impossible without *some* laws and regulations. These vary from specifying the side of the road on which we should drive, to prohibitions on taking the lives of other people. What bothered Rousseau was how we could have it both ways: how can we think of ourselves as free and also as obliged to obey the law?

EXERCISE

Rousseau seems to be presenting us with a choice: either we should think of ourselves as free or we should think of ourselves as being obliged to obey the law. In other words, we cannot both be free *and* subject to the law of the state. In order to illustrate this point (which is the starting point of Rousseau's discussion), I would like you to write down three different laws you are obliged to obey, and say briefly how each places a limit on your freedom. Write your thoughts down on a piece of paper before reading my discussion. Remember it is always best to write down your answers to the questions in the exercises. Vaguely formulated thoughts are no substitute.

DISCUSSION

Here are the three laws that came to my mind and the way I thought they constrained my freedom:

1 In Britain, I have to drive on the left-hand side of the road. This means I cannot cut corners or drive in any way I like.

2 I have to pay taxes. This means I cannot choose how I spend all the money I have earned.

3 I am not allowed to take my neighbour's flowers. This means I have to cultivate my own.

Whatever three you chose, I hope you will have seen that each does place a limit on your freedom. Simple as this exercise was, it does raise one of the most important problems in political philosophy. If we are naturally free, what authority does the state have to restrict our freedom? Rousseau seems to be providing us with a choice. Either we obey the law and limit our freedom, or we become anarchists and preserve our freedom by abandoning the law altogether.

The radical conclusion Rousseau actually comes to is that we do not have to choose between freedom and the authority of the state. It is his argument for this conclusion that I will be examining for the remainder of Part 1. He argues that as we are naturally free people, we are right to obey the state *only if* it does not detract from our freedom. We do not have to become anarchists because (as Rousseau will try to show) there is a way in which we can obey the state which allows us to keep our freedom.

2 PROVING THE POINT

Rousseau's argument that might does not equal right

Before providing the argument for his conclusion, Rousseau considers another possible source for the state's authority. Would it be legitimate for the state to get its authority simply by exercising naked power? This thought might strike you as so absurd as to not be worth bothering about. It seems obvious that forcing people to obey you and it being right that they obey you are different things. Remember, however, that philosophy is concerned with argument. What seems obvious to you might not seem obvious to others, and, furthermore, the claim that legitimacy derives from naked power has been held by many throughout history. Two thousand years ago, the Greek philosopher Socrates spent much time arguing against the position. There are occasions even today in which a victorious state has held that winning a war gives it the right to rule over its enemies. Superior force, they claim, makes it right that they should rule.

Below are three excerpts from a chapter of *The Social Contract* entitled 'On the right of the strongest'. I would like you to read the excerpts and my notes that follow each one, keeping in mind that Rousseau is considering whether what he calls 'force' (the naked use of power) can be transformed into what he calls 'right' (legitimate authority). In other words, he asks the question: because you can *force* me to obey you, is it *right* that I should obey you?

Excerpt 1

> The strongest is never strong enough to be master all the time, unless he transforms force into right and obedience into duty ... Force is a physical power; I fail to see what morality can result from its effects. To give in to force is an act of necessity, not of will. At most, it is an act of prudence. In what sense could it be a duty?

> *(Rousseau: Cress (ed.), 1987, bk1, ch.3, p.143)*

Note 1

Rousseau opens the chapter with the claim that 'The strongest is never strong enough to be master all the time, unless he transforms force into right and obedience into duty.' In the first half of the sentence he gives a problem, and in the second the solution to that problem. The problem is that illustrated by the proverb, 'When the cat's away, the mice will play.' No matter how strong you are, you cannot be there all the time. If your being master comes only from your power, then, when you are away, the people over whom you are master will not necessarily obey you. As

master, you have to transform power (your force and their obedience) into something else (your right and their duty). In other words, the cat has to convince the mice that it has legitimate *rights* over them and they have a *duty* to obey. Unlike force, such authority remains when the cat goes away.

Excerpt 2

> *Let us suppose for a moment that there is such a thing as this alleged right. I maintain that all that results from it is an inexplicable mish-mash.* For once force produces the right, the effect changes places with the cause. Every force that is superior to the first succeeds to its right. *As soon as one can disobey with impunity, one can do so legitimately*; and since the strongest is always right, the only thing to do is to make oneself the strongest. For what kind of right is it that perishes when the force on which it is based ceases? If one must obey because of force, one need not do so out of duty; and if one is no longer forced to obey one is no longer obliged. Clearly then, this word 'right' adds nothing to force. It is utterly meaningless here.
>
> (*Rousseau: Cress (ed.), 1987, bk1, ch.3, p.143; italics added*)

Note 2

What Rousseau considers in the chapter is whether the mice ought to accept the cat's arguments. Put philosophically, if your power stems from your superior force, can you provide an argument to show that your subjects *ought* to obey you rather than merely obey you for fear of the consequences?

In Excerpt 2 Rousseau provides us with a form of argument that will lead to his conclusion. Look again at the opening sentences: 'Let us suppose for a moment that there is such a thing as this alleged right. I maintain that all that results from it is an inexplicable mish-mash.' In other words, let us assume that there is such a thing as a right that results from power, and we will see that what follows is a contradiction. This is the form of argument known as a **reductio ad absurdum**, a technique for showing that a position is false which you have already looked at in Unit 4 (Block 1, p.163). For this type of argument to work, there must be an implicit assumption which we know to be true. We then pretend that the claim we want to show is false is true, and show that this leads to a contradiction of the implicit assumption. Thus we are justified in rejecting the claim which, for the sake of the argument, we pretended was true.

Now let's apply the *reductio* (the short name for *reductio ad absurdum*) to Excerpt 2. Look at the italicized sentences. The first says, 'Let us suppose for a moment that there is such a thing as this alleged right.' It is the alleged right – that simple power is enough to give legitimate authority – that Rousseau wants to show is false. So, for the sake of the argument he assumes the alleged right is true. This provides the first **premise** of his *reductio*: simple power is enough to give legitimate authority.

Rousseau then needs to show that this premise results in a contradiction and so cannot be true. Well, what does result from the first premise? We know from its definition that it would be wrong to disobey legitimate authority, so that gives us our second premise. The two premises lead to the conclusion that it is wrong to disobey simple power. However, we know this is not true, as Rousseau will show in Excerpt 3. So the *reductio* can be set out as follows:

> Implicit assumption: It is not wrong to disobey someone simply because they are more powerful than us.
>
> Premise 1: Simple power is enough to give legitimate authority.
>
> Premise 2: It is wrong to disobey legitimate authority.
>
> Conclusion: It is wrong to disobey someone simply because they are more powerful than us.

So the conclusion of the *reductio* contradicts the implicit assumption that we know to be true and proves the claim (that simple power is enough to give legitimate authority) to be false.

Excerpt 3

> If a brigand takes me by surprise at the edge of a wooded area, is it not only the case that I must surrender my purse, but even that I am in good conscience bound to surrender it, if I were able to withhold it? After all, the pistol he holds is also a power.
>
> Let us then agree that force does not bring about right, and that one is obliged to obey only legitimate powers. Thus my original question keeps returning.
>
> *(Rousseau: Cress (ed.), 1987, bk1, ch.3, pp.143–4)*

Note 3

I said, in explaining the *reductio*, that we know it would not be wrong to disobey someone simply because they are more powerful than us. In order to make the argument watertight, Rousseau goes to the trouble of proving this as well. The method he uses is a **thought experiment** (see Block 1, p.159). In Excerpt 3, Rousseau asks us to consider being robbed by a brigand. It is certainly true, he says, that the brigand has power over me: he is pointing a pistol at me. Rousseau asks us to consider whether it is simply that 'I must surrender my purse' or whether 'I am in good conscience bound to surrender it'. In other words, whether I should surrender it because I will get shot if I do not, or whether I should surrender it because the pistol gives the brigand legitimate authority over me and I ought to do what is right. It is obvious both to Rousseau and to us that I would not be *wrong* to attempt to conceal my purse from the brigand (even though it might be dangerous). The pistol gives the brigand *power*, not *authority*. If we accept the thought experiment (and it seems fine to me), we have to admit that merely having naked power

does not give the brigand right. This is a simple demonstration, but it establishes an important conclusion reached by Rousseau: the source of the authority of the state is not simply its power.

So, Excerpt 1 set up the problem, Excerpt 2 provided us with an argument (the *reductio*) and Excerpt 3 provided another argument (a thought experiment) to demonstrate the truth of the implicit assumption underlying the *reductio*. All in all, it is an exhaustive demonstration of the claim that might does not equal right. I hope it is clear why Rousseau's work was held in such esteem by the revolutionaries. He was discussing the crucial matters of the times – the source of legitimate authority and the difference between legitimate authority and a state sustained only by power. I also hope it will be clear that these questions are of equal importance today. Having seen that Rousseau *does not* think legitimacy derives only from power, it is time to turn to his positive ideas about where it *does* come from.

Summary

1 By using a thought experiment and a *reductio*, Rousseau has shown that power is not the source of any legitimate authority the state has over us.

3 THE FUNDAMENTAL PROBLEM

In a chapter of *The Social Contract* called 'On the social compact', Rousseau gives us a succinct statement of what he thinks of as 'the fundamental problem for which the social contract provides the solution':

> Find a form of association which defends and protects with all common forces the person and goods of each associate, and by means of which each one, while uniting with all, nevertheless obeys only himself and remains as free as before ...
>
> *(Rousseau: Cress (ed.), 1987, bk1, ch.6, p.148)*

Look at the key points in this quotation. The first half seems to be talking about the state, 'a form of association'. The second half insists that even if we live in such a state, 'nevertheless' we must obey only ourselves and remain 'as free as before'. As I said above, Rousseau believes it is possible to have both complete freedom and yet also legitimate authority (p.99).

Rousseau's solution to reconciling the apparently unreconcilable is hinted at in the intriguing suggestion that 'each [person] ... obeys only himself'. If other people have authority over us, we have the problem of explaining how that authority could be legitimate. However, if we have only to obey ourselves this problem does not arise; it is obviously all right for me to tell myself what to do. What Rousseau seems to be saying

is that all we have to do is to find a way of structuring the state such that while it may appear to be commanding us, we are in fact commanding ourselves.

In other words, if what the state wants is always exactly what the individual wants, then the authority of the state over the individual will be the same as the authority of the individual over the individual. As we are in charge of ourselves, there is no problem of the legitimacy of the authority of the state. We have sovereignty over ourselves, and if the state is merely an extension of this, the problem of legitimacy will not arise. It is only if the sovereignty is located somewhere else, for example in a monarch, that there is a problem.

But how could Rousseau possibly convince us of his vital claim, that what the state wants is always exactly what the individual wants? Although the state is composed of individuals, this does not mean that all the laws of the state are exactly what each individual wants. But this is what Rousseau seems to be saying, that the state would never tell me to do anything I would not do myself. It is his attempt to make good this claim that people through the ages have found so gripping. For some, presumably including Marat and Guevara, it has opened up the possibility of a free and equal relation between the individual and the state. For others, it has contained the seeds of disaster; namely a justification for the worst forms of **totalitarianism**. Most agree, however, that Rousseau's simple formula, *that we can be both free and ruled only if we rule ourselves*, is a compelling one.

The particular will, the will of all and the general will

What Rousseau needs to show is this: in obeying the state, individuals obey only themselves.

The first step in the argument is to distinguish between the different types of **will** an individual may possess. 'Will' is a slightly old-fashioned term; what is meant is a goal or desire. I might have a will to be prime minister or to make a cake. Rousseau calls the particular desires of an individual their **particular will**. He assumes that our particular will is mostly going to be concerned with our own advantage. We will see in a moment that he does not claim we always think according to our particular will. The **will of all** is what you get if you add together the particular will of each person. This is likely to be a motley collection of different goals and desires, some of which will agree with each other and others of which will not. Finally, and most controversially, we have the **general will**. Precisely what Rousseau means by this should become clear in the discussion that follows, but an initial formulation might be something like this: the general will of a group concerns that which is in the best interests of the group taken as a whole rather than as a collection of individuals.

The idea of the general will is Rousseau's lasting contribution to political philosophy and plays a central role in his argument. He thought that if a collection of individuals were acting as a group, inevitably questions would arise which required an answer from the group as a whole. This can be applied to any group in a contemporary context – a sports team perhaps, or a neighbourhood watch group – as well as to the state. For example, a sports team might need to decide whether to continue to play together or to disband. A neighbourhood watch group might be asked if they wanted to sponsor additional streetlights. The state might need to decide whether it ought to raise an army. Rousseau's idea is that for each of these questions there is a single correct answer: this would be the general will of that group in response to that question. Rousseau sometimes talks about the general will as 'the will of the group' or, as he is interested in politics rather than other kinds of association, 'the will of the state'. (Do you think it is likely that there will be a single general will for entire states? If you have doubts, make a note of them now. I will discuss the doubts I have in Part 2.)

Let me illustrate the three different types of will by applying them to a question asked of a sports team: who is to be captain? Let us say that each player wants to be captain: that is, each of them has a particular will to be captain. The will of all is the sum total of all of these; that is, that each and every one of the players should be captain. The general will, that which is in the best interests of the team, is that there should be just one captain (presumably the person who would do the job most effectively). The example is only to help you grasp the point; when we come to consider whether the state's authority is legitimate, things get slightly more complicated.

> The three kinds of will Rousseau identifies can often be seen when decisions need to be made about distributing finite resources. Consider, for example, a charity which has £10,000 to allocate among the five projects in which it is engaged. Each of the managers of these projects thinks their project would benefit from all of the money. So each has a *particular will* for all of the £10,000. The *will of all* is the sum of all these particular wills. Obviously, as it only has £10,000 the charity will not be able to satisfy the will of all. What needs to be worked out is the *general will* of the charity – that is, the way to spend the money that would do most good to the charity as a whole (see Barry, 1967, pp.119–20).

We can now use this idea of different types of will to rephrase Rousseau's solution to the problem of legitimacy. The general will of the state is that which is best for the state as a whole; we can express this by saying it is what the state wants. Hence, if individuals put aside their particular wills and think instead according to the general will, then what the individuals want and what the state wants will be the same. Hence, the problem of

legitimacy will not arise because our individual will and the will of the state will be identical. We can put it in terms of the sports team. I desperately want to be captain (my particular will) but I realize I am not the best person for the job. As a matter of fact, Bloggs would be the best captain (the general will). So I do not think about what I want, but about what would be best for the team and support Bloggs as captain. If everyone in the team thinks the same way, then nobody's desires are thwarted.

In this subsection we have been looking at Rousseau's justification for the claim that in obeying the state individuals obey only themselves. Using the new terminology, the justification is as follows: *if individuals adopt the general will, then, in obeying the state, individuals will be obeying only themselves.*

This immediately raises another question. It is certainly true that *if* individuals adopt the general will there is no problem of legitimacy, but what justification is there for thinking that individuals *will* adopt the general will? Hence, we have a new question for Rousseau: *why should an individual think according to the general will and not according to their particular will?*

Before discussing this question, however, I want to consider whether Rousseau's argument is that we adopt the general will on *all* matters. Let us take a step back. What is wrong with obeying one's particular will? The answer is that if I obey my particular will, I am forcing my will on you so that you do not get what you want. Think about the sports team. If I obey my particular will and make myself captain (imagine I bribe the selection committee), I frustrate the other players who also want to be captain.

But is it true that *whenever* I obey my particular will I am forcing my will on others? In other words, are there desires of mine I could follow which would not affect other people?

EXERCISE

Write down two or three particular desires of yours which, in normal circumstances, you could follow without affecting other people.

DISCUSSION

Here are three examples I came up with:

1 My desire to eat cod and not plaice with my chips.

2 My desire to wear a white shirt to work rather than a blue one.

3 My desire to watch the rugby on television rather than the soccer.

It's only important for an individual to adopt the general will if their particular will is going to infringe the freedom of others. In most circumstances, whether or not I eat cod or plaice with my chips matters to no one. Of course, if there were a shortage of cod then it would matter. In those circumstances, I would need to act according to the general will. In circumstances in which it does not matter, I can continue to act according to my particular will.

Does this mean that everything that infringes the freedom of others, no matter how trivially, should be a matter of acting according to the general will? I don't think so. Rousseau restricts the general will to 'fundamental' matters. These are matters in which others are being thwarted, their freedom is being infringed, to an intolerable extent. When you listen to the audio-cassette in Part 2 you will hear that scholars of Rousseau disagree about exactly what is covered by the general will and what is not. For the moment, this need not matter to us. Sometimes I can obey my particular will (when I choose my shirt) and sometimes I should obey the general will (when there is a cod shortage). We need not decide exactly where the dividing line falls.

Summary

1 Rousseau's fundamental problem is to find a way in which we can live in a state and yet remain as free as before.

2 An individual would remain as free as before if their will always coincided with the will of the state.

3 The will of the state is what is best for the state: it is the general will.

4 So, if each individual adopts the general will, each individual would remain as free as before.

5 An individual does not have to adopt the general will for every decision – only on important matters that will affect other people.

(Note: there will be further discussion on the general will in Part 2 after you have listened to the audio-cassette.)

4 FROM THE STATE OF NATURE TO THE CIVIL STATE

To give his argument credibility, Rousseau needs to tell us why, in matters which concern the state, the individual should think according to the general will and not according to their particular will. If he can do that, he will have shown that the state's authority is legitimate because, in obeying the state, individuals are obeying only themselves (that is, they

are obeying the general will which they have freely chosen). His line of thought, which is explored below, goes as follows:

1 The particular will is a product of appetite.

2 The general will is a product of reason.

3 To act on appetite is slavish and bad.

4 To act on reason is noble and good.

5 We should be noble and good.

6 So, we should obey the general will.

Rousseau draws the contrast between the general will and the particular will by contrasting the civil state with what he calls 'the state of nature'. The point of this is to get us to reflect on the difference that living in a civil state makes to our characters and attitudes. Once again, this is a thought experiment. (Remember what I said at the beginning. If you do not agree with the results of the thought experiment, it does not mean you have misunderstood Rousseau's argument. Write your objections down and read on.) We can think of people in a state of nature as being devoid of the kind of relations with others that go to make a civil state; we might imagine them as isolated hunter-gatherers. The usefulness of thinking of people in this way is that we can contrast the kind of life enjoyed in a state of nature with the kind of life enjoyed in the civil state. Thus we can get an idea of the changes that are brought about by living in a civil state. It does not matter whether or not people ever actually lived in this imagined state of nature. It is the same kind of experiment someone might try in order to find out the impact having a dog has had on their family. They imagine their family without a dog and notice the differences between what they imagine and what they know to be true. It is possible to do this even if the family has always had a dog. In a similar way, Rousseau asks us to imagine what life would be like in the state of nature so that we can notice the differences between life in the state of nature and the life we know in the civil state.

> Rousseau asks us to think about what life would be like in a state of nature in order to discover the difference made to our lives by living in a civil state. In the seventeenth and eighteenth centuries, there was also much discussion about how people *actually* lived their lives before states were formed. Rousseau contributed to the debate in *Discourse on the Origin of Inequality* (1754). How people actually lived is obviously a historical and not a philosophical matter. Contemporary political philosophers still use the same thought experiment as Rousseau: they compare the life we lead in the civil state with the life we *would* lead if we were in the state of nature in order to see what advantages or disadvantages the civil state brings.

We are now going to look at a chapter of *The Social Contract* entitled 'On the civil state' in which Rousseau first describes the thought experiment. The first paragraph contrasts the advantages that a person has in the civil state with those that they would have had in the state of nature. I have italicized each of those things Rousseau thinks we would *gain* in a change from the state of nature to the civil state.

> This passage from the state of nature to the civil state produces quite a remarkable change in man, for it substitutes *justice* for instinct in his behaviour and gives his actions *a moral quality* they previously lacked. Only then, when the *voice of duty* replaces physical impulse and *right* replaces appetite, does man, who had hitherto taken only himself into account, find himself forced to *act upon other principles* and to *consult his reason* before listening to his inclinations. Although in this state he deprives himself of several of the advantages belonging to him in the state of nature, he regains such great ones. His *faculties are exercised and developed*, his *ideas are broadened*, his *feelings are ennobled*, his *entire soul is elevated to such a height* that, if the abuse of this new condition did not often lower his status to beneath the level he left,[*] he ought constantly to bless the happy moment that pulled him away from it forever and which transformed him from a stupid, limited animal into an intelligent being and a man.
>
> [*] That is, if we abuse our new condition (the civil state) we will end up worse off than we were in the state we left (the state of nature). In other words, unless we run the state properly so that we do not lose our freedom, we would be better off in the state of nature.
>
> *(Rousseau: Cress (ed.), 1987, bk1, ch.8, pp.150–51; italics and footnote added)*

EXERCISE

Now reread the paragraph, and note down all those things Rousseau thinks an individual would *lose* by coming out of the state of nature. I counted five.

DISCUSSION

Rousseau thinks an individual would lose instinct, physical impulse, appetite, listening to their inclinations, and being a stupid limited animal.

In short, what Rousseau is doing in this paragraph is contrasting the various great qualities given to us by living in a civil state with various rather animal-like, base qualities we would have if we lived in the state of nature.

Remember this contrast and we will see what Rousseau does with it in a moment. Before doing so, however, let us look at the remaining two paragraphs of the chapter.

EXERCISE

As you read the following extract, compile the 'balance sheet' of 'credits and debits'. In other words, list those things we gain and those things we lose by moving to a civil state from the state of nature.

> Let us summarize this entire balance sheet so that the credits and debits are easily compared. What man loses through the social contract [that is, the civil state] is his natural liberty and an unlimited right to everything that tempts him and that he can acquire. What he gains is civil liberty and the proprietary ownership of all he possesses. So as not to be in error in these compensations, it is necessary to draw a careful distinction between natural liberty (which is limited solely by the force of the individual involved) and civil liberty (which is limited by the general will), and between possession (which is merely the effect of the force or the right of the first occupant) and proprietary ownership (which is based solely on a positive title).
>
> To the preceding acquisitions could be added the acquisition in the civil state of moral liberty, which alone makes man truly the master of himself. For to be driven by appetite alone is slavery, and obedience to the law one has prescribed for oneself is liberty. But I have already said too much on this subject, and the philosophical meaning of the word *liberty* is not my subject here.
>
> *(Rousseau: Cress (ed.), 1987, bk1, ch.8, p.151)*

DISCUSSION

On the credit side (those things we gain in the civil state) are civil liberty, proprietary ownership and moral liberty.

On the debit side (those things we lose by moving away from the state of nature) are natural liberty, unlimited right to everything that tempts us and that we can acquire, and possession.

Let us look first at the debits, or what Rousseau thinks we would *lose* in the change from the state of nature to the civil state. By 'natural liberty' Rousseau means that a person in the state of nature is free from any hindrance to action; their freedom is limited solely by their physical capabilities. By 'unlimited right to anything that tempts him and he can acquire', Rousseau means that as nothing in the state of nature is owned by anyone, if a person desires something they can simply pick it up or pluck it off a tree. If two people want the same object, force will determine who comes out on top; in other words force will determine 'possession'. You might think that Rousseau is going back on his earlier claim that naked power does not give rise to legitimate authority. He is not; there he was talking about legitimate authority in the civil state. Here he is talking about a state of nature in which questions of legitimacy do not arise. Indeed, the fact that there is nothing to stop people simply

pushing each other around is one thing which justifies the move to the civil state.

Now let us look at the benefits from the change to the civil state. First there is 'civil liberty': the liberty which occurs when individuals live according to the general will as opposed to their own particular wills. Second there is 'proprietary ownership'. Obviously, there are certain options that will not be open to those in the state of nature. For example, imagine that you are living in the state of nature and come across an apple tree which happens to bear particularly nice apples. It will not be an option for you to cultivate this for your own benefit. Whenever anyone wants an apple they will simply come and take one off the tree, so there seems little point in your breaking your back to look after it. If enough people want nice apples, the crop could disappear overnight. In the civil state, because there are legal institutions of ownership, your claim to be the owner of the tree will be recognized and you can stop people picking your apples. This has an exciting consequence. It looked initially as though someone in the state of nature enjoyed a perfect liberty; there was no one to stop them doing anything. However, in another sense, they hardly had any liberty at all. As nobody could own anything, there was no point in anyone investing any of their time or energy in anything, as there was no guarantee that their plans would not be upset by the actions of others. They were not free to cultivate their own apples or indeed do anything that required co-operation from others. That does not seem to be freedom so much as the most tedious form of slavery.

Moral liberty

Apart from proprietary ownership and the opportunities that brings, the other benefit of the move from the state of nature to the civil state was 'moral liberty'. This is a key concept for Rousseau's argument. The chapter you read opens with the following claim:

> This passage from the state of nature to the civil state produces quite a remarkable change in man, for it substitutes justice for instinct in his behaviour and gives his actions a moral quality they previously lacked.
>
> *(Rousseau: Cress (ed.), 1987, bk1, ch.8, p.150)*

And in the final paragraph it says:

> To the preceding acquisitions could be added the acquisition in the civil state of moral liberty, which alone makes man truly the master of himself. For to be driven by appetite alone is slavery, and obedience to the law one has prescribed for oneself is liberty.
>
> *(Rousseau: Cress (ed.), 1987, bk1, ch.8, p.151)*

Here is the beginning of Rousseau's solution to the problem of why an individual should act on the general will rather than on their particular

will. He talks, in the first paragraph, of 'a remarkable change in man'. That is, a remarkable change takes place in a person who moves from the state of nature to a civil state. In the state of nature a person acts on instinct and appetite, while in the civil state they act according to justice and possess 'moral liberty'.

Consider a parallel example. The person in the state of nature is like a person who is driven by an uncontrollable desire for chocolate. Their life is dictated by the availability of chocolate bars; everything they do has to take this into account. Such a person would not be free to do things that people without such a desire are free to do. They are not free to enjoy anything without knowing where the next bar of chocolate is coming from, nor are they free to visit places where chocolate is unavailable. We might say, along with Rousseau, that they are a 'slave' to their appetites.

In the same way as we are inclined to think that there is something wrong with a person who is a 'slave' to chocolate, or perhaps a 'slave' to television, Rousseau thinks that there is something wrong with people who are always driven by their own desires. They are not behaving in a way befitting their status as people. Rousseau makes great claims for a person leaving this reliance on their desires to participate in a civil state:

> His faculties are exercised and developed, his ideas are broadened, his feelings are ennobled, his entire soul is elevated to such a height that ... he ought constantly to bless the happy moment that pulled him away from it forever and which transformed him from a stupid, limited animal into an intelligent being and a man.
>
> *(Rousseau: Cress (ed.), 1987, bk1, ch.8, p.151)*

This really is a 'remarkable change'; in joining the civil state we escape the slavery of appetite and fulfil ourselves as human beings.

Let us review matters and see how far we have come. Rousseau has pointed out that the civil state actually increases our freedom, as it gives us the freedom to do all manner of things we could not do outside it. It also gives us the opportunity to avoid following our appetites and choose to do something else instead. This constitutes an increase in freedom, because following our appetites is a form of slavery. We can compare the state of nature with the civil state in the form of a table.

State of nature	Civil state
Natural liberty	Civil liberty
Right to anything one can acquire	Rule of ownership
Slave to appetite	Guided by reason
Stupid, limited animal	Ennobled, intelligent being

What has this to do with the general will? We need to take seriously the change from the state of nature to the civil state. There is not much benefit to be gained if we move from pursuing our stupid, limited lives

as individuals to pursuing our stupid, limited lives within a state. Rather, we must abandon our inclinations and consult our reason and think as a member of the state. To think as a member of the state is to adopt the general will. In order to benefit from the ennobling change, we must think as members of the state and not as individuals; we must adopt the general will. So we can add one more row to our table.

State of nature	Civil state
Particular will	General will

You will recall that the purpose of Rousseau's thought experiment – which considered the state of nature – was to show us the difference civil society makes to human life. The result has been to show us that in order to reap the benefits of civil society, we ought to adopt the general will. Look, once again, at Rousseau's line of thought:

1 The particular will is a product of appetite.

2 The general will is a product of reason.

3 To act on appetite is slavish and bad.

4 To act on reason is noble and good.

5 We should be noble and good.

6 So, we should obey the general will.

Rousseau has tried to convince us of this by describing the difference between the state of nature and the civil state and, in effect, asking which we think is better. To be in the state of nature would be to act on appetite and so be slavish and bad. To be in the civil state is to act according to reason and so be noble and good. We ought 'constantly to bless the moment' that we moved into the civil state, because this gives us the chance to be noble and good. So, says Rousseau, it is in each of our interests to choose the general will.

All the steps of Rousseau's argument – three premises and a conclusion – are now in place.

1 If in obeying the state we will be obeying only ourselves, then there is no problem of legitimacy.

2 If we think according to the general will, then in obeying the state we will be obeying only ourselves.

3 Each of us ought to think according to the general will.

Conclusion: If we do what we ought, there will be no problem of legitimacy.

Rousseau has been trying to establish premise 3, why each of us ought to think according to the general will. To do this he has provided a thought experiment comparing the state of nature with the civil state. What he

has given us is a mixture of argument and assertion. Let us try to separate the elements of each.

In the glossary 'argument' is defined as 'reasons or evidence supporting a conclusion'. There is argument, even **deductive argument** (an argument that uses logic to get a true conclusion from true premises) in the thought experiment:

1 In the state of nature, we cannot rely on the co-operation of others.

2 If we cannot rely on the co-operation of others, there are many worthwhile things we cannot do.

3 Therefore, in the state of nature there are many worthwhile things we cannot do.

'Assertion' is defined in the glossary as an 'unsupported statement'. And there is much that falls under this definition in Rousseau's thought experiment. Why should we believe Rousseau when he says that the change from the state of nature to the civil state will cause 'a remarkable change in man'? He uses emotive words: 'slavish' as opposed to 'reasonable'; 'stupid' and 'limited' as opposed to 'ennobled' and 'intelligent'. This is not really argument. Because it is not really argument, we have been given no conclusive reason to believe it.

What are we to make of Rousseau's thought experiment? The argument seems valid and its premises seem true. But what about his attempts at persuasion, his assertions? Even though Rousseau does not provide an argument to support his assertions, some of what he says does seem plausible. For the television programme TV10, I went to South Africa to see if the change in government in 1994 had made a difference to how the people thought of themselves and each other. I discuss this, and other aspects of Rousseau's thought experiment, in Part 2. For the moment it is only important that you understand what Rousseau is trying to do. That is, he is trying to persuade us that the civil state is better than the state of nature, and part of being in the civil state is that we fulfil ourselves by obeying the general will.

The social contract

We can agree that being a member of a civil state gives us plenty of opportunities which we would not have outside it. We might also think that someone who is driven solely by their own appetites is not as free (because they have fewer opportunities) as someone who is able to take a broader view. Once they have been pointed out to us, these claims may seem little more than common sense. Rousseau has, then, given us an argument for relying on our reason rather than trusting our instincts. But is this strong enough to persuade each and every individual always to adopt the general will? What is to stop individuals in the civil state lapsing occasionally and acting so as to satisfy their appetites?

Let us go back to the example of the sports team I used when I first introduced the general will. Part of joining a sports team (or any team for that matter) is that you either tacitly or explicitly agree to act as a member of the team when the situation demands it. You do not act as an individual – ignoring the captain whenever you feel like it and never passing the ball. The team does not work unless each individual acts as a member of the team.

Rousseau would argue that the same goes for living in a civil state. Living in a civil state brings lots of advantages, as we have seen. We have also seen that the only way to avoid people being subject to wills that are not their own is for everyone to choose the general will. What if someone in the state chooses instead to act according to their particular will? We saw in the exercise on p.106 that if their actions did not affect anyone – if it was merely a matter of choosing what to wear or what to eat – this would not matter at all. However, if their will concerns other people then it does matter.

Rousseau thought it would be in each individual's best interest to think according to the general will, and so escape brutish stupidity. He thought that both in the way people are educated and in the day-to-day running of the state, people should be reminded of this fact. That is, they should be encouraged not to think of themselves as individuals so much as members of the state. The French revolutionaries adopted this idea, and organized lively festivals to disseminate propaganda for the state. *The Social Contract* was published within a month of a treatise on education on which Rousseau had been working entitled *Émile*. *Émile* contains many references to *The Social Contract* and Rousseau's view that individuals should adopt the general will rather than their particular wills. A persistent theme is that children should be *brought up* to think in terms of the needs of the state. 'Good social institutions', says Rousseau early on in *Émile*, 'are those best fitted to make a man unnatural, to exchange his independence for dependence, to merge the unit in the group, so that he no longer regards himself as one, but as a part of the whole, and is only conscious of the common life' (Rousseau: Foxley (ed.), 1993, p.8). (By 'unnatural' Rousseau does not mean 'peculiar'; he means 'not in the state of nature'.) Later on he says, 'Apart from self-interest this care for the general well-being is the first concern of the wise man, for each of us forms part of the human race and not part of any individual member of that race' (Rousseau: Foxley (ed.), 1993, p.258). The wise person is someone who is prepared to adopt the general will on certain issues. Rousseau also sought to co-opt religion to strengthen the social bonds. I have reprinted some of his thoughts on this in *Resource Book 2*, B1, for you to read if you are interested.

Let us look at an example of someone acting according to their particular will. Imagine it is the general will of a state that people do not unnecessarily endanger others. As it is the general will, it is also the will each individual would be right to adopt. However, one person, let us call him Fred, chooses to act on his particular will and drives around at great speed. Everyone else is being forced by Fred to live in danger of being killed, which is an infringement of their freedom. So you can see that merely by choosing to act according to his particular will, Fred is exercising illegitimate authority over others. Only if everyone adopts the general will is everyone's freedom protected. (At this point you may well ask about Fred's freedom. Is it not infringed if we demand he adopt the general will? I will return to Fred when I examine that question in Part 2, Section 3.)

If an individual chooses to act according to their particular will in a way that affects other people, then those other people are subject to a will that is not their own. That would destroy the whole point of living in a civil state for those people. They would be better off in the state of nature. Admittedly they would have been slaves to their appetites, but at least they would have been free from the particular will of other people. Being subject to the will of others, Rousseau thought, is the worst position in which a person could find themselves. Freedom was very important to Rousseau; remember, the whole argument is meant to show how the state's authority can be legitimate by showing it is compatible with *each* individual's freedom.

Rousseau's idea is that living in the civil state is like signing a contract in which one agrees to abide by the general will and not one's particular will. This is why he called his book *The Social Contract*. Like any contract, the social contract is to do with gains and losses. In the state of nature we were free in the sense that nobody had authority over us. Being a member of the civil state brings with it all sorts of other benefits, but we lose these benefits if others do not act according to the general will. For if they act according to their particular wills and it affects us, we would be subject to a will that was not our own. To avoid this situation, Rousseau says that we should think as if each individual, in joining a civil state, commits themself to behave as a full member of the state. We contract to get the benefits of a civil state, but we sign away our rights to act on our particular wills (except in matters such as choosing our shirts which – usually – do not affect anyone else).

Summary

1 Rousseau tries to convince us that we should all obey the general will by giving us a thought experiment.

2 In the thought experiment we contrast the civil state with the state of nature.

3 Some of these contrasts are shown by argument. We do have more opportunities in the civil state.

4 Other contrasts are simply asserted, such as that we have a 'remarkable change' in ourselves and our attitudes.

5 If we accept Rousseau's thought experiment, it gives us grounds for accepting that we ought to obey the general will.

6 Rousseau likens living in a civil state to signing a contract. We contract into the benefits of the state, and in return we contract out of obeying our particular wills on fundamental matters that affect others.

This is a good place for you to stop and look over the ground we have covered.

■ Think about each of the three premises in the argument (p.113), and make sure you have grasped Rousseau's reasons for each.

■ Consider whether you think they are good reasons.

Try to put yourself in Rousseau's place; think about the problems he posed for himself and the solution he came up with. You need to have grasped the argument before you go any further with these units. We will not be covering any more material from *The Social Contract*. Rather, I am going to look at a number of questions that arise from what we have already covered. Some of these questions might have already occurred to you. After that, I am going to contrast Rousseau's solutions with a contemporary political solution about how to run a state.

PART 2 INVESTIGATING THE ARGUMENT

1 THE 'REMARKABLE CHANGE IN MAN'

There is something wonderful about Rousseau's aim: to release us from the slavery of our appetites and realize the better side of our natures in living together and co-operating together in a state. If our true nature is to adopt the general will, then the problem of showing that the state's authority is legitimate disappears. If everyone adopts the general will, nobody would be subject to a will that is not their own. In such a situation, Rousseau says, individuals have a chance to develop their full potential. This is one of the most interesting aspects of Rousseau's thought: the link he draws between the way people are governed and their individual character. Coming to live in a civil state produces 'quite a remarkable change in man'. Look again at an excerpt from Rousseau that we discussed in Part 1 (p.109).

> This passage from the state of nature to the civil state produces quite a remarkable change in man, for it substitutes justice for instinct in his behaviour and gives his actions a moral quality they previously lacked. Only then, when the voice of duty replaces physical impulse and right replaces appetite, does man, who had hitherto taken only himself into account, find himself forced to act upon other principles and to consult his reason before listening to his inclinations. Although in this state he deprives himself of several of the advantages belonging to him in the state of nature, he regains such great ones. His faculties are exercised and developed, his ideas are broadened, his feelings are ennobled, his entire soul is elevated to such a height that, if the abuse of this new condition did not often lower his status to beneath the level he left he ought constantly to bless the happy moment that pulled him away from it forever and which transformed him from a stupid, limited animal into an intelligent being and a man.
>
> (Rousseau: Cress (ed.), 1987, bk1, ch.8, pp.150–51)

In this paragraph Rousseau says that an individual will be much improved 'if the abuse of his new condition did not often lower his status to beneath the level he left'. In other words, an individual will benefit from living in a state only if that 'new condition' does not 'lower his status' to below that which it would be in the state of nature. The civil state, if it is run properly, will change us and *improve* our nature. A person's individual character is profoundly affected by the sort of state in which they live. Rousseau often returned to this theme in his writings. This is one reason why Rousseau seems in many ways a modern thinker.

Look at this reply to Aristotle, who had claimed that some people were born for slavery and others for domination:

> Aristotle was right, but he took the effect for the cause. Every man born in slavery is born for slavery; nothing is more certain. In their chains slaves lose everything, even the desire to escape. They love their servitude the way the companions of Ulysses loved their degradation. If there are slaves by nature, it is because there have been slaves against nature. Force has produced the first slaves; their cowardice has perpetuated them.
>
> *(Rousseau: Cress (ed.), 1987, bk1, ch.2, pp.142–3)*

People born in chains think as slaves, because of the way they are treated. To put it another way, there are people who think naturally as slaves, but only in the sort of unjust state which allows slaves in the first place. Thereafter, they become moral cowards which keeps them in their place. The same point is often made nowadays – 'if you treat them like animals, they will behave like animals' – although few can match Rousseau's rhetoric.

One shining example of this cowardice being thrown off was the slave revolt in Haiti in 1791 which drove the British and Spanish from the island. This was led by Toussaint L'Ouverture, a slave who had been inspired by reading Rousseau (see Doyle, 1990 edn, pp.412–13).

Rousseau thought people would act according to the general will and develop their true natures only if they lived in a properly run state. Unless the state's authority is legitimate, they will fail to develop their full potential. To see if Rousseau's view was reflected in reality, I went to South Africa for TV10 – which relates to this part of the units. Until 1994 only white people were allowed the vote in South Africa. As a result, the government was viewed by the majority of South Africans and by the world at large as lacking legitimacy. In 1994 the first truly democratic elections were held, and a parliament drawn from all the racial groups was elected. I wanted to find out if Rousseau's view about the link between government and moral character was reflected in this changing country. In other words, I wanted to find out if people's attitudes to themselves, each other and their country changed as their beliefs about the legitimacy of the government changed. Here are some of the things people said:

1 'Today [election day] to me means a dramatic change in South Africa. It means me being counted as an important person ...'

2 'We are going to be equals, blacks and whites ...'

3 'There is a will among South Africans to change and there is a will among everybody to accept one another. For me that is a promise and for me that is something that makes me feel confident that

people are going to find one another and one day we will all talk with one voice as South Africans.'

4 'People are realizing far more than they did that we are all in the same boat together ...'

5 'It is the beginning of a new South Africa. We are going to have everything we were deprived of ...'

6 'You look in the schools today and you see black and white kids playing together in the playground, that is where the future lies.'

7 'The fact of so many people who have suffered so greatly having such incredible goodwill is a very powerful force ...'

Rousseau is discussing the change from a state of nature to the civil state. In South Africa the change was from a system in which the minority had the vote to a system in which the majority had the vote. These two changes are very different. I am not trying to claim that South Africa is governed according to Rousseau's ideas. I only want to test Rousseau's general claim that people's characters are influenced by the way in which they are governed. If this were true, one would expect an improvement in South African politics to lead to a change in the outlook of South African people along the lines Rousseau suggests. The television programme concentrates on four specific issues: the link between legitimacy and an individual's character and actions, the general will, equality and community. I was surprised, as I hope you will be, at the extent to which these issues were at the front of people's minds.

EXERCISE

Rousseau's 'remarkable change' is not only a change in each person (they are ennobled and so on) but also a change in each person's attitude to others (people co-operate with each other and see each other as equals). Look back at quotations 1 to 6 above. Divide them into those which are about people's attitudes to themselves and those which are about people's attitudes to each other. Then look at quotation 7 and note what it says about people's attitude to the changes in South Africa.

DISCUSSION

Quotations 1, 2, and 5 are concerned with how people's attitudes to themselves have changed. The speakers feel they will no longer be disregarded by the state, but will be counted as citizens. They will be important, equal and given that of which they had been deprived.

Quotations 3, 4, and 6 concern people's attitudes to each other. There seems to have been a change from people thinking of themselves as

individuals or as part of a racial group to thinking of themselves as one citizen of a state among others.

Quotation 7 rather speaks for itself but I could not resist putting it in. I was very impressed in South Africa at the lack of bitterness that characterized the attitudes of those individuals who had previously been disregarded by the state. Their attitude seemed to have changed from resentment to goodwill.

Of course, I cannot know at the time of writing (1997) what the future of South Africa will be. By the time you read this, the country could be altogether different. However, that does not alter the fact that the change in South Africa did come along with a whole package of changes that were highly reminiscent of those Rousseau suggests.

If Rousseau is right about the link between individual character and the legitimacy of government, this strengthens the view that it is important to have legitimate governments. In writing his autobiography, *Confessions* (1782–9), towards the end of his life, Rousseau looked back on the work he had done in political philosophy and produced the following conclusion:

> I had seen that everything is rooted in politics and that, whatever may be attempted, no people would ever be other than the nature of their government made them.
>
> *(Rousseau: Cohen (trans.), 1953, p.377)*

Summary

1 Rousseau has not provided a deductive argument for the link between how we are governed and our individual character.

2 None the less, the idea is not absurd. Some evidence can be found that there is such a link.

2 IN SEARCH OF THE GENERAL WILL

I explained the role of the 'social contract' and explored the link Rousseau draws between the legitimacy of the government and the individual's character in Part 1. The final part of my discussion of Rousseau will be about the general will. This is the most significant contribution he made to political philosophy. Earlier in these units I defined the general will as that which is in the best interests of the group taken as a whole, rather than as a collection of individuals (p.104). I illustrated this with an example of a sports team: it is the general will of the team that the person most qualified should be captain, even if each particular player would like to be captain. Even with this example,

however, a nagging thought might occur to you: how do we know who is the most qualified person? *How do we know the general will?* That will be our first question. The second question is more radical. It asks whether there *is* anything to know. Even if it is plausible that there is a single correct answer to the question as to what is in the best interests of a sports team, *is there a single correct answer as to what is in the best interests of the state?* This is connected to the question as to whether or not Rousseau's philosophy is totalitarian.

How do we know the general will?

The crucial point of which to remind ourselves before we embark on a discussion of this issue is that Rousseau believed that a state has one and only one general will; it is the single correct answer to the question of what is in the best interests of the state. Think of it like a problem in mathematics in which we are sure there is a correct answer; we simply do not know what it is. To get the answer in maths involves either us or someone else working through the correct mathematical procedures. What we need is an analogous set of procedures in the case of the general will. What are the best procedures for working out what is in the best interests of the state?

Look, once again, at Rousseau's argument as to why we should obey the general will.

1 The particular will is the product of appetite.

2 The general will is the product of reason.

3 To act on appetite is slavish and bad.

4 To act on reason is noble and good.

5 We should be noble and good.

6 So, we should obey the general will.

To be a **citizen** of a civil state is to escape the slavery of appetite and inclination and think according to reason. This 'remarkable change' elevates us from being 'a stupid, limited animal' to something noble. To ensure the state's authority is legitimate, everyone who is part of the state must think according to the general will. To discover the general will we must consult our *reason*, for our inclinations will only tell us what *we* want to do – which would be our particular will. What is it to 'consult our reason'? It is just what it says; to think in a clear-headed and rational manner about what would be best for the state. Obviously, *if we assume there is only one right answer, then everyone who is thinking in a clear-headed and rational manner will come up with the same answer.* As Rousseau says, the closer we get to unanimity, the more certain we can be that we have got the general will (see Rousseau: Cress (ed.), 1987, bk4, ch.2, p.205). The point is very important to Rousseau's argument, so

it is worth repeating. There is a single correct answer to the question of what is in the best interests of the state. We arrive at this answer by consulting our reason, and as there is only one answer, if we all think in a clear-headed and rational way, then the answer should be the one each of us arrives at.

The claim that there is only one right answer to questions of what is in the best interests of the state is one that is open to question and, indeed, I shall be questioning it shortly. For the moment, however, for the purposes of examining Rousseau's argument, I am going to argue as if it were true.

What if everyone deliberates and does not come up with the same answer? Keeping the assumption that there is only one right answer, we can assume that some have made a mistake. But how do we know who has made the mistake and who is right? The obvious thing to do – what we would do in maths – is to get everyone to think through the problem again. But what if we still do not get unanimity? What Rousseau needs is an error-free method for discovering the general will. The one he chose was to ask each person to vote for their view of the general will. A mathematician called Condorcet showed that, provided certain assumptions are made, this is a good method for finding the answer to questions. This gave Rousseau the method he was looking for. If there was not unanimity in deciding on the general will, *the best procedure for determining the right answer was to take a vote*. Hence, if we do not have unanimity, the way we discover the general will is to take a vote.

The Marquis de Condorcet was a mathematician with a passion for applying reason to social matters. After playing a considerable part in the Revolution in the role of a moderate republican, he died in a prison cell at the height of the Terror. One of his enduring achievements was to use simple statistical techniques to prove that, given certain constraints, putting a matter to the vote was the best procedure for finding the answer to a question, provided there was a single correct answer. The result of the vote is far more likely to be right than the view of any one voter. Whether Rousseau knew of Condorcet's proof is controversial; it was published twenty years after *The Social Contract*. But there is much in Rousseau's work to suggest that he had at least a firm intuitive grasp of these points.

To follow the argument here you do not need to know the details of Condorcet's proof. Although the proof is valid, the constraints Condorcet specifies are only fulfilled for a fairly narrow band of questions. In particular, Condorcet's faith that votes would deliver the correct answer on political questions was unfounded. The consequence is that voting will not, in fact, give Rousseau the procedure of finding out the general will. However, there are far more interesting things wrong with Rousseau's system than a mere failure to find a correct procedure, so for

the sake of finding these interesting things, I am going to proceed (for a while at least) as if voting *is* a good procedure for discovering the general will.

Rousseau, like Condorcet, thought the vote would only yield the right answer given certain constraints. I shall look at three of the constraints: (a) that people vote according to what they take to be the general will, rather than their particular wills; (b) that there is no 'fixing' of the vote through factions; and (c) that there is some measure of equality of wealth and power.

(a) People vote according to what they take to be the general will, rather than their particular wills

The reason Rousseau has this as a constraint is obvious if you remember what it is he is trying to do. Recall that he thinks the best way to discover the general will is to consult our reason. Hence, each individual is trying to work out what the general will is. It is only if there is no unanimity that a vote is taken; but the vote is to determine what the general will is, not to find out what people's particular wills are. Hence, people need to vote according to what they think is the general will.

(b) There is no 'fixing' of the vote through factions

Rousseau puts this constraint on the vote so as to avoid corruption. Let us take an example. Imagine all the members of a state get together to discover the general will concerning the location of a new national stadium. Each consults their reason, but no unanimity results. Hence, a vote is called. However, before the vote is taken all the inhabitants of one of the towns secretly agree not to vote according to what they think is the general will, but rather what they think is best for the town. The vote will not now be an uncorrupted procedure for discovering the general will of the state, as it will be biased towards one part of it. If the town is populous enough, they may corrupt the vote altogether. This is what Rousseau himself says:

> If, when a sufficiently informed populace deliberates, the citizens were to have no communication among themselves, the general will would always result from the large number of small differences, and the deliberation would always be good. But when intrigues and partial associations come into being at the expense of the large association, the will of each of these associations becomes general in relation to its members and particular in relation to the state. It can be said, then, that there are no longer as many voters as there are men, but merely as many as there are associations. The differences become less numerous and yield a result that is less general. Finally, when one of these associations is so large that it dominates all the others, the result is no longer a sum of minor differences, but a single difference. Then there is no longer a general will, and the opinion that dominates is merely a private opinion.

> *(Rousseau: Cress (ed.), 1987, bk2, ch.3, p.156)*

In the first sentence Rousseau states his view that voting is the best way of finding what the general will is. Provided enough people state honestly what they think the general will is, the errors each makes will cancel out and what emerges will be the right answer. In the second sentence he states the problem we are considering. The will expressed by the group who have clubbed together to vote in their town's best interest would be the general will *for the town*, which is not the general will for the state taken as a whole. Remember when I introduced the general will, I said it was that which was in the best interests of whatever group it was that was being asked the question: sports team, neighbourhood watch or whatever. We could put Rousseau's point here by saying that factions are bad because they look after the general will for themselves, as opposed to the general will for the state.

'If there are partial societies,' Rousseau goes on to say, 'their number must be multiplied and inequality among them prevented' (Rousseau: Cress (ed.), 1987, bk2, ch.3, p.156). In other words, if there have to be factions, then there should be as many as possible and they should be as equal as possible. For obviously, the more equal factions there are, the less chance any have of getting their way and so the less chance they have of corrupting the vote as a procedure for discovering the general will of the state. If this solution is pushed to its logical conclusion, the number of factions will be the same as the number of individuals, in which case there may as well be no factions at all.

(c) There is some measure of equality of wealth and power

Another danger of corruption Rousseau identifies comes not from partial associations, but from the possibility that the rich might try to sway the vote through bribery. The rich might pay the poor not to vote according to what they think is the general will, but according to what the rich would like the outcome to be. Rousseau does not require absolute equality, but he is aware that too great a difference between rich and poor brings with it the possibility of this sort of corruption.

Regarding equality, we need not mean by this word that degrees of power and wealth are to be absolutely the same, but rather that 'no citizen should be so rich as to be capable of buying another citizen, and none so poor that he is forced to sell himself' (Rousseau: Cress (ed.), 1987, bk2, ch.11, p.170).

In the last exercise we looked at the importance people attached to the legitimacy of government, and how this made them feel about themselves (p.120). Although Rousseau's use of the vote (to discover the general will) is very different to the use of the vote in South Africa (to elect politicians), the second and third constraint Rousseau mentions are relevant to both. The relevance is that thinking in terms of factions and massive inequalities of wealth are distorting influences

in a vote no matter what its purpose. Consider the two quotations below taken from TV10.

1 On partial associations: 'People are beginning to think as South Africans and not to think of colour any more ... that has affected the minds of the people not only the blacks; the whites also were victims of the past ...'

2 On equality: 'Democracy ... is also about how do you change the conditions of people's lives. The reality in our country is that 80 per cent or more of the wealth in this country lies in the hands of under 20 per cent of the population.'

Summary

1 We asked two questions. The first was: how do we know the general will for a state? The second was: is there such a thing as the general will for a state?

2 So far, we have considered only the first question. Rousseau believed that the best method of discovering the general will was to take a vote. (Even if this is doubtful, we have carried on as if it were true so as to get to other interesting areas of Rousseau's thought.)

3 This vote had to be taken under three conditions: (a) that people vote according to what they take to be the general will, rather than their particular wills; (b) that there is no 'fixing' of the vote through factions; (c) that there is some measure of equality of wealth and power.

3 'FORCED TO BE FREE': ROUSSEAU AND TOTALITARIANISM

If you look back to the Chronology of the Revolution in *Resource Book 2*, A1, you will see that from about August 1792 the revolutionary government in Paris instituted the Terror. Throughout the following year, many thousands were to be killed in Paris and throughout France by the guillotine, the firing squad, burning, drowning and starvation. Although Rousseau himself was horrified by violence, those who sought justification for the Terror were able to find it (or thought they were able to find it) in his work. Further on in the chronology we see that in June 1794, at the height of the Terror, Robespierre gave a speech to the Convention praising Rousseau. How could Rousseau, whose work as we have seen is chiefly concerned to protect people's freedom and save them from being subject to wills that are not their own, possibly serve as a justification for such barbarism? To see how, I am going to look at three situations in which there is a conflict between what an individual thinks and the general will.

A simple mistake

For the first, let us look again at the situation in which all the people of a state meet together to discover what the general will is as to where to put a new stadium. Once again, let us imagine each consults their reason with no unanimous result. This time, let us imagine that one citizen, Jane, thinks that the general will is to put the stadium where it will do least damage to the environment. Whether or not this is her particular will is irrelevant; remember, the aim of each person is to discover the general will. This is what Jane thinks is the general will. However, after the vote she finds she is in the minority; most people decided the general will was to put the stadium at a place where car-parking was plentiful and where it would cause least inconvenience.

It is important to remember that Rousseau thinks that the general will is the single correct answer as to what is in the best interests of the state: hence, either Jane is right or the rest are right. Rousseau's next thought was that, provided the constraints are observed, the best procedure for discovering the right answer is to take a vote. The fact that Jane was out-voted shows that she cannot have been right; she was simply wrong about what is in the best interests of the state.

> When a law is proposed in the people's assembly, what is asked of them is not precisely whether they approve or reject, but whether or not it conforms to the general will that is theirs. Each man, in giving his vote, states his opinion on this matter, and the declaration of the general will is drawn from the counting of votes. When, therefore, the opinion contrary to mine prevails, this proves merely that I was in error, and that what I took to be the general will was not so. If my private opinion had prevailed, I would have done something other than what I had wanted. In that case I would not have been free.
>
> *(Rousseau: Cress (ed.), 1987, bk4, ch.2, p.206)*

There are two points here. The first has already been discussed; I have gone along with Rousseau's claim that the vote is more likely to discover the general will than any individual voter. Hence, if my view is not that of the majority, then as long as the vote was taken correctly, this almost certainly 'proves merely that I was in error'.

The second point is made in the final two sentences of the quotation: 'If my private opinion had prevailed, I would have done something other than what I had wanted. In that case I would not have been free.' Reverting to the example discussed above, what Rousseau means is as follows. Jane wants the stadium located according to the general will. The general will is that the stadium should be located where car-parking is plentiful. Her private opinion of the general will is that it should be located in the place that causes least environmental damage. However, if her private opinion were acted upon she would not get what she wanted, because her private opinion is not the general will. Hence, if Jane is a follower of Rousseau she should abandon her private opinion

and adopt the opinion which the result of the vote showed to be the general will.

To illustrate this point let us consider an analogy. Remember, analogies are never total; there will always be some parts of the analogy that are relevant, and some that are not. The relevance of the analogy that follows is to show that cases of people not knowing what is 'good' for them occur more often than you may think.

■ Imagine someone whose goal it is to travel to Milton Keynes. This is analogous to Jane's goal which is to follow the general will.

■ This person believes the train on platform 1 is the train to Milton Keynes, although in fact the train on platform 1 goes to Liverpool. This is analogous to Jane's private opinion: she believes the stadium should be built where it causes least environmental damage whilst the general will is that the stadium should be built where car-parking is plentiful.

■ It would be best to persuade our train passenger to abandon their belief, and get on the right train. Analogously, we should persuade Jane to abandon her belief, and adopt the general will.

In each case, both the passenger and Jane can only get what they really want by abandoning their own point of view. If freedom is getting what you want, then getting something which is not what you want (even if in your private opinion you believe it is what you want) is not an increase in freedom.

EXERCISE

Now work through this example to make sure you have followed the point. (Again this is an analogy designed to show the logic of the argument.) You want some free-range eggs, and the free-range eggs are on shelf 3 (this is the general will).

You believe, falsely, that the free-range eggs are on shelf 2 (this is your private opinion about the general will).

If you buy the eggs on shelf 2:

1 Do you get what you want?

2 If freedom is getting what you want, has the purchase increased or decreased your freedom?

DISCUSSION

1 You have not got what you want. You want free-range eggs, and the ones you have bought are not free range. Analogously, if Jane had

got her own way, she would not have got what she wanted (because she wanted the general will).

2 It would have decreased your freedom. If freedom is getting what you want, and you have not got what you want, your freedom must have decreased. Analogously, if Jane got her own way her freedom must have decreased.

Are we just playing with words here? How can we be sure that *we* know what Jane wants better than she does? To explore these thoughts, read through the next two examples.

The irresponsible citizen

The second situation I shall consider is a person who lives in the civil state, but who does not really take the social contract seriously; let us call him Charles. Charles enjoys the benefits of the civil state, but does not want to pay the costs. Hence, when it comes to paying taxes he is nowhere to be found and his annual holidays always coincide with any period when the state wants him to do any work. Whenever there is a vote he only pretends to be voting according to the general will, but secretly he is voting according to his particular will in the hope that he will bias the vote in that direction. For example, when voting for where to put the national stadium, he may vote for it to be near a hotel complex in which he has a financial interest, regardless of the good of all. What can be done with someone who will not direct themselves to the social good? (Remember Fred, the irresponsible car-driver in Part 1? He can be considered in this light as well as Charles.)

> In fact, each individual can, as a man, have a private will [particular will] contrary to or different from the general will that he has as a citizen. His private interest can speak to him in an entirely different manner than the common interest. His absolute and naturally independent existence can cause him to envisage what he owes the common cause as a gratuitous contribution, the loss of which will be less harmful to others than its payment is burdensome to him ... Thus, in order for the social compact [contract] to avoid being an empty formula, it tacitly entails the commitment – which alone can give force to the others – that whoever refuses to obey the general will will be forced to do so by the entire body. This means merely that he will be forced to be free.
>
> *(Rousseau: Cress (ed.), 1987, bk1, ch.7, p.150)*

The answer Rousseau gives us here is that Charles and Fred can be *forced* to adopt the general will.

How are we to understand this? Here are three things Rousseau has said about the general will. (You might disagree with some of these, or take them to be mere unproven assertions. Remember to note down any doubts you have, and then read on.)

- Obeying the general will is what makes us intelligent and ennobled.

- Everyone really wants to be intelligent and ennobled.

- Getting what we really want is an increase in our freedom.

Constructing an argument from these points, we can arrive at the following:

1 It is all right to force people to do what they really want.

2 Charles and Fred really want to obey the general will.

3 So, it is all right to force Charles and Fred to obey the general will.

4 Obeying the general will is freedom.

5 So, it is all right to force Charles and Fred to be free.

Fulfilling their better nature must be something both Charles and Fred really want, even if they act as if it is not. If they are forced into adopting the general will, they are forced into getting something they really want. Hence, forcing Charles and Fred to adopt the general will is forcing them to be dignified human beings and not stupid, limited animals. We are doing them a favour, making them free. 'In Genoa', Rousseau says, 'the word *libertas* [liberty] can be read on the front of prisons and on the chains of galley-slaves. This application of the motto is fine and just' (Rousseau: Cress (ed.), 1987, bk.4, ch.2, p.206). It is fine and just because punishing people for not obeying the general will is giving them liberty: the liberty that goes along with being forced to be an ennobled person.

Honourable disagreement

I find this talk of forcing people to obey the general will rather worrying. The case of Charles is made easier by the fact that he is disobeying the general will for the worst motives; he does not care for anyone else and is only out for himself. And Fred's actions are quite obviously irresponsible. However, let us consider the third situation, that of Sarah. Like Jane, Sarah thinks the stadium ought to be built where it has least effect on the environment. She has listened to all the arguments for the view that it ought to be at the place where car-parking is most plentiful, but she does not agree. She feels the state ought to develop in harmony with the environment. However, the majority have voted to put the stadium at the place where car-parking is most plentiful. According to Rousseau, the vote is the best way to discover the general will, so the general will is to put the stadium at the place where car-parking is most plentiful. So Sarah is wrong and should change her mind. But Sarah is not at all convinced and does not want to change her mind. This is an altogether more difficult case. Let us examine the options that are available to Rousseau to deal with this:

1 He could hold that Sarah, who sounds a responsible person, could
 have discovered the general will with the unaided exercise of her
 reason. She is right and everybody else is wrong.

2 He could maintain that the case is just like that of Jane. The vote has
 demonstrated that Sarah was wrong in her judgement about the
 general will, and, like Charles, she should be forced to adopt the
 general will. After all, she would only be being 'forced to be free'.

3 He could abandon the idea of a single general will altogether and
 maintain that political decisions of this sort are not a matter of
 definite rights or wrongs. There might be a range of views on any
 question, and something to be said for all of them.

Let's now consider each of the options and discuss whether or not they
can be accommodated in Rousseau's argument.

Option 1

Rousseau cannot say this because he is wedded to the idea that the vote
is a better method of discovering the general will than the thoughts of
any single voter. I said above that we needed to grant Rousseau this;
otherwise the state would have no way of discovering the general will.
Without some procedure for discovering the general will, we would not
know whose view to adopt. There would be a great danger of adopting a
view that was not general, hence making anyone who disagrees with it
subject to a will that was not their own.

Option 2

It is the availability of this option that explains how Rousseau's work
came to be used to justify totalitarianism. If one follows Rousseau in
believing that there is only one course which it is best for us all to take
and that we have a reliable procedure for discovering that course, then
anyone who does not agree with us taking that course is deliberately
choosing an option that is not in our best interests. If this were the case,
such a person would seem no better than Charles. How can it be right
deliberately to choose a course of action which one knows is not best for
the state and the people in it?

It would be difficult these days to accept that it was all right to force
Sarah to adopt a position with which she did not agree. It was all right to
force Charles, because Charles was exploiting his position so as to take
the advantages without paying the costs. It was also all right to force Fred
because he was acting in an irresponsible manner. Sarah, however,
honestly and conscientiously holds a view which is at variance with the
majority. In TV10, university lecturer Anthony Holiday tells an anecdote
about one of his students who thought that forcing someone to adopt the
view of the majority would be the best option to take. Dr Holiday says, 'I
can't help recollecting just a little while ago we had elections on my

campus. One of the brighter of my students was elected to the office of SRC [Student Representative Council] president. I heard the speech he made and I found it absolutely terrifying. He said, 'From now on, the decision of the majority *becomes* your decision.'

'The decision of the majority *becomes* your decision.' Because it is the majority decision and therefore the general will, it is a decision which we all ought to make our own. Anyone who does not can be forced to adopt it. I agree with Anthony Holiday in finding this option 'pretty frightening'.

Option 3

The other two options have proven unsatisfactory. If we abandon the method of finding the general will, we will never know what it is. However, if we stick to the method, we end up persecuting people who do not agree with the general will regardless of how reasonable or sincere they are in their beliefs. The only other option would be to abandon the idea that there is a single correct course of action for society to follow. In other words, we should reject Rousseau's claim that society has a general will. And, once we abandon the claim that society has a general will, we also abandon the claim that there is a procedure for finding out the general will. Obviously, there cannot be a procedure for finding something that does not exist! Hence, if we take option 3, we get option 1 as well.

We only have to look at Rousseau's argument to see the impact that abandoning the idea of a general will would have. Let me repeat the argument for the legitimacy of government:

1 If in obeying the state we will be obeying only ourselves, then there is no problem of legitimacy.

2 If we think according to the general will, then, in obeying the state we will be obeying only ourselves.

3 Each of us ought to think according to the general will.

Conclusion: there is no problem of legitimacy.

Obviously, if there is no general will this argument collapses completely.

Consider the following quotations from people who were interviewed in TV10. They suggest the same problem as we have encountered here. A modern state has a *diversity of views* about how the state ought to be run.

'South Africanism [must] embrace a common nation on the one hand, and *diversity* within that nation as well.'

'One thing that people need to know is that *there can be honourable disagreement*. A lot of the time people tend to think that those who disagree with them must be either wicked or stupid.'

4 ANOTHER SIDE TO EVERY ISSUE

Now listen to AC4, Side 1, Band 2, on which you can hear a discussion I had with Jonathan Wolff and Nicholas Dent. We covered general issues, such as the definition of the general will, the difference between the general will and the will of all, dissent from the general will and what Rousseau would have thought about contemporary politics. We also discussed the contentious issue of the extent to which Rousseau's philosophy justifies the extreme actions taken by Robespierre and others.

I would now like to pick up on a point made during the discussion on AC4, when Jonathan Wolff remarked that 'with Rousseau, there is always another side to every issue'. Indeed, Jonathan Wolff and Nicholas Dent disagree about whether or not Rousseau's philosophy does have totalitarian implications. I want to look at this disagreement, and to set the problem up I have imagined the speeches of two lawyers. The first lawyer, the prosecution, puts forward the case that Rousseau's philosophy does have totalitarian implications, while the second lawyer defends Rousseau's philosophy from this claim.

> *The prosecution*: Rousseau claims that, for any question society faces, there is a single correct answer: the general will. This is what the people would decide if they were reasoning correctly. We can grant that if people reason incorrectly in the sense of having false beliefs, the decision they reach may not be the one they wanted to reach. For example, if a person is working out where best to put a stadium and thinks there is ample car-parking at a park when there is not, they might come to a conclusion which is not the one they want. They think they know where best to put the stadium but they do not. In this case, others are doing them a favour in correcting the false belief and thus changing the person's view to that of the general will. But this is very different from the case where someone genuinely disagrees, when in full possession of the facts, about where the stadium should go. In this case, to force them to adopt the general will is forcing them to act in a way they do not want to and that is, first, obnoxious and totalitarian and, second, not 'freedom' in any sense.

> *The defence*: The prosecution has allowed that if anyone has been reasoning from a false belief, we do them a favour in putting them right. As we agree on this case, we can ignore it. I would like to make two further points, however. First, the second case the prosecution mentions, that is when someone genuinely disagrees with the general will, is merely the first in disguise. Rousseau claims that if the people reason correctly, they will all arrive at a single correct answer. It is as if we had set the people a maths problem; provided they are all thinking

correctly, they should all come up with the same answer. Hence, anyone who disagrees, no matter how 'genuinely', cannot be right. Hence, those who disagree are simply reasoning incorrectly and we are, the prosecution admits in such a case, doing them a favour by putting them right. It may be stretching the word 'freedom' to count getting what you really want as an increase in freedom (as would be the case here, given that the person really wants the right answer), but it is not incomprehensible to say we are benefiting them by forcing them to be free.

The prosecution: This is all very well, as it stands, but the assumption on which the defence has built their case is false. I will grant that Rousseau believes political problems to be like maths problems which have one correct solution. In this, however, he is wrong. Take the stadium again. Some think it should have an out-of-town site because car-parking is ample and it will create little disturbance. A minority who do not have cars do not agree; it will be inconvenient for them if the stadium is out of town. We can assume that nobody is wrong about the facts. Is the defence seriously suggesting that, in forcing people to adopt the policy of building it out of town, the majority are acting in the minority's best interests and 'forcing them to be free'?

It seems, then, as if the case for the defence rests on the claim that the general will is the single correct answer to questions that affect the state. If you do not believe this, the case against Rousseau looks strong. On the audio-cassette, Nicholas Dent said that he would speak in Rousseau's defence. To see what his point is, let us go back to the exercise where we considered which decisions were and were not a matter for the general will (p.106). What colour shirt I wear is, in usual circumstances, a matter for me only and thus can be left to my particular will. Only fundamental matters are to be decided by the general will. Nicholas Dent argues that the general will covers only very fundamental matters such as 'basic citizenly rights and protections'. In other words, the general will covers only the basic framework of the state. What the defence should say, according to Nicholas Dent, is that the position of a stadium is nothing to do with the basic framework of the state, and so has nothing to do with the general will. Rather, it is something on which Rousseau would have been content that there should be disagreement and discussion. Those things which are covered by the general will, such as respecting each other as citizens, would encourage tolerance rather than intolerance.

Jonathan Wolff expresses some sympathy with Nicholas Dent's view. In the main, however, he supports the view I have argued for in these units, that 'the logic of Rousseau's position does push us in the direction of intolerance'. He would, he says, be willing to speak 'at least partially' for the prosecution of Rousseau. What should the jury decide? Does Rousseau's philosophy have totalitarian implications or not? The prosecution has made a good point; Rousseau does assume that there is

a single best answer which everyone should adopt and this assumption is difficult to swallow. But it is easy to sympathize with Nicholas Dent's point as well. The essence of political decisions is that they affect a lot of people, and it seems only fair that, in making them, we all try to take each person's view into account and make other people take each person's views into account as well.

So, in short, the case for and against Rousseau's philosophy having totalitarian implications is as follows:

Case for the prosecution

1 The general will covers a range of political issues.

2 Dissent on these issues is not allowed.

3 Hence, Rousseau is against the expression of people's opinions.

Case for the defence

1 The general will covers such things as our basic rights and duties.

2 Part of these rights and duties is to respect people's opinions.

3 Hence, Rousseau encourages respect for the expression of people's opinions.

Like Jonathan Wolff, I think the general will covers more than the basic framework of the state. Because Rousseau is searching for unanimity, he is opposed to discussion and debate. On fundamental political issues, anybody who disagrees with the general will can be forced to act in accordance with it. This is why I have argued that we abandon the idea as being too restrictive.

Summary

1 In Sections 3 and 4 I have considered whether or not Rousseau's philosophy does contain a justification for totalitarianism.

2 Dissenters from the general will were divided into three sorts:
 (a) those whose view differed from the general will because they were wrong about the facts;
 (b) those whose view differed from the general will because they were acting selfishly;
 (c) those whose view differed from the general will through honest and conscientious disagreement.

3 It seems unacceptable to force the third sort of dissenter to adopt the general will.

4 This lead us to abandon the idea of the general will and embrace diversity instead (although as we heard on the cassette this is not the only possible view).

5 Finally, we looked at 'another side of the issue'. Nicholas Dent argued that the general will did not cover day-to-day politics, but only absolutely fundamental issues. As such, it would be compatible with political disagreement.

Conclusion

As I said at the beginning of the units, I have not been attempting a systematic account of Rousseau's thought. Instead, I have tried to follow a train of thought through *The Social Contract* which aims to show the conditions under which a government could be legitimate. At times you may have felt as if you were on a sort of intellectual coach tour, with the coach shooting through towns at which you would have liked to stop and failing to go down streets that looked interesting. Of course, there is nothing to stop you from going back and following up some of these trails later.

So, where has the coach tour brought us? Our problem was to show that the authority of the state was legitimate. And we concluded that Rousseau's claim – that there is a single general will which ought to be adopted by everyone – was suspect. We then decided that room has to be made for honourable disagreement on political questions. Finding a legitimate way to run a state that allows for this kind of diversity is the task of Part 3.

PART 3 FROM ROUSSEAU TO DEMOCRACY

1 EMBRACING DIVERSITY

If we reject the idea of the general will, we also reject Rousseau's solution to the fundamental problem with which we started. Instead, we need to find another solution that does not suppress disagreement and debate on political issues – one that embraces diversity.

Let us look again at Rousseau's 'fundamental problem':

> Find a form of association which defends and protects with all common forces the person and goods of each associate, and by means of which each one, while uniting with all, nevertheless obeys only himself and remains as free as before ...
>
> *(Rousseau: Cress (ed.), 1987, bk1, ch.6, p.148)*

I am going to divide Rousseau's problem into two parts. First, the issue of the people being sovereign. If you refer back to Part 1 (p.97) you will find a discussion of sovereignty. I said there that 'one of Rousseau's ideas ... was that, to be legitimate, the authority the state has over the people must come from the people themselves'. (This is what Rousseau means by 'remaining as free as before' in the quotation above.) This is the first part of Rousseau's problem: *how can we run the state so that authority comes from the people themselves and is not imposed from outside?*

The second part of the problem is that the state should take account of the interests of each person. Rousseau talks about 'each associate' and 'each one obeys only himself'. In other words, each member of the state must be accounted for with nobody left out. Rousseau solved this by insisting that *each* person should act according to the general will, whether voluntarily or by being forced to. Without the general will we need another solution to this problem: *how can we run the state so that each person's views are taken into account and nobody is left out?*

In many parts of the world democracy is thought to be the best solution to the problem of how to run the state. However, if we are going to show that democracy can embrace diversity, we need first to look more closly at what diversity entails.

Pluralism

Remember the choices I made about the colour of my shirt and the sort of fish I would eat with my chips (p.106). That exercise enabled us to divide the questions an individual has to face into two sorts: those which concern only the individual, and those which concern other people. I am going to call those questions that only concern individuals 'private questions'. Likewise, questions that concern other people I will call 'public questions'. As we saw in the exercise, only public questions raise the problem of legitimacy. For if a group of people are affected by a decision on which they do not all agree, some of them will be subject to a will that is not their own, which immediately raises Rousseau's question of how this can be legitimate.

We concluded our discussion of Rousseau in Part 2 with the claim that there is often no such thing as a single correct answer to public questions. That is, we have to accept that there are a number of different yet reasonable views about the way a state ought to be run. I used the example of different views about where a stadium ought to be sited: some wanted it put where it would do least damage to the environment, whilst others wanted it put where it would be most convenient for its users. I am sure you can think of other examples from contemporary political debates: some favour higher taxes and more money spent on projects which are in the public interest, while others favour lower taxes and less public spending.

Abandoning the concept of a general will leaves us with an area of political debate which is full of competing views. The doctrine that the political system should take different views into account is known as **pluralism**. Most of the political systems in Europe, and many in other parts of the world, are pluralist. I am going to look at the kind of political system that operates in these states, and whether or not Rousseau would have thought it was legitimate. I am then going to look at the consequences for legitimacy in adopting a pluralist system.

What is pluralism?

Pluralism rests on the belief that each person is entitled to their views, and nobody is entitled simply to dismiss those views out of hand. If there is a plurality of views about what the outcome of a public decision should be, nobody has the authority to override these views. So, in public decision-making, a number of views need to be taken into account. The definition I have given in the glossary is as follows:

Pluralism: doctrine that the political system should take different views on a single issue into account.

Which different views ought pluralism to take into account? Let us start by considering taking all views into account, and call this 'broad

pluralism'. That is the doctrine that the political system should take *every* different view on a single issue into account.

Imagine the consequences of adopting this as a policy. In deciding what to do, the pluralist would need to take into account views held by young children, people certified as mentally incompetent and also people with bizarre and extreme opinions. For example, consider a case in which someone began a campaign to enforce a law whereby we all had to clap our hands three times at midday. The person did not have any coherent reason to support their view that we should do this, they just said we should. Is this a view pluralism needs to take into account?

Remember, Rousseau was not a pluralist. His opposition to pluralism rested on the claim that there was a single correct course of action for society to follow: that is, the general will. His view of debate and discussion between competing political views is summed up in the following quotation: 'The more harmony reigns in the assemblies, that is to say, the closer opinions come to unanimity, the more dominant too is the general will. But long debates, dissensions, and tumult betoken the ascendance of private interests and the decline of the state' (Rousseau: Cress (ed.), 1987, bk4, ch.2, p.205).

What we need is some way of separating views we need to take seriously from those we do not need to take seriously. The problem with some views, for example the view that we all ought to clap our hands three times at midday, is that they are not reasonable. If we use being reasonable as a way of ruling out certain views, we arrive at something I am going to call 'narrow pluralism'. That is the doctrine that the political system should take every *reasonable* view on a single issue into account.

But who is to decide what is and what is not reasonable? This is a difficult political problem. Consider the following views, for example, all of which have been in the news around the time at which I am writing. There is no universal agreement as to whether these views are reasonable or unreasonable.

1 Sikh motorcyclists need not wear a helmet because they need to wear a turban.

2 All children, regardless of their religious background, should participate in a Christian assembly at school.

3 Children should only be exposed to one particular set of cultural practices (as practised, for example, by the Amish sect in America).

4 A period of military service should be compulsory for all young adults.

I am sure you can think of your own examples. The fact that it is not obvious whether or not a view is reasonable is a problem for narrow

pluralism. Broad pluralism knows which views to take into account: all of those which people hold. Narrow pluralism has to make a judgement as to whether the view is reasonable or unreasonable and this is not always easy.

Which of the two should a political system work with, broad pluralism or narrow pluralism? You will probably agree that, even though it has its problems, narrow pluralism is much the better option. If we had to take everyone's views into account, no matter how ill-formed and unreasonable, no public questions would ever be decided. What about the problem of deciding which views are reasonable and which views are not? This is a difficult problem which people in public service face all the time. Nobody has a magic formula which will tell us which views are reasonable and which views are not. Instead, society excludes from politics those people whose views are unlikely to have been the product of mature reflection: those under eighteen years of age, the mentally incompetent and so on. This is not an ideal solution: there are unreasonable adults and reasonable children. Some such rule is needed, however, if narrow pluralism is to work.

Pluralism and democracy

Now that we have sorted out what pluralism is (I shall drop the 'narrow' from now on), let us see how it fits with **democracy**. When I talk about 'democracy', I shall be talking about the particular democratic system of government current in most European countries, in America, and in many other parts of the world. There are many important differences between these systems but I shall not be concerned with these differences, as the question I am asking need not take them into account. What I am interested in is whether democracy, taken broadly, can solve Rousseau's problems and also accommodate pluralism. If it can, it looks to be a good system. Once we have decided that, we could then go on to look at the alternative democracies there are and judge between them. For the purpose of these units, however, it is Rousseau's question that matters. Hence, I will discuss only the broad idea of democracy and leave further questions to one side.

The broad idea of democracy is something like this. People who have similar ideas on how a state should be run form themselves into groups (political parties). These parties then each put forward their ideas. Each person in the state then votes according to which ideas they want to see put into practice. The party which gets the most votes wins, and its ideas are put into practice. In short, democracy is like a marketplace for people to sell their ideas to the electorate. Provided your idea is reasonable, you are as entitled to try to 'sell' your ideas as anyone else. If enough people are willing to 'buy', then you (or your party) will win the vote and you will be entitled to put your ideas into practice. This gives us our first conclusion: democracy can accommodate pluralism. So democracy is

pluralistic in that it does not insist on a single view, even if it does not take every view into account.

EXERCISE

To make sure that you have grasped the difference between Rousseau's philosophy and democracy, answer the following questions. If you need to refresh your memory on either point, refer to Part 2 (pp.122–4).

1 What does Rousseau think the will of the state is? How does it differ from the view of the democratic system?

2 What does Rousseau use voting for? How does it differ from the use of the vote in the democratic system?

DISCUSSION

1 The will of the state

Rousseau: the will of the state is the general will. The general will is what is *in fact* in the best interest of the state. If an individual is clear-headed and thinking according to reason, they will adopt the general will. If not, they can be forced to do so by the state.

Democracy: abandons the idea that there is an interest of the state which is independent of people's actual views. The will of the state is the actual view of the majority of the people.

2 The use of voting

Rousseau: voting is the way of finding out what the general will is, in the same way that doing a sum is the way of finding out what the answer to a maths problem is.

Democracy: voting is a way of discovering what the view of the majority is. It is finding out what people want, not finding out what they think the answer to a problem is.

Summary

1 Pluralism is the view that, on public questions, the different views people express should be taken into account.

2 Broad pluralism, which claims that every view that is expressed needs to be taken into account, was rejected.

3 Narrow pluralism, which claims that every *reasonable* view that is expressed needs to be taken into account, was accepted. Which views are reasonable was identified as a difficult political problem.

4 This problem is solved, in part, by restricting participation in politics to those who are likely to have reasonable views.

5 It was concluded that democracy can accommodate pluralism.

2 POWER TO THE PEOPLE

The first of the two sub-problems I have taken from Rousseau was that the state should be run so that the people govern themselves (p.137). Do the people govern themselves in a democracy? First, a brief definition:

Simple democracy: a system in which the people themselves are sovereign. Only they have the right to make laws.

I described the way laws are made in a simple democracy in terms of political parties (p.140). It is worth looking at one reason why democracy needs parties, rather than each person voting on every issue. Rousseau had witnessed a system without parties in small Swiss mountain states (although even here not all the people were consulted – it was generally only adult men). In a state of any size, such as modern-day Britain, the problems would be enormous. There would need to be a referendum on every issue. The problem and the standard solution to it were clearly presented by the English political philosopher Thomas Paine. (Incidentally, Paine was not only an admirer of Rousseau's work, he also played an active part in the French Revolution.)

> Representation was a thing unknown in the ancient democracies. In those the mass of the people met and enacted laws (grammatically speaking) in the first person. Simple democracy was no other than the common hall of the ancients. It signifies the *form* as well as the public principle of the Government. As those democracies increased in population, and the territory extended, the simple democratical form became unwieldy and impracticable; and as the system of representation was not known, the consequence was, they either degenerated convulsively into monarchies or became absorbed into such as then existed. Had the system of representation been then understood, as it now is, there is no reason to believe that those forms of Government now called monarchical or aristocratical would ever have taken place. It was the want of some method to consolidate the parts of society after it became too populous and too expensive for the simple democratical form, and also the lax and solitary condition of shepherds and herdsmen in other parts of the world, that afforded opportunities to those unnatural modes of Government to begin.
>
> (Paine, 1966 edn, p.173)

Paine makes three key points in this passage. First, that simple democracies become impossible once a state gets to a certain size. Second, that finding that democracy has become impossible, what tends to happen is that they 'degenerate convulsively' into monarchies or aristocracies. Obviously, if consulting the people is becoming impossible,

it is easier not to consult them. Third, that a better solution to the problem of simple democracies is to adopt what he calls 'representation'. Many agree with Paine's analysis of the problem and his solution has been widely adopted. Instead of every person turning up at meetings to make laws, many band together to send a representative in their place. The representatives form the government and make the laws. Hence, we have a different form of democracy:

Representative democracy: a system in which the people themselves are sovereign. They express their sovereignty by electing a government, and the government has the right to make laws.

I am going to discuss representative rather than simple democracy, as that is the form which modern democratic systems of government take. Hence, when I say 'democracy', I will mean 'representative democracy'.

Rousseau *hated* the idea of a representative body deciding fundamental issues. One point of adopting the general will was that it freed you from your appetites, and ennobled you by making you 'consult your reason before listening to your inclinations'. He thought representation was merely a way of getting other people to do this consulting for us; we were shirking our duty to become properly fulfilled people. As you can see from the following quotation, he found the most developed system of representation at the time, the English system, particularly irritating:

'Sovereignty cannot be represented for the same reason that it cannot be alienated. It consists essentially in the general will, and the will does not allow of being represented. It is either itself or something else; there is nothing in between. The deputies of the people, therefore, neither are nor can be its representatives; they are merely its agents. They cannot conclude anything definitively. Any law that the populace has not ratified in person is null; it is not a law at all. The English people believes itself to be free. It is greatly mistaken; it is free only during the election of the members of Parliament. Once they are elected, the populace is enslaved; it is nothing. The use the English people makes of that freedom in the brief moments of its liberty certainly warrants their losing it' (Rousseau: Cress (ed.), 1987, bk3, ch.15, p.198).

In a democracy, then, people vote to elect a government and the government makes the laws. Each person does have an input, however small, into the process which makes the laws. Contrast this with the traditional monarchy.

Monarchy: a system in which a single person is sovereign. That is, all power is invested in the hands of one person who has the right to make all the laws.

In a monarchy, the people have no input into the making of laws. Hence, we can conclude that democracy does preserve some sense of Rousseau's demand that in obeying the will of the state we are obeying only ourselves.

Is Britain a monarchy? It has a single person who is the head of state, yet the monarch does not have supreme power. This is because Britain is a constitutional monarchy; the monarch's powers are severely restricted by Parliament and the political system is that of a representative democracy. Rousseau would not have understood why Britain persisted as a monarchy of any sort; he thought royalty was outdated in his day, let alone more than 200 years later!

Summary

1 Because of the size and complexity of the state, it is not possible for the people to vote on every issue.

2 Instead, each person has a vote to elect a government which has a right to make laws.

3 Because each person has a vote, each person has an input into the way laws are made. So, democracy does preserve some sense of Rousseau's demand that in a just state the people govern themselves.

3 MINORITY MATTERS

In this section of these philosophy units, we will see if democracy succeeds in solving the second problem I have taken from Rousseau: *is democracy able to take each person's views into account and leave nobody out?* According to Rousseau, people who have to live according to the will of others are not free. So, if democracy forces some to live according to the will of others, some people in a democracy will not be free. This is the subject of TV11.

As we have seen, Rousseau believed a state ought to be run according to the general will. However, he also believed that once the general will had been decided, government would need to decide on other, day-to-day laws. This is an aspect of his work that we have not investigated. He considered several ways in which such a government might be run, including simple democracy and representative democracy. He identified practical problems with the first, of the sort

Paine discussed, and concluded: 'Were there a people of gods, it would govern itself democratically. So perfect a government is not suited to men' (Rousseau: Cress (ed.), 1987, bk3, ch.4, p.180). Instead, like us, he favoured a representative system but only for day-to-day matters. As this is a separate issue from the fundamentals of Rousseau's account, namely the idea of the general will, I have not discussed it.

In a democracy a vote is taken and the majority elect their representatives. The views of the majority are then reflected in the way the representatives vote on issues. It follows from this that the state will be run according to the will of the majority of people. What about those people who lost the vote? If they continue to live in the state, they will be living in a state that is run according to the will of others. But, according to Rousseau, people who have to live according to the wills of others are not free. It seems that democracy cannot solve Rousseau's second problem. It cannot take full account of the views of each person.

Let us take an example. Imagine a state which has a population of a thousand people. There are two parties; one wants to form a union with a larger state and the other wants to maintain independence. They vote, and those who want to merge with a larger state win. This means that all those who voted to maintain independence have to live with a result they do not want. They are subject to the will of others. This is characteristic of democracy. Although each person has a vote, the result of that vote does not have an equal effect on everybody. Some people like it and some people do not. There is equality of input, but not equality of output. The point is dramatically illustrated if we consider the problem of those people who are always on the losing side in elections: so-called **persistent minorities**.

Take, for example, the British Green Party. They have had some moderate electoral success (particularly in European elections) but at the time of writing have never had a representative in the government where the laws are made. Of course, in a representative democracy there is no reason why they should; they do not command enough popular support. That is just the point: there are individuals whose will is that we should not aim for economic growth (a view supported by the Green Party); they are a persistent minority – their will has never been, and in the foreseeable future seems unlikely to be, part of the output of British democracy.

In the real world of politics things are seldom so black and white. We vote for a political party whom we agree with on some things and disagree with on others. As a result, some of our views will be represented and others will not. In order to keep things simple, I have been writing about people who feel that none of their views are represented in the laws that are made. The fact that there could be

people like this is a problem for democracy. It shows that democracy is not necessarily a way of representing everyone's interests. Once you have grasped this point, you can see it also applies to anyone who has only some of their views represented. You might be lucky enough to have all your views represented by a particular party, and that party win a majority of votes. If not, you will have some views that are not represented. In that case, on those matters, you will be governed according to the will of others. This is a problem whether it is some of your views that are not being represented or all of them. For the sake of simplicity, I will continue to talk as if it is all of a person's views that are not being represented. Let me summarize the difference between Rousseau's system and democracy on this point:

- Rousseau's system ensures that the will of *each* person *always* coincides with the will of the state (either voluntarily or by force).

- Democracy allows each person an input, but in terms of the output the view of each person coincides with that of the state only *some* of the time and, for persistent minorities, *never.*

The problem with persistent minorities, as we have seen, is that they are the group whose views are never represented in the will of the state. You might think that having an input into the decision-making process in the form of a vote is enough of a reason to obey the will of the state, even for a persistent minority. Otherwise you might think that persistent minorities are subject to a will that is not their own and have no reason to obey that will. At least, they do not have the reason that non-persistent minorities have to obey the will of the state: namely, that their will and the will of the state will coincide at some time or other.

Is the power the state has over persistent minorities legitimate? This question is important, because if we say that the situation is not legitimate, then we are saying that individuals who support the Green Party (for example) would be right to try to disobey the will of the state, even though in practice they are forced to obey or face consequences such as imprisonment. It would be right for many individuals, all those individuals in persistent minorities, not to obey the will of the state (that is, not to obey the law). Unless we think having a vote is reason enough, the conclusion is difficult to escape.

In TV11 Susan James says, 'The initial problem lies in the fact that we may have a group of people who feel very strongly about a particular issue or who find it very difficult to get their existence and their needs represented in the political arena at all. They may find that in election after election they remain a minority and in that way they remain unrepresented. If these issues are dear to their hearts then obviously it may become very difficult for them to continue to live with the system as it exists. It may also arise as a question why they should continue to live with it.'

Is there any reason why minorities, particularly persistent minorities, *should* obey the will of the state? Why should they live according to the will of others and not be free? This was the question I put in TV11 to Neil MacCormick, who is both a philosopher and a candidate for a minority party, the Scottish Nationalist Party. He gave me three reasons why minorities should stay within a democracy.

1 Minorities can make their influence felt

> I keep wanting to tell you that ... [minorities have] a considerable influence on government and policies. I do not say I am entirely happy with the way things stand at the moment, of course not. But it wouldn't be true to say that it has been all or nothing, and since not all, only nothing ... In some way you ought to be trying to work out ways of conducting the affairs of a polity [a state] so that no substantial constituent of opinion can feel itself to be wholly excluded.
>
> *(Neil MacCormick, TV11)*

In other words, even though minorities may lose the election they can still make their voices heard. The obvious methods to do this are argument and persuasion. One of the points made in the programme is that it is worth the majority paying some attention to this. If members of a minority do feel themselves to be 'wholly excluded', they might use other methods apart from argument and persuasion: civil disobedience and even violence. As Labour politician Tony Benn says, also in TV11, 'riot is the historic method the disenfranchised [those who are not represented] have always used to draw attention to their grievances'. I shall not discuss whether or not it is right for minorities to use such methods to draw attention to their grievances. The point is that democracy is flexible enough not to have to ignore its minorities. Even though they are not in a position to put their views into action, they can keep trying to persuade the majority and so have an influence. A democracy is likely to be a more peaceful and stable place if the majority listens to minority views.

2 Minorities always have the hope of winning next time

> It is very difficult for an argument in politics ever to be conclusively pronounced finally dead ... [One of the things that keeps minority parties happy with the system] is that neither victory nor defeat in a democratic system is ever final. The necessity of a democratic system is to leave the question open again at the next election.
>
> *(Neil MacCormick, TV11)*

This point can be illustrated by going back to my earlier metaphor of the marketplace. If not enough people 'buy' the ideas of a political party this time, one thing that will stop that party trying to close down the market is the knowledge that they can return and try to win next time. Of course, persistent minorities might start to grow sceptical of ever

winning. If this happens, this justification for staying within democracy will not appeal to them.

3 They should support a system from which they derive benefits

> Here I am working in a university paid for through the UK exchequer, enjoying very substantial civil liberties and taking part in politics. Indeed, taking part in politics against the present constitution of the state, and accepting the protection of the state. It would be very unreasonable for somebody in my position to say that just because I haven't persuaded the majority of people to vote on my side, I should therefore pack it in and stop obeying.
>
> *(Neil MacCormick, TV11)*

The democratic system provides a number of benefits, including civil liberties and security. It would be unjust for someone willingly to accept the benefits while at the same time they were attempting to undermine the democratic system. It may be that some minorities feel that they do not want the benefits. Some protesters live, as much as they can, outside the system. In addition, some might feel they have no option but to accept the benefits. As they did not choose to accept them, they might not feel any obligation to the democratic system. Neil MacCormick's point is that people who are willing to take part in the democratic system would put their own views into action if they were in the majority. They are not in a position to object, therefore, if the opposition do the same. Those people who are willing to play the game cannot complain if they lose.

Philosophy is about giving reasons, not about making assertions. Above we have three reasons for minorities to stay within a democratic system. It does not mean that all minorities should stay within the system all the time. You can see that the first reason only works if the majority parties are willing to listen. The second reason only works if minority parties are allowed to campaign freely on an equal footing with the majority. The third reason only works if minorities actually do enjoy the benefits of democracy and are not discriminated against.

Where does this leave us on the question as to whether democracy can look after the interests of each individual? The short answer is that it cannot. In an election somebody wins and somebody loses. However, if the democracy is strong enough, and flexible enough, it can do enough to look after the interest of minorities to keep them in the system.

> One of the advantages of contemporary democracies, for all their failings, is that they allow in good circumstances the possibility that we can explore and develop ways of better representing the full diverse range of opinions and commitments that exists in our society. This is a very difficult problem both philosophically and of course in practice. While we have the means to

continue to explore that, that seems to me an enormously strong advantage of democratic societies.

(Susan James, TV11)

Conclusion

To conclude, here are brief statements of the two positions we have considered on how a state should be run.

- *Rousseau*: there is a single correct answer to the question of the will of the state: the general will. The best procedure for finding out what this is is to conduct a vote. All individuals would adopt the general will if they were thinking properly, so the state is right to force them to adopt it if they do not. Hence, all individuals are accounted for.

- *Democracy*: having rejected Rousseau's position in order to accommodate a plurality of wills, we considered government by majority will. The will of the state is decided upon by looking at the will of all the individuals. However, as these individuals do not agree, the will of the state is decided by the majority. Thus, there will always be some individuals whose will differs from the will of the state at some time. The will of persistent minorities always differs from the will of the state. However, there are various ways in which minorities can be included and so kept within the system.

Rousseau desired a system of government which governed in the best interests of each and every one of us. The problem was that, to do this, it had to assume there was one single way in which each and every one of us ought to be governed, whether we recognized this or not. Democracy takes into account how we actually think we ought to be governed. The problem with this is that, unless we are in the majority the whole time, there will be times in which we are governed in a way with which we do not agree.

Summary

1 In a democracy, the majority wins and the minority loses. Hence, democracy cannot accommodate Rousseau's demand that each person's view is represented.

2 Persistent minorities, those who lose at every election, never have their views represented.

3 Despite this, the situation is not hopeless for minorities. There are three reasons for them to remain within a democratic system:

 (a) They can keep arguing so as to influence the majority.

 (b) They can campaign to win next time.

 (c) They enjoy the benefits of democracy, so they should try not to undermine it.

The classical ideal

I would like now to relate the philosophical ideas we have been looking at to the broader concerns of Block 3. The title of this block is 'History, Classicism and Revolution'. History was discussed in Units 8 and 9, and I have discussed Rousseau's revolutionary ideas in these units, 10 and 11. What about 'classicism'? Unit 12, which looks at the artists Jacques-Louis David and Caspar David Friedrich, explores the issue of what classicism is. Rousseau, as we have seen, is concerned with the effects politics has on our individual characters. In the exercise that follows, I would like you to consider the kind of person Rousseau thinks a properly run state would produce. What would we have to be like to live in the kind of state Rousseau recommends?

EXERCISE

Read through Part 1, Section 4, 'From the state of nature to the civil state', and Part 2, Section 1, 'The "remarkable change in man"', and write down the characteristics of the kind of person Rousseau thinks a properly run state would produce. For example, a Rousseauean state produces people who *think about the general good*.

DISCUSSION

The kind of person that Rousseau thinks a properly run state will produce have the following characteristics: they are ennobled, intelligent and honourable; they think about the general good; they put their state before themselves; they consult their reason rather than their instincts; they are rather unimaginative and very obedient (in that they always obey the general will).

The point of this exercise is that a particular sort of person emerges. If we thought of the sort of person fostered by democracy, we might come up with something different. For example, a person who thinks a lot about their particular interests, who has no need to put the state before themselves, who wants to go their own way and think for themselves. The collection of traits which go to make up a Rousseauean person are characteristic of the classical ideal. They were supposed to be the kind of traits that were possessed by the inhabitants of ancient Rome. The French revolutionaries saw themselves as pursuing this classical ideal. Their vision of a perfect citizen was similar to that of Rousseau. You will see this reflected in the art of David in the next unit.

4 ROUSSEAU AND US

We seem to have come a long way from Marat inciting the passions of Parisian revolutionaries with his readings from *The Social Contract*. In a way we have; we have looked at Rousseau's idea for government and found it unacceptable. We have not, however, left Rousseau behind altogether. We have kept his idea, an idea which was prominent in the Revolution, that sovereignty resides with the people – 'man is born free'. Both Rousseau and democracy preserve the idea that government is legitimate only if it in some way springs from us; it is not legitimate if it is imposed from outside. Democracy is an attempt to give people a voice in the way they are governed. Rousseau connected legitimacy with 'a remarkable change' in people's attitudes and character. People who are governed well, people who govern themselves, have a better attitude to themselves and to government than those who have no chance of making the state's will their own. We certainly found evidence for this in the nascent democracy of South Africa. This, perhaps, is the most important idea we have in common with Rousseau and the revolutionaries. It is only possible, in Rousseau's words, for our feelings to be ennobled and our soul elevated if the state leaves us free rather than enslaved.

GLOSSARY

Entries below marked with an asterisk have been repeated from the glossary in Unit 4, Block 1.

argument* reasons or evidence leading to a conclusion.

assertion* unsupported statement.

authority person (or institution, such as the state or government) has authority if they are able to command others to do things.

citizen for Rousseau, a member of a state. A citizen has undergone the 'remarkable change' and participates in the general will. A citizen has the privileges, but also the responsibilities, of membership.

constitutional monarchy system in which the powers of the monarch are constrained by other constitutional bodies (for example, by Parliament).

deductive argument an argument that uses logic to get a true conclusion from true premises.

democracy system in which the people themselves are sovereign. They express their sovereignty by electing a government, and the government has the right to make the laws.

general will that which is in the best interests of the group taken as a whole rather than as a collection of individuals.

government that group of people whose task it is to formulate the laws of a state.

legitimate authority is legitimate if it does not force people to obey it, rather it is *right* that they obey it.

monarchy system in which a single person is sovereign. That is, all power is invested in the hands of one person who has the right to make all the laws.

particular will the particular will of an individual is that individual's own desires. (Rousseau assumes that our particular will ismostly concerned with our own advantage.)

persistent minorities individuals or groups of individuals whose views are never adopted by the democratic state.

philosophy 'The analysis of reasons and arguments is the particular province of philosophy ... In fact, inasmuch as philosophy has a distinctive method, it is this: the construction, criticism and analysis of arguments' (Block 1, p.146).

pluralism doctrine that the political system should take different views on a single issue into account.

premise* statement from which a conclusion is derived.

reductio ad absurdum* literally a reduction to absurdity. Strictly speaking it is a technique for showing a position to be false by supposing that the position is true and then demonstrating that this leads to a contradiction.

rights privileges we have as a member of society. For example, the right to life and the right to defend ourselves in court.

thought experiment* imaginary situation designed to bring out a particular point.

totalitarianism as used here, a political view that does not permit the consideration of alternatives.

sovereign source of authority in government. In a monarchy the king or queen is sovereign. In a republic the people are sovereign.

state organization which exists when a number of people are subject to a set of laws which govern their conduct, the laws being enforced by the imposition of penalties.

will goal or desire.

will of all sum total of the particular wills of every person in the group.

REFERENCES

BARRY, B. (1967) 'The public interest', in A. Quinton (ed.) *Political Philosophy*, Oxford University Press, pp.112–26.

COHEN, J.M. (trans.) (1953) *Jean-Jacques Rousseau: Confessions*, Harmondsworth, Penguin.

CRESS, D.A. (ed.) (1987) *Jean-Jacques Rousseau: The Basic Political Writings*, Indianapolis, Hackett.

DOYLE, W. (1990 edn) *The Oxford History of the French Revolution*, Oxford University Press (first published 1989).

FOXLEY, B. (ed.) (1993) *Jean-Jacques Rousseau: Émile*, London, Dent.

PAINE, T. (1966 edn) *The Rights of Man*, London, Dent (first published 1791–2).

SUGGESTIONS FOR FURTHER READING

You may find it helpful and interesting to look at one or more of the following:

DENT, N. (1992) *A Rousseau Dictionary*, Oxford, Blackwell.

HARRISON, R. (1993) *Democracy*, London, Routledge.

WOLFF, J. (1996) *An Introduction to Political Philosophy*, Oxford, OPUS.

HAMPSHER-MONK, I. (1992) *History of Modern Political Thought*, Oxford, Blackwell.

LEVINE, A. (1981) *Liberal Democracy: A Critique of Its Theory*, New York, Columbia University Press.

ACKNOWLEDGEMENTS

Grateful acknowledgement is made to the following source for permission to reproduce material in these units:

Jean-Jacques Rousseau, *The Basic Political Writings*, translated by Donald A. Cress, 1987. Hackett Publishing Company, Inc., Cambridge, MA and Indianapolis, In. All rights reserved.

UNIT 12
ART, HISTORY AND POLITICS: DAVID AND FRIEDRICH

Written for the course team by Linda Walsh

Contents

STUDY COMPONENTS				
Weeks of study	Texts	TV	AC	Set books
1	Resource Book 2 Illustration Book	TV12	AC4, Band 3	–

Aims and objectives

The aim of this unit is to explore two key questions:

1 How is our understanding of works of art shaped by investigation into the political, social and cultural circumstances of their production?

2 What is the broader historical and cultural significance of the style of a work of art?

By the end of this unit, you should be able to:

1 identify the main characteristics of the Neoclassical art of David and the Romantic art of Friedrich;

2 interpret the works of these artists by considering an interplay of formal, historical and cultural factors;

3 make observations on the respective roles of convention and innovation in artistic production.

1 INTRODUCTION

AGSG, ch.6, sect.1, 'Introduction'

In this unit we are going to look at paintings in relation to the historical, social and political circumstances in which they were produced. When studied in this way, paintings are not just seen as self-sufficient objects of attention but acquire new significance as products of a particular era. You will remember that Unit 1 raised questions concerning the role of biographical and historical information when looking at art. If we knew about the life, times and political allegiances of Gustave Courbet, what might this contribute to our interpretation of his *Still Life with Apples and Pomegranate* (Block 1, pp.33–5)? The unit asked similar questions in relation to Rembrandt van Rijn's *Artist in his Studio*: how might knowledge of his patrons, the workings of his studio and conditions in seventeenth-century Holland enhance our response to the painting's form and make us more 'competent and successful spectators' of Rembrandt's paintings (Block 1, p.45)?

Can historical information bring us closer to the experience of those who would have viewed a work at the time at which it was produced? My view is that it can. Armed with knowledge of the ideas, events and values which were current at the time a work of art was produced, we can participate in 'historical looking' which will enrich our understanding of a painting's form. But this method of interpretation should not be used to short-circuit the essential primary act of close visual and formal analysis outlined in Unit 1.

The historical context in which a painting's form evolves will lead us to a related question, the issue of **style**. Why is it that an artist chooses to paint in one style rather than another? By 'style' I mean a particular cluster of formal characteristics, that is, features of a painting's **form**. Form is determined by the artist's choice and arrangement of lines, colours, shapes and paint and by the treatment of pictorial space. Style may be associated with a particular artist (we speak, for instance, of the style of Rembrandt) or with a group of artists (for example, the Impressionists). Examples might include:

- the small, separate dabs of paint, bright colours and informal composition of Pierre-Auguste Renoir's Impressionist style in *Path Climbing through the Long Grass* (Colour Plate 37);

- the shell-like curves, asymmetry, pastel colours and delicate flesh tones of the French eighteenth-century **rococo** style in François Boucher's *Diana Leaving her Bath* (Colour Plate 38);

- the dramatic swirls of paint, loose brushwork and indistinct outlines typical of some of Joseph Turner's works, such as *Snowstorm: Steamboat off a Harbour's Mouth* (Colour Plate 39);

■ the bold lines, simplified contours and variations on blue typical of Pablo Picasso's so-called 'blue period' in *Girl in a Chemise* (Colour Plate 40).

In this unit we'll be looking at the historical context of two particular artistic styles: the **Neoclassical** style of the French artist Jacques-Louis David (1748–1825), official artist to the French Revolution and later Napoleon; and the **Romantic** style of the German artist Caspar David Friedrich (1774–1840). We'll examine the value of style labels and see what broader significance they might have in relating a work of art to its social and political context. These artists have been chosen because, although roughly contemporary, they lived through different social and political conditions. The television programme that relates to this study week is TV12, *A Question of Style: Neoclassicism and Romanticism*, and it will examine further the question of style.

Note: background information on both David and Friedrich appears in the form of chronologies in *Resource Book 2*, C5, C6.

2 WAYS OF LOOKING

FIGURE 12.1 *J.-L. David*, Portrait of the artist, *1794, oil on canvas, 81 x 64 cm. Musée du Louvre. (Photograph: Alinari)*

Our first key question is: 'How are the meanings of works of art shaped by investigation into the political, social and cultural circumstances of their production?' The most useful way of approaching this might be to see what we can discover about a painting without any historical knowledge about it, rather as you did in Unit 1. We can then compare our initial response and interpretation with a later attempt at 'historical looking'.

Looking at form

EXERCISE

Let's begin by looking in detail at a work by David, *The Lictors Returning to Brutus the Bodies of his Sons* (Colour Plate 41). Spend a few minutes looking at the painting and write a brief description of what it contains, saying which elements strike you most immediately or forcefully. The main object of this exercise is to identify what seem to you to be the salient features of the painting.

DISCUSSION

The first thing that struck me about this painting was the unhappy and anxious group of female characters on the right. They seem to have abandoned their seats and their sewing basket in order to turn towards two human shapes being carried inside on litters. Beneath the second litter is a statue and under that a man broods in the shadows as he clutches a piece of paper in his hand. His feet are very tense. The grim expression of this man, and the grief shown by the women, suggest that the shapes on the litters represent dead or wounded bodies. You may also have noticed that the whole of David's scene takes place inside a building of which the columns and floor tiles resemble those of ancient Rome, as do the costumes.

Before we learn about the period, story and setting of this scene, let's look more closely at the way in which it is composed. The four exercises that follow focus on aspects of the painting's composition. Before tackling these exercises you may find it helpful to refer to Unit 1 in which the techniques for organizing or 'composing' formal elements (colour, shape, line) and pictorial space (the imaginary three-dimensional space of the painting) were outlined (Block 1, pp.14–24).

EXERCISE

Look at the painting again and make notes on the way in which David has created an illusion of depth. Can you say how he has used perspective lines to suggest three-dimensional space and a particular viewpoint for the spectator? What is the effect of this viewpoint?

DISCUSSION

Look at Figure 12.2. This shows the perspective lines of the painting – created by the lines along the tiled floor, the bricks in the walls, and the tops of the columns – and how they converge at a point close to the left shoulder of the tallest female figure. The horizontal line on which this point occurs is the horizon line or eye level, that is the level at which it is assumed our eyes will view the scene. This line is positioned more than half-way up the picture, and suggests that we look directly at the tallest female figure. We are not looking significantly up or down at this scene: we are led to see it from a height similar to that of the main figures. Does this have the effect of making us feel we could be present in the room itself, or on its threshold, particularly as the figures are close to us and the picture plane? You will recall from Unit 1 that the picture plane is the horizontal plane we imagine as the 'front' of the imagined three-dimensional space of the painting, like the screen on a television set (Block 1, pp.23–4). Our angle of vision is such that we seem to be standing parallel to, and looking directly at, the main figure groups, particularly the group of women on whom the perspective lines converge.

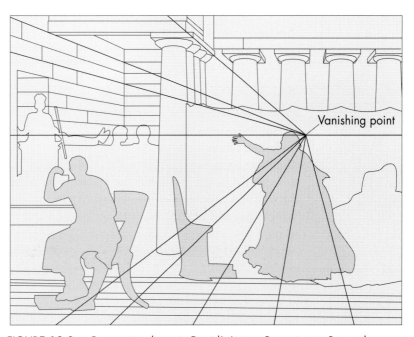

FIGURE 12.2 *Perspective lines in David's* Lictors Returning to Brutus the Bodies of his Sons

There is something else about the suggested recession into depth of this work. It's as if the artist leads our eye along perspective lines and into the depths of the room only to block it half-way on its journey. The column nearest to us, the wall and dark doorway to the left of this column and the curtain screen on the right-hand side cut off the view of what lies beyond, making us focus on the action closer to us. And yet there are hints or glimpses of greater depth in the dark brickwork beyond a second row of columns, too distant from the main light source to be significantly illuminated by it. The colours and features of those members of the procession who are first to enter the room are darker and less precise than those behind them, another indication of their greater distance from the viewer. This gives the effect of a frontstage/backstage division.

EXERCISE

What do you notice about the tonal range (the range in brightness from the whitest white to the darkest black) and distribution of light in the painting? Look at this aspect carefully before going on to read my discussion.

DISCUSSION

The first thing I noticed was a kind of spotlight effect on the female figures. It seems that all the formal elements of this painting – perspective lines, angle of vision, bright light and bright colours – are conspiring to focus our attention on these figures. Bright light also falls on the column and empty chair near the centre of the painting, on the feet of the seated man and on the legs of the body on the second litter. There is a broad tonal range in the painting as a whole, from very bright to very dark, and this creates some dramatic contrasts. Light seems to pour into the scene from different angles: from the doorway on the extreme left to illuminate the procession of figures, the central column, the empty chair and the group of women; from above (perhaps from a clerestory or upper row of windows – these upper regions of space are merely hinted at), again onto the women. Another shaft of light illuminates the lower part of the seated figure on the left. The light falling on the female group and on the sewing basket seems unnaturally intense: another 'theatrical' effect. The face and upper body of the man on the left are in shadow; he is less brightly lit than the empty chair. This is intriguing. If we look at the painting in greater detail, we can see that light and shade are used as a means of suggesting three-dimensional volume (see Block 1, p.16). If you look at the folds of drapes, at shadows on hands, arms and feet, you can see how David exploits this technique of suggesting depth and volume.

EXERCISE

How does David use colour, and to what effect? For this exercise, half-close your eyes and forget the subject-matter of the painting. Try to see it as an arrangement of patches of colour on a two-dimensional surface.

DISCUSSION

I think the main colour interest in this scene lies in the bright reds and oranges, offset by white, of the women, table-cloth and empty chair. They stand out against the browns and greys around them. There are odd patches of bright colour elsewhere: the blue robes of the woman on the extreme right; the flesh tones, sandals and sheet of the body being carried into the room. But there is an abundance of dark, neutral colours. Notice how certain colours are 'echoed' or repeated. The blue of the litter-bearer's sleeve is echoed in the hairband and sash of one of the girls and in the robes of the woman on the right. The colour of the tablecloth is echoed in the cushion of the man on the left. If we regard orange as a variation on red (red mixed with yellow) we *could* see the whole painting in terms of an opposition of reds and blues (some of these blues having a greyish character). There is, then, a carefully composed pattern of colours which enlivens some parts of the canvas and throws them into dramatic relief while helping to bind the whole together.

A further consideration is the 'temperature' of the colours. Both traditionally and scientifically, some colours (for example, reds, browns, creamy yellows, orange) have been established as having a 'warm' effect and others (for example, many blues and greys) as 'cold'. The colours of the female group generate a warm glow, offset by the cooler greys of the screen behind them. Note how they are linked, through their colours (as well as through bright light), with the leg and foot of the body being carried into the room. The temperature of colours has another effect: all other things being equal, warm colours seem to advance towards us and cool ones to recede. Colour can, then, play a role in determining the way in which we notice and relate to the various elements of a composition.

EXERCISE

Look more closely now at the way in which figures are grouped and positioned in the painted scene. What do you notice about the way in which the female figure group relates to other figures and objects in the painting? What do we learn from the poses and expressions of figures?

DISCUSSION

Three of the female figures are huddled together into a tight-knit group, roughly triangular in outline, which is bound together through interlacing curved lines. They make a kind of 'fan-shape' which is echoed in the shapes made by the folds of the drapery behind them and by the triangular piece of cloth held by the woman on the far right. Such an echoing of shapes is common in the painting and can be seen, for example, in the folds of the tablecloth and the row of columns in the background. The group of female figures is close to the woman on the far right, who hides her face, but completely separate from the male figures on the left; the empty chair seems to form a barrier between these two halves of the painting. The seated man on the left is close to, but turns his back on, the procession in the background. His meditative expression seems to remove him even further from the immediate action. His tightly clenched toes show how tense he is. The poses, expressions and gestures of the female group show their intense awareness of some tragic event and, in the case of the tallest woman, conflicting desires to rush towards the procession and to support the younger girls. Her expression is 'answered' by that of the litter-bearer.

It seems, then, that we can gain an awful lot from looking at this painting purely as an arrangement of formal elements. We can appreciate the arrangements of colour, light and shape in their own right, as we might in an abstract painting, or, using our knowledge of human nature, as signs of meaning extending beyond paint and canvas. We can sense tension, drama, unhappiness, dark brooding and grief in this scene, which seems to have been 'pictured' in such a way that it draws attention to some figures, actions and poses more than to others. Let's turn now to some 'historical looking'.

Historical looking

What I mean by 'historical looking' is a way of looking at art in which our responses to and interpretation of an artwork are shaped by knowledge of the historical circumstances in which it was produced and to which it refers. The scope of such a historical inquiry can vary enormously to include some or all of the following:

1 The relationship between an artwork and the artist who produced it, and specifically the events and preoccupations of that artist's career.

2 The relationship of an artwork to developments within the art world, including:

 (a) contemporary events and trends in the art world (the institutions and theories of art and the education and training of artists);

 (b) preceding traditions in art practice;

(c) prevailing styles and genres ('genre' here means category of subject-matter such as history painting or portraits).

3 Broader connections between an artwork and the historical circumstances in which it was produced, including:

(a) contemporary or earlier political events and institutions;

(b) the relationship between an artwork and other kinds of intellectual or artistic expression, including philosophical thought, ideas from literature, history and so on;

(c) contemporary social values, for example those held by a particular class or section of society – their aspirations, beliefs, moral values, relationship to other groups, and social practices (the way different groups live);

(d) the commercial motivation and circumstances of the production of paintings (nature of commission, patronage, state and predominant interests of the contemporary art market).

This list is not exhaustive, nor will we have space here to consider all the items on it or how they might relate to one another, but it does give some idea of what a historical inquiry into a work of art might involve. Units 5 and 8 discussed the importance of selecting and using source material in the context of a historical inquiry. The same principles apply here. That is, we need to consider the nature, relevance and reliability of any sources on which we draw in trying to see an artwork within the context of its own time.

A note on detail

As this section moves on to discuss the political and historical context of David's paintings, you will find that considerable background information has been given. Please don't feel that you have to learn all the detail; it is not necessary. Where artworks are discussed in a historical context it is essential that you have an understanding of what that context is, but it is not important that you should remember all the details. What is important is that you learn how your study of artists and artworks can be supported and enhanced by knowing something of the historical circumstances in which the artists lived and worked.

Is there any meaningful relationship between David's *Brutus* and contemporary political events?

First of all, the content and caption of David's painting tell us that he is drawing on a classical story about Brutus and his sons. The story of Lucius Junius Brutus (not the same Brutus as Caesar's assassin Marcus Brutus, who lived five centuries later) was recorded by the Roman historian Livy (59 BCE–17 CE) and the Greek essayist Plutarch (*c.*46–*c.*126 CE). It would have been familiar to educated contemporaries of

David, who were well acquainted with ancient Greek and Roman thought and literature. As we saw in Unit 8, this kind of knowledge was central to the **Enlightenment**, an intellectual movement dedicated to the emancipation of knowledge from fear and superstition and to the use of independent reasoning and science. These ideals were often harnessed to social criticism, but classical texts would also have been familiar to David's more conservative contemporaries.

EXERCISE

The story of Brutus is told in the extract from Robert Herbert's book *David, Voltaire, Brutus and the French Revolution*, reproduced in *Resource Book 2*, C1. Please read this now. With Herbert's account in mind, can you now identify any of the figures in David's painting?

DISCUSSION

From reading Herbert's account you should have been able to identify the figure on the left of David's painting as Brutus and the bodies on the litters as those of his dead sons. You may also have guessed that the group of female figures on the right represent Brutus' wife and her two daughters.

The other figures are (on the extreme right) a servant (now thought to have been drawn by one of David's pupils) and (in the left background) the lictors. Lictors were officers in the service of consuls or other magistrates who executed the sentences given to offenders. They carried the *fasces* – bundles of rods with a projecting axe blade, a symbol of a magistrate's power and of law and order – and these can be seen in David's painting. We see the lictors carrying the bodies of Brutus' sons, killed by his own order in his capacity as magistrate. Brutus holds in his hand the letter to Tarquin listing his sons' names, proof of their treason. He sits beneath a statue which represents Rome, and below the statue is a sculpted relief of Romulus and Remus – the legendary founders of Rome nurtured by a she-wolf. We can see how the painting relates to a period of Roman history in which, according to tradition, a republican form of government used magistrates and respect for the law to replace the power of autocrats.

How can we see this artwork, then, both as a product of the artistic conventions and of the political climate of eighteenth-century France – where David lived and worked for most of his life? The date of the painting – 1789 – is significant here. If you turn to the Chronology of the Revolution in *Resource Book 2*, A1, you will see that this was a year of political upheaval leading, in August, to discussions on the 'Declaration of the rights of man and the citizen'. It seems tempting, in the circumstances, to forge a link between political events in France in 1789

and the anti-royalist, pro-republican sentiments implicit in David's painting, particularly in view of its timing. David worked on his *Brutus* mainly throughout 1788 and 1789, although he based it partly on sketches made earlier when he had been studying in Rome. He was finishing the painting in August 1789, when delegates of the nobility at Versailles renounced their feudal privileges and the text for the 'Declaration of the rights of man and the citizen' was drawn up.

Following on from the popular success of his *Oath of the Horatii* exhibited in 1785 (this painting is discussed in TV12), David was asked by the Comte d'Angiviller, General Director of Fine Arts, to submit subjects for another royal commission. At this time d'Angiviller exercised considerable control over French cultural affairs, partly by advising on important appointments at the Royal Academy of Painting and Sculpture. The Academy was the source of all dominant views in France on the subjects and styles to be chosen by artists. For artists, membership of the Academy provided extensive teaching of artistic methods but was also the main means of establishing a reputation and securing official commissions. From 1667 onwards, exhibitions known as Salons (named after the *salon carré* or 'square room' of the Louvre in which they were held) took place, and in the second half of the eighteenth century these were biennial. These Salons were exclusive in that only full and probationary members of the Academy could exhibit their work there.

D'Angiviller, who was appointed by the king, Louis XVI, oversaw the Academy's objectives and the promotion of its members to higher ranks. With this kind of control d'Angiviller had a direct influence on the status of different styles and subjects and helped establish a firm framework of artistic values within the Academy. In David he knew he was dealing with an artist who had already received an academic training laying emphasis on 'grand' and important subjects from the Bible, ancient mythology and history, and on close study of the idealized treatment of the human figure represented in ancient sculpture and in drawings, engravings and imitative casts based upon it (see *Academy Figure*, Plate 128). David had won awards and prizes, including the *Prix de Rome* (Rome prize), which had allowed him to study at the French Academy's 'annexe' in Rome. He had already proved himself in his publicly exhibited work.

David's choice of the Brutus subject for the royal commission might seem politically contentious. But did he 'play the system' for political ends? His choice of a specific episode in the Brutus story was significant. Early in 1789, while the government was under the impression that David was considering subjects it had suggested to him, he had quietly decided to paint an episode from the Brutus story which was, arguably, pro-republican in sentiment. Also, David invented a particular episode of the Brutus story not mentioned by Livy or Plutarch: the return of the sons' bodies to the family home. This brings to the fore the conflict between

political duty and family allegiances represented for many generations of Romans and Europeans in the Brutus example.

In these circumstances we might see parallels between the court of Louis XVI and that of Tarquin; between eighteenth-century French aristocrats who had renounced some of their privileges but whose retaliation was greatly feared and Tarquin's plotting with Roman aristocrats while in exile; between Brutus' opposition to tyranny and the establishment of the National Assembly which aimed to curb the powers of tyrants; between Brutus' famed powers as an orator in inspiring people to stand against corruption and well-known orators of the French Revolution, such as Camille Desmoulins, who inspired the mob in speeches made in 1789. We should note, however, that such a parallel between France and the Roman Republic is not exact. The Republic was in fact an oligarchic form of government, in which political power was shared by a small group of people. It was 'republican' in the sense that it was against rule by one man, whether king or tyrant, but it was not exactly the kind of republic to which the French aspired.

In fact, we don't have any evidence that people who saw David's painting exhibited did make such specific historical and political connections. Indeed, David seems in some respects to have played down the potentially provocative or 'revolutionary' nature of the subject. What we do have, however, is an interesting document which seems to express fear about the way in which David's painting *might be* interpreted when exhibited at the Salon, which traditionally opened on 25 August, the king's feast day (*la Saint-Louis*). The document is a letter from Charles-Étienne-Gabriel Cuvillier to Joseph Vien, dated 10 August 1789. Cuvillier, of the Royal Fine Arts Office, was acting on behalf of d'Angiviller, General Director of Fine Arts. D'Angiviller, himself a count and aristocrat, had been ordered into protective exile by Louis XVI and had left France for Spain at the end of July, probably on account of his well-publicized royalist views. Vien was president of the Academy. The letter refers to the forthcoming Salon for which David's *Brutus* was more than two weeks late. (See *The Salon of 1789*, Plate 129, which shows the painting *in situ.*)

EXERCISE

You will find Cuvillier's letter in *Resource Book 2*, C2. Please read it now. When you have read the letter, try to explain Cuvillier's attitude to 'Monsieur David's painting' in the third paragraph. Is he worried?

DISCUSSION

The tone of Cuvillier's letter does seem to be quite anxious. He is plainly relieved that David's painting *Brutus* is behind schedule ('is still far from finished'), no doubt because he hoped it would appear too late to be included in the exhibition at all. This seems to be because he suspects the painting would 'furnish more food to the fermentation', presumably the events of 1789. Cuvillier at least saw the painting as politically contentious, and his fears seem to have been fuelled by d'Angiviller's advice about the 'choice of subjects which will be exhibited' relative to 'the interpretations which might escape from an observer and which might be awakened by others'. (Note that it was not uncommon for eighteenth-century writers and artists to use subjects from the ancient world as indirect criticism of their own society.)

EXERCISE

I would like you now to answer the following questions using the skills of primary source analysis that you learned in Units 8 and 9.

1 How useful is Cuvillier's letter as a source for determining whether and in what way people in late eighteenth-century France made connections between art and politics?

2 How might we distinguish between the letter's witting (conscious, explicit) and unwitting testimony on the relationship between art and politics?

DISCUSSION

1 Cuvillier was obviously well placed to sense official royalist concerns about the potential for art to inflame political passions. He reports d'Angiviller's views in a way which suggests he was in close contact with him ('Monsieur ... thinks') and he's seen 'instructions prepared by Monsieur the General Director'. He is alert to the reactions of theatre audiences where subjects of a similarly controversial nature are concerned. The way in which he speaks of Lavoisier and Tollendal implies some knowledge of French intellectuals and officials and of their character and status. We are obviously reading a letter by someone well informed of the cultural and political issues of his day.

2 Cuvillier's letter is witting testimony to the belief of a leading member of the artistic establishment that art can bring 'pleasure' and can 'serve morale' for a wide public, or bring them a 'useful diversion' from current events, as well as bringing 'glory' to artists. It states quite openly and intentionally an awareness of the power of paintings to alter the mood, both social and political, of the public which views

them. It is perhaps difficult for us to understand this in an age in which visual images have been devalued by their constant transmission on television and film, their superabundance in posters, magazines and so on. But it should not be impossible for us to realize the potential eloquence of an outstanding image which seems to resonate with the important events of its own time, even if the idea of an art exhibition inciting revolution is far from our own experience. Cuvillier's letter openly expresses fear, caution and defensiveness in the face of the possible exposure of the public to such images ('caution', 'on guard', 'not risking anything'). The letter is also witting testimony to Cuvillier's fear of 'the mob' or mass revolt ('the fermentation'). (There were contemporary reports, in a radical journal entitled *L'Observateur*, that on receipt of Cuvillier's letter Vien wrote to David's wife, asking her to dissuade her husband from exhibiting the *Brutus* that year. Those reports were subsequently denied.)

Unwittingly, the letter reveals Cuvillier's subservience to his superiors and to the hierarchical structures of the artistic establishment. I say 'unwittingly' because he doesn't tell us openly and intentionally of his subservience to d'Angiviller, but this subservience emerges insidiously, from 'between the lines', in his constant reiteration of d'Angiviller's concerns and instructions. We also glean some sense of an educated art audience who will pick up on the political implications of the paintings in question irrespective of their intended meanings. Unwittingly, the letter also reveals some sense of a politically conscious group of artists who may decide 'not to contribute' to the Salon (perhaps from fear or on principle as a protest against censorship?). Their fears may be based on the possibility of damage to, or theft of, their works, to which there is an oblique reference in the postscript.

We would perhaps need to identify a larger number of sources of this kind in order to justify a political reading of David's *Brutus*, in view of the fact that neither David nor any of the recorded critics of the Salon of 1789 attributed any political meaning to the painting. We should examine whether there was any hard evidence on which to hang a political interpretation of David's work, or whether our inquiry must remain on the level of the accumulation of circumstantial evidence, that is of indirect rather than conclusive support for an emphasis on political aspects of the *Brutus*. One source of circumstantial evidence is the body of facts relating to David's life and opinions. We must tread carefully here, however, since the facts of an artist's life, views and intentions are not *necessarily* relevant to a particular painting. Even if an artist has helped us along by stating their intentions in relation to a particular work, we must weigh this 'help' against the fact that intentions are often not realized (or not capable of realization). Furthermore, the meanings of works of art are not fixed for all times, people and places, or simply

reducible to the artist's own views. Viewers will interpret a work of art in the light of their own circumstances, experiences and knowledge. But at least we know that David shared a particular social, cultural and political setting with contemporaries like Cuvillier and that this context might have influenced him, either consciously or unconsciously. We are, therefore, justified in looking into the matter of how *likely* it was that he was preoccupied by political concerns, bearing in mind that interpretation of paintings should never be reduced to any simple connection with contemporary events.

Is there any convincing evidence that David cared about politics?

There is little evidence that David had any particular political allegiances before he completed the *Brutus*. There is, however, plenty of evidence of the political views he held *after* the Salon of 1789. After the first public exhibition of the *Brutus* David was treated as a hero. Irrespective of his intentions in the painting (about which we can only speculate), its implicit association with the events of 1789 and David's reputation as a radical critic of the Academy and champion of its dissident students (on which, more later) were increasingly recognized by his contemporaries. David's reputation was quickly applied to political causes. A brief survey of subsequent events will suffice to show the nature and extent of his involvement.

In June 1790 he took part in a commemoration of the Oath in the Tennis Court – which a year before had marked the founding of the National Assembly – and later in the year he was commissioned by Mirabeau and the Jacobins to paint the subject. The proposed subject attracted much publicity and a year later the National Assembly, to which the painting was to be presented, gave its final approval for this massive picture (7 x 10 metres) to be financed by public subscription. David's status as semi-official painter to the Jacobins was confirmed in 1791, when his large preparatory drawing of *The Oath in the Tennis Court* (Plate 126) was exhibited at the Salon alongside *The Oath of the Horatii* (Colour Plate 43), *The Death of Socrates* (Colour Plate 44) and *Brutus. The Oath in the Tennis Court* (discussed in Unit 8, pp.26–7) shows patriots from ordinary walks of life. In the centre we see Bailly, the Mayor of Paris, reading the oath. David had made many sketches and notes on the occasion of the oath itself. He went on to begin work on a painted canvas of the subject, in which he included nude figures based, in the 'best' tradition of academic painting, on study of Greek and Roman statues, but this was never completed (see *The Oath in the Tennis Court*, fragment, Plate 127).

There is plenty of evidence that David's sympathies lay with the 'extreme left' in revolutionary politics. Anita Brookner, a scholar of David's career, states that 'history records him only as a deranged and exalted supporter of the more extreme opinions and characters of the time' (Brookner,

1980, p.97). In responding to her views we should, of course, consider any critical and political bias she might bring to bear. The evidence is drawn mainly from the period 1790–94. From 1790 onwards David's house became a meeting place for dissidents who issued various bulletins both to the Academy and to the Commune of Paris. David served on a number of revolutionary committees. In 1792 he was elected as a deputy to the National Convention, the body set up to replace the National Assembly after the suspension of the monarchy. He sat alongside well-known revolutionary figures such as Marat, Danton, Robespierre and the Montagnards. The Montagnards were an association made up of the Jacobins and the (often radical) Paris contingent; the name 'Montagnards' or 'mountain dwellers' arose because its delegates occupied the highest seats in the Convention's chamber and this 'mountain' enjoyed popular symbolic status in prints, wallpaper designs and so on (see Revolutionary wallpaper, Colour Plate 45).

In a speech delivered to the Convention, David recommended that the throne and busts of Louis XIV and XV, 'monuments of feudalism and idolatry' kept in apartments at the French Royal Academy in Rome, should be destroyed (Brookner, 1980, p.102). In 1793 he became a member of the Committee of General Security and in the same year he was listed as a member of the Committee of Public Instruction. In 1794 he became president of the National Convention and signed many arrest warrants for men and women. In Brookner's view (1980, p.95) his behaviour was often 'delirious' and he made many impassioned speeches of revolutionary fervour. He managed a few financial and monetary matters on behalf of revolutionary bodies, but his activities were related mainly to the organization of revolutionary festivals and pageants.

David seems to have accepted Mirabeau's views on the propaganda value of such festivals. Drawing on the example of the Olympic Games in Greece, Mirabeau was aware of the emotive and persuasive power of large spectacles:

> What effect could not be produced by the crowns of oak, laurel, olive, distributed to virtuous men, patriotic soldiers, useful writers, masters in all arts? Anthems composed by the most celebrated poets, sung by young citizens and virgins, accompanied by that simple but majestic and touching music which stirs great gatherings; speeches appropriate to the circumstances, delivered by orators worthy of the free men who would come to listen to them?
>
> *(quoted in Brookner, 1980, p.103)*

The ten festivals devised by David combined dramatic effects with imagery drawn from both Christian and pagan sources. They were a new kind of religious ceremony held in honour of Nature, Humanity, Conjugal Love, Filial Piety, Truth, Justice, Modesty, the Benefactors of Humanity and the Martyrs of Liberty. David constructed huge mountains from cardboard and plaster, lyres and trophies from silver foil. Features of these festivals included an altar to the fatherland, a Fountain of

Regeneration from which participants drank water, cavalry, trumpets, cannon, guns and rousing music. Common symbols of the Revolution were used:

■ pikes (considered to be the weapons of freemen);

■ branches of oak (sacred to the druids) and olive (a symbol of peace);

■ the masonic level (a symbol of equality);

■ Phrygian caps (the *bonnets rouges* or 'red caps' associated with liberty);

■ *fasces* (considered to represent solidarity or fraternity).

Biblical symbols were also used:

■ the Ark of the Covenant (given a more secular flavour by the Revolution with tablets engraved with the Rights of Man and Acts of the Constitution placed in the 'ark' or chest rather than the scrolls of Jewish law described in the Bible);

■ the release of birds symbolizing the release of the soul;

■ frugal meals similar in spirit to the loaves and fishes;

■ the Eye of Surveillance (the all-seeing eye of God, with overtones of more sinister political surveillance).

We can see equally explicit political intentions in some of David's other revolutionary works, for example his design for a theatre curtain, *The Triumph of the French People* (Plate 132). A figure representing the French people, complete with the revolutionary symbols of Herculean club (the weapon associated with the Greek mythological hero Hercules, who often stood for virtue and courage), level and Phrygian cap, rides in a chariot at the front of which we see antique figures representing Art, Commerce and Abundance. In front of the chariot, citizens strike tyrants with swords. The winged figure of Victory is obviously on their side. Behind the chariot walk ancient and modern heroes including Brutus, William Tell (a fourteenth-century legendary hero who fought for Swiss independence) and Cornelia, Mother of the Gracchi. (The Gracchi were radicals who sided with ordinary Romans rather than their own ruling class at a time of crisis, and Cornelia was a model Roman matron said to have described her children as her 'jewels'.)

EXERCISE

One of David's most startling homages to the Revolution is his painting of one of its heroes, *The Death of Marat* (1793) (Colour Plate 46). The story behind the death of Jean Paul Marat is told in an extract from Anita Brookner's *Jacques-Louis David* reproduced in *Resource Book 2*, C3. Please read this now. ■

David had visited Marat on the day before his death and had seen him in his bath, working at an improvised desk, an up-ended packing case. His painting shows Marat dying rather than dead (the quill has not yet fallen from his hand). We also see Charlotte Corday's letter in Marat's hand. It reads, 'Il suffit que je sois bien malheureuse pour avoir droit a votre bienveillance' ('My misfortune commends me to your kindness'). The other paper is an order for a gift of money to be sent to a soldier's widow. The patch on Marat's sheet shows his frugality in an age when people could be denounced by their servants for the slightest sign of luxury. The background is also austere. Apparently, in reality, Marat's wallpaper was rather grand – it contained illusionistic antique pilasters – and there were pistols and a map on the wall of the room in which the bath was situated. David was an eloquent defender of Marat and had recently spoken in his defence at the Convention. There can be no doubt, then, of David's revolutionary allegiances in the years 1790–94. He delivered a speech to the Convention on 29 March 1793, when he presented his portrait of an earlier revolutionary hero, Lepelletier, to its members (see *Lepelletier de St.-Fargeau*, Plate 133). David imagined, in his speech, how an old father might talk to his children about the painting's notion of dying for one's country:

> Do you see this deep wound? You are crying, my children! You are looking away! But you must also pay attention to this crown of immortality. The fatherland holds it ready for each of its children. Learn to earn it: there will be no lack of opportunity for great souls. If for example an ambitious man spoke to you of a dictator, of a tribune ..., of a regulator ..., or tried to usurp the smallest portion of the people's sovereignty, or if a coward dared to propose a king to you, you must fight or die, like Michel Lepelletier, rather than ever agreeing to such a thing. Then, my children, the crown of immortality will be your reward.
>
> *(quoted in Brookner, 1980, p.110; trans. L. Walsh)*

The relevance of this moral and political example to David's *Brutus* is very clear. Nevertheless, we must be careful about applying *retrospectively* to this painting ideas expressed by David years after he painted it. It could be argued that, after 1789, he was simply swept along by events and by the tide of opportunity, the subjects of his earlier paintings making him an obvious 'adopted son' of the Revolution. There is even greater cause for caution if we consider much later events which cast doubt on any simple interpretation of David and his art as politically radical. David drew Marie Antoinette, aged, disfigured and missing her wig, teeth and corset, as she passed his window on 16 October 1793 on her way to the guillotine (sketch of Marie Antoinette, Plate 134). But the same artist who voted for the death of the king and celebrated the death of the queen became first painter to Napoleon in 1804, five years after Napoleon's *coup d'état* in 1799. In this role he helped to glorify the emperor and his military exploits, which ended with Napoleon's defeat in 1815 at the Battle of Waterloo and with his abdication in the same year. *Bonaparte Crossing the Alps at Mont Saint Bernard* (1800–1) (Colour

Plate 47) offers an image of the emperor leading his army into Italy. Napoleon actually crossed the Alps on a mule, but wanted to be shown 'calm on a fiery steed'. He was too impatient to pose for this portrait and lent to David only the hat and cloak he had used on the expedition.

Even before this defection to a more autocratic style of government, however, David had wavered in his support of the Revolution and its ideals. In 1794, when Robespierre had fallen from favour and been executed, David denied any close allegiance to him and said he had been mistaken to think him virtuous. In the rapidly changing allegiances of the Revolution such denials were commonplace. They should make us pause to consider, however, the possible role of opportunism in David's political activities. And the fact remains that his republican sympathies were only clearly expressed in the years *following* his *Brutus*. Political interpretations were imposed on his earlier works by those who wished to capitalize on, or counter, contemporary events. This does not rule out, of course, the possibility that he wished to engage artistically with some of the political debates of his time, regardless of his own loyalties and attitudes.

Cultural resonances in David's art

We have seen how difficult it is to prove any definite link between the *Brutus* and specific political events and ideals. It is often possible, however, to explore the *general* historical and cultural context of a work of art as a way of exploring part of its meaning. I mean to focus here on the ideas, values and beliefs of a society or a section of a society as revealed in its way of life, institutions, customs, artefacts and writings. It can be very fruitful to explore a painting in terms of the social, cultural or moral *values* which may have nourished it (and, conversely, to use a painting as part of our investigation into the ways of thinking or culture of a particular society). The process involves first putting forward a theory about the nature of the connection between art and its broader cultural context, and then seeing whether there is enough evidence to support this theory in a particular case. Let's take an example.

EXERCISE

Read through the six statements below and then answer this question:

How can the information in the statements be applied to David's *Brutus* in order to support the theory that a work of art is shaped, in part, by the ideas and values of the society in which it is produced?

1 Jean Paul Marat's status as a hero of the Revolution was confirmed by David's painting of his death.

2 Marat used to read Rousseau's *Social Contract* to crowds gathered on street corners (p.93).

3 In *The Social Contract* Rousseau addresses the question of what it is that makes it right that we should obey laws. In exploring this question he had recourse to the concept of the *general will*, defined thus: 'the general will of a group concerns that which is in the best interests of the group taken as a whole rather than as a collection of individuals' (p.104).

4 Rousseau and Voltaire were among a number of thinkers and writers of the Enlightenment, an intellectual movement which came to maturity in the middle and later decades of the eighteenth century. As I've already suggested, Enlightenment thinkers typically believed that humankind could progress and improve through the use of reason (p.166). They sought intellectual and political liberty, were opposed to tyranny, and often exemplified and dignified their ideas by reference to ancient Greece and Rome.

5 The story of Brutus was popular with educated sections of the French public throughout the eighteenth century. Voltaire's play *Brutus* was performed on and off from 1730. On 17 and 19 November 1790 the first two performances of a revival of *Brutus* at the National Theatre in Paris took place. Royalists (pro-monarchy) and radicals (pro-republican) admired different parts of the play but the radical spectators made more noise. Lines belonging to Brutus included: 'Gods! Give us death rather than slavery!' (quoted in Brookner, 1980, p.93; trans. L. Walsh), and

If in the heart of Rome there be a traitor, Who laments the king or who wishes a master, May he die a death full of tortures, Take care, Romans, no mercy to traitors: Were they our friends, our brothers, our children, Look only to their crimes and honour your oaths.

(quoted in Herbert, 1972, p.72)

Such lines were interpreted as a blow for liberty against tyranny. At the second performance of the revival, a stage tableau of David's painting was enacted at the moment when the death of Brutus' son was announced (the focus in Voltaire's play is on one of Brutus' sons: Titus) (see Herbert, 1972, p.78). The play was performed regularly until 1799, the advent of Napoleon's rule.

6 A cult of Brutus developed in the Revolution. Busts of Brutus were often displayed alongside those of Marat, William Tell and Lepelletier, all martyrs and heroes of the people. Many patriots changed their names to Brutus, as did many villages and towns. Brutus badges, buttons and playing cards were popular (see *Playing Cards of the Revolution*, Plate 135). The last major French government commission of a work on the Brutus theme was in 1798, a plaster statue for the Palais Bourbon by Frédéric Lemot.

DISCUSSION

It would be quite simple, on the basis of the information given, to apply to David's painting the theory that a work of art is shaped, in part, by the ideas and values of the society in which it is produced. We could construct a story in which thinkers and writers such as Rousseau and Voltaire expressed the views of their educated contemporaries in such a way that conditions (the 'cultural context') were ripe for the creation of David's painting. David, as artist, simply acted as a vehicle for expressing such views (on political liberty) in visual form. Like his later *Death of Marat*, David's *Brutus* can be seen as a representation of a kind of political heroism or duty in which the best interests of society are put before those of the individual. Furthermore, his painting appeared at the exact point at which a general dissatisfaction with autocratic rule was to turn into mass popular support for alternative models of government. Brutus, as a historical figure, became a kind of sign or symbol of such cultural developments. We can therefore interpret David's painting as a part of these broader networks or patterns of thought and fashion – a rather 'grand' Brutus badge (see statement 6 in the exercise).

EXERCISE

Can you think of any ways in which you'd like to challenge the story I've just constructed? Think back to the pieces of information I gave you in the last exercise. How reliable do you think they are? Is there anything else we need to know before accepting the 'Brutus badge' theory?

DISCUSSION

I think we need a great deal more evidence and research before accepting this interpretation of David's painting. We need to know more about some of the texts I've mentioned (for example, Rousseau's *Social Contract* and Voltaire's *Brutus*) and about other texts by the same writers. It's usually accepted, for instance, that Voltaire wanted to reform, rather than abolish, the monarchy in France. He was in favour of a more enlightened (rational, humane) style of absolute rule. Rousseau was more radical. In other words, my 'neat' story omitted many relevant nuances. (Just to reassure you, however, at no point have I been deliberately misleading in what I've said.)

Another way in which you might challenge my story is by questioning the way in which I've strung facts together. Perhaps you felt I took a wrong turning at some point? Or jumped to conclusions? Perhaps I assumed too easily that David, as artist, was some kind of unthinking, passive mirror of contemporary trends? Didn't his own imagination *transform* cultural influences in a subjective way?

Or you might prefer to construct an alternative story, perhaps based on different theory and evidence. One such theory might be: paintings are the product of an autonomous (independent) set of concerns, those of the practices and institutions of art. You might want to argue, for example, that David's *Brutus* can be explained purely by reference to the world of art, its traditions and institutions.

I will look briefly at how such a story might be constructed in the last part of this section. In the meantime, however, let's note an interim conclusion. Our work so far in this section has shown how it is often possible to locate a work of art in a meaningful way within a general cultural context – ideas and values 'in the air' or 'resonating' throughout the period in question – even when we can prove no firm connection with specific events or derive any specific 'message' from the work in question. However, such connections, which are open to diverse interpretation, must rest on sound assumptions, careful argument and accumulation of evidence, both in establishing cultural trends or patterns and in relating them to particular paintings. In this way, we can back up conjecture with evidence.

Can we separate the concerns of art from those of society at large?

Let's see whether we can isolate David's art in the history of artistic traditions and institutions, and away from the world of politics and literature, as suggested at the end of the discussion above. David's choice of subject was not without precedent in the world of art. For some time subjects such as the story of Brutus had been commonplace in French and European history paintings – paintings dealing with subjects from the Bible, history and ancient mythology. For an example, see Gavin Hamilton's *Oath of Brutus* (1763–4) (Plate 136), which shows Brutus swearing on Lucretia's blood.

The French Academy of Painting and Sculpture had been established in 1648 during the reign of Louis XIV. It had become an agent of royal power, with many of its prominent artists, such as Charles Lebrun (1619–90), principally engaged in glorifying the monarch by depicting his military achievements, decorating his royal residences, painting members of his court and carrying out commissions for religious works for the Catholic Church (which was, at the time, another instrument of the monarch's power). Many of these artists sought to emulate the work of earlier masters such as Nicolas Poussin (1594–1665), a seventeenth-century French history painter who had spent much of his time studying and working in Rome. Poussin in turn had derived much of his inspiration from ancient Greek and Roman statuary, relief-carving and architecture as well as from Renaissance masters such as Raphael and Giulio Romano.

These Renaissance masters were themselves regarded as 'transmitters' of an intellectual and 'grand' tradition of classical antiquity often applied to subjects relevant to Western Christianity (images of the Holy Family, saints and scenes from the Bible). 'Classical' art was assumed, by theoreticians working from antiquity to the eighteenth century, to display certain stylistic characteristics: a clear organization of space; a carefully balanced composition; a sense of harmony and proportion in the drawing of individual elements, such as the human figure; a capacity to reflect but improve upon forms observed in nature or reality.

Poussin's *Testament of Eudamidas* (Plate 137) displays such features. Its figures, based on observation not only of life models but also of classical statuary, reveal a close attention to the proportion of their bodily parts. They are arranged in a balanced pattern (two pairs of linked figures to the right of the body of Eudamidas) within a carefully mapped out space. Their gestures, expressions and poses aim to express general, rather than particular, aspects of human experience: its deep, essential qualities rather than the record of an individual but perhaps less perfect, less expressive moment. Colour and light are arranged in such a way that they harmonize the whole composition. This combination of balance, harmony and proportion is evident even in Poussin's more 'riotous' **bacchanalian** subjects such as *The Triumph of Pan* (Colour Plate 49). These do represent a different 'strain' of classicism, often described as 'Dionysian' (Dionysos was the Greek god of wine, associated with fertility cults and ceremonies involving the release of mass emotion) to distinguish them from the 'Apollonian' (Apollo being the Greek god symbolic of light, manly beauty and reason).

By the eighteenth century a tradition of 'grand' art, based on the morally uplifting and intellectually challenging subjects from the mythology and history of ancient Greece and Rome and on sacred history, had become firmly established in France. Such paintings were described as being in *le grand goût* or *le grand style*. These phrases are difficult to translate but were applied, through equivalent English phrases such as 'the grand manner', to art which showed noble, uplifting and 'great' qualities in both its style and subject-matter.

Such art had to demonstrate the most noble thoughts and feelings of humankind in its most serious, significant and testing experiences. *Testament of Eudamidas* (Plate 137), for example, tells a story taken from the Greek writer Lucian (*c.*120–*c.*180 CE). Eudamidas, a lowly but honourable man, lies dying. He dictates a will in which he entrusts the care of his mother and daughter to two friends, Aretaeus and Charixenus. These two friends did fulfil their obligations, despite the taunts from others who accused Eudamidas of being too ready to spend his friends' money. A seventeenth-century theoretician, Du Fresnoy, had stressed that 'grand' art was as much a matter of style as of subject-matter:

> We say, 'Here is a work in the grand style' when we mean that all within it is grand and noble; that the parts are freely marked out and drawn; that the expressions have nothing base or alien to their character; that the drapery is full and rich and that light and shadow are handled broadly.'
>
> *(Du Fresnoy, 1973 edn, 'Explication des termes'; trans. L. Walsh)*

Raphael's *Alba Madonna* (Colour Plate 50), with its sacred subject (the Virgin Mary with the Christ child and Saint John), noble facial expression, rich, full drapery and 'broad' handling of light and shadow, might be considered an example of such a work. A 'broad' handling of light and shadow involves the artist using broad areas of light to unite principal figures and objects rather than distracting the eye by the use of more dazzling and detailed effects of light.

As far as the art establishment of eighteenth-century France was concerned, the grand style or taste had come under significant attack in the early and middle years of the century. As more people outside the court and monarchy patronized or commissioned art, and as art dealers discovered extensive markets for art among the 'upper-middle' or educated and property-owning classes, it became obvious that customer demand did not always operate in favour of grand history subjects. Paintings for personal pleasure, portraits, subjects from everyday life and erotic mythological fantasies became extremely marketable and, from the 1740s onwards, various theorists (including La Font de Saint Yenne and Denis Diderot) complained about the trivialization and lack of moral seriousness in many of the subjects and styles chosen by artists. The Academy, with its rigid hierarchies, placed history paintings at the top of a scale below which came (in descending order) portraits (the greater the status of the sitter the greater that of the portrait), everyday-life subjects, landscape and still lifes (see 'A note on the genres of art', Block 1, p.25). It was happy to allow membership within any of these categories of specialization, as long as those lower in the order remembered their place. With some dismay, the Academy witnessed the 'decadent' trend towards more trivial subjects and styles which had spread to the court and to some of its own artists.

François Boucher (1703–70) was regarded as one of the main sources of artistic corruption. One of his most important patrons was Mme de Pompadour, mistress to Louis XV. He taught at the Academy, where his erotic mythological subjects such as *Diana Leaving her Bath* (Colour Plate 38) had classified him as a 'history' painter in the loosest sense of the term: this subject-matter was 'classical' (although the word 'antique' was more common in the eighteenth century) but without a correspondingly elevated treatment. *Diana Leaving her Bath* is painted in what came to be known as the **rococo** style – a term of abuse coined by one of David's pupils, Maurice Quai, at the end of the eighteenth century. The term was derived from the French word *rocaille*, meaning rock and shell work for the encrustation of grottoes and fountains. The label 'rococo' is often associated with the art and design of Louis XV's

reign. As far as painting was concerned, it was applied to works which were largely decorative and elegant rather than intellectual, which made extensive use of pastel colours such as rose-pink and sky-blue and of asymmetrical S curves such as those found on certain sea shells. Its natural context was felt to be the apartments of royal and aristocratic patrons who would use paintings in a setting of white and gold panelling, elegantly and delicately curved furniture, mirrors and candlelight (see Rococo interior, Colour Plate 51).

Louis XVI came to the throne in 1774. D'Angiviller, as we have seen, built on the earlier efforts of those who had tried to steer the interests of artists and public alike towards the more morally elevated subjects of history painting (p.167). On the occasion of his first major series of commissions in 1777 he requested for that year's Salon eight large-scale paintings, each of which would have to take a subject drawn from a list of imposing moral categories:

> From ancient history:
>
> (1) Act of Religious Piety among the Greeks
> (2) Act of Religious Piety among the Romans
> (3) Act of Unselfishness among the Greeks
> (4) Act of Unselfishness among the Romans
> (5) Act of Incentive to work among the Romans
> (6) Act of Heroic Resolve among the Romans
>
> From French national history:
>
> (7) Act of Respect for Virtue
> (8) Act of Respect for Morality
>
> *(quoted in Crow, 1985, p.189)*

If we look at this list of categories we can see that David's *Brutus* would have sat quite happily among them. We can also see how eighteenth-century 'classicizing' reflected the moral and religious concerns of the eighteenth century rather than those of the ancient world. This underlines the importance of placing a work of art in its complete context, including the way in which it relates to developments within the art world. However, we can also see how, in eighteenth-century France, it was almost impossible to separate the concerns of artists from the power and institutions of monarchy.

Other factors which shaped the *Brutus* appear to be more contained within the world of art. As established by Robert Herbert, the painting draws extensively on earlier art, particularly classical or antique models (Herbert, 1972, ch.2). Brutus' head was based on the Capitoline Brutus (Plate 138) – mistakenly thought, at the time, to represent Lucius Junius Brutus – of which David owned a copy and had earlier sketched an outline (tracing after Capitoline Brutus, Plate 139). David's studies at the Academies in Paris and Rome had brought him into close contact with such models, either in the form of plaster casts (often used as the basis of

drawing exercises by students at the Academy in Paris) or original sculptures.

Students of history painting at the Academy studied Greek and Roman sculpture as a means of improving their sense of proportion and as a means of learning how to improve on nature by emulating particular poses, expressions and subjects. This approach was supplemented by study of ancient history and literature, which was felt to add intellectual dignity to their endeavours. One statue David saw in Rome was the *Seated Philosopher* at the Palazzo Spada (Plate 140), and it is thought that Brutus' pose was based in part on this. David may have got the idea for Brutus' right arm from a sketch he traced from a book, a seated Jupiter (Plate 141). A raised forearm held at some distance from the head was a gesture often used in Roman statuary by figures trying to command attention while they spoke. In David's painting Brutus looks as if he has been roused from meditation, his hand just beginning to separate from his head. There are hints in some of David's letters that he may have taken this idea from Michelangelo's *Isaiah* (Plate 142). It has also been pointed out that the fourteenth-century Italian artist, Giotto di Bondone, provided a precedent for separated figure groups and carefully delineated figures as you can see in his *Vision of Joachim* (Plate 143), and that Poussin may have inspired David's approach to austere composition and eloquent gesture (see Plate 137).

The idea in the *Brutus* of the mother with two children clinging to her may have come from classical reliefs showing the Niobids, or children of Niobe, who were killed in spite by Leto, mother of Apollo and Artemis, because Niobe had boasted of the children's beauty (see Niobid Sarcophagus, Plate 144). We also know that David asked a pupil, Jean-Baptiste Wicar, to sketch details of a hairstyle suitable for the daughter of Brutus he outlined in the sketch shown in Plate 145 (*The Fainting Daughter*). He asked Wicar, in Florence at the time, to find an appropriate style in a sculpture or relief of Roman bacchantes, women who attended bacchanalian feasts and who were often shown in a state of ecstasy or frenzy. The undulating poses and thrown back heads of bacchantes were often used to express extreme grief as well as joy. The statue representing Rome on the left of the painting, and the sculpted relief of Romulus and Remus, also have identifiable precedents.

We could interpret the *Brutus*, at least in part, as the result of a dialogue taking place in the internal affairs of art and artists. David certainly felt very strongly about the contemporary state of the Academy in Paris. Along with other artists, many of them his pupils, he fought to establish a new, more democratic constitution for the Academy.

This was based partly on personal disappointments. The Academy had failed to appoint him as Director of the French Academy in Rome. It had also refused to stage an exhibition of the works of Jean-Germain Drouais, one of David's pupils who had died before achieving any formal

academic status. David rebelled against the Academy's rigid way of attributing status to art and artists, its strict controls over membership, the allocation of lodgings at the Louvre and its official hierarchies of rank. At its meetings, for example, members sat in a strict hierarchy of seats, ranging from low stools to armchairs. He himself had always shown an aloof attitude to its requirements, submitting paintings late for exhibitions (as happened with the *Brutus*), changing his choice of subject and size from those stated in the original commission so that his paintings would make a greater impact.

From 1790 onwards David's home became a meeting place for dissidents who issued regular bulletins to the Academy and the Commune of Paris. Throughout the Revolution he set up alternative societies for artists which helped to erode the powers and privileges of the Academy. In 1792 he resigned from the Academy and in 1793 the Academy was suppressed, along with other institutions of learning seen as instruments of royal power.

It has been argued that the stark figures and composition of paintings like *The Oath of the Horatii* and the *Brutus* were part of David's protest against more traditional styles of history painting promoted by the Academy. He certainly added a new intensity and moral austerity to the Neoclassical works of his teacher, Joseph-Marie Vien (see *La Marchande d'Amours*, Plate 146).

If we look at some of the preparatory sketches for the *Brutus* (Plates 147–50), we can see how David experimented with the composition eventually cutting down the number of figures and producing a more clearly ordered and defined space in the final arrangement of the columns. Note also how Brutus' pose changes from one of dejection (*The Dejected Brutus*, Plate 151) to one of interrupted meditation (*Brutus Seated, Head Erect,* Plate 152), and how the mother has assumed a more protective pose in the oil study (Plate 150). The basket (not present in these studies) was obviously a fairly late idea too, and the central chair assumes a progressively more important position.

Contemporary critics found the background of the finished work 'very dark' and the figures 'a bit too much cut out against the background' (see McWilliam *et al.*, 1991, p.104). Others felt that the painting was divided into two halves, one light and the other dark, which meant that the spectator had to work harder at seeing it as a whole – although the effort was felt to be worthwhile. Yet others were startled but impressed by the idea of placing the central character or 'hero' in the dark.

It is clear from such commentaries that critics were accustomed to more obviously harmonized compositions: with light and shadow unifying, rather than separating, different parts of the composition; with figures mutually interlinking rather than being clearly separated; and with the most 'important' figures or heroes (in this case, Brutus) being brightly lit. But can we isolate these stylistic debates within the art world?

In TV12, art historian Tom Crow argues that this radical approach to the formal aspects of art was part of David's attempt to purify and regenerate art at all levels. His style was called the 'true' style in order to distinguish it from more elaborate, elegant and decorative treatments of history subjects. The clearly defined contours (outlines) of David's figures, their references to antique statuary with its respect for mathematical proportion and nobility of facial expression, the reasoned use of perspective and classical architectural elements, the expressive use of bodily pose and gesture, and the austere settings of his paintings formed a cluster of stylistic characteristics later labelled 'Neoclassical' by nineteenth-century critics. At the end of the eighteenth century, the 'true' or 'antique' style stood for a kind of moral and political virtue. Crow attributes a political intention to David's *Oath of the Horatii* while arguing that David's idea of 'patriotism' was not feverishly nationalistic.

I would argue that David's particular kind of **Neoclassicism** cannot easily be detached from its general cultural, political and social context. Even when we look at it purely in terms of its evolution within the traditions and institutions of art, we have to acknowledge how closely artistic concerns were bound up with broader social issues. Tom Crow has argued, in his book *Painters and Public Life in Eighteenth-Century Paris,* that a new art public emerged in the eighteenth century, nourished by the ideas of the Enlightenment and by a greater exposure to works of art through the public exhibitions, the Salons (Crow, 1985). This public was alert to the broader social and political significance of David's radical approach to style and to its implicit questioning of the interdependent power of the Academy and the monarchy it served. The fact that the 'Declaration of the rights of man and the citizen' was read out at the opening of the Salon of 1789 testifies to the political sensitivities of this new art public.

If we return, then, to the two key questions set out in the aims of this unit (p.156), we can see that an investigation into the historical circumstances in which a work of art was made *can* make us attend to a broad range of meanings revealed by its historical context and its relationship to stylistic conventions. We can already see how the issue of style leads us to broader cultural concerns. A brief study of the work of another artist, Friedrich, will show how a different national, cultural and political context can produce and inform our viewing of a form of art very unlike David's. TV12 compares and contrasts more systematically the stylistic aspects of the work of these two artists.

3 THE SIGNIFICANCE OF STYLE

Style, religion and politics

FIGURE 12.3 *Caspar David Friedrich, Selfportrait, c.1810, black chalk on paper, 23 x 18.2 cm. Kupferstichkabinett Staatliche Museen zu Berlin-Preussischer Kulturbesitz. (Photograph: Jörg P. Anders)*

Caspar David Friedrich was, like David, active as an artist in the late eighteenth and early nineteenth centuries. He was born in Greifswald, Pomerania, a Protestant state in north-eastern Germany, part of which was at the time under Swedish rule. In this period, what we now know as Germany consisted of a number of independent states united by a

language rather than an administration (see Figure 12.4). I'll ask you shortly to look closely at one of Friedrich's works, *Cross in the Mountains*. Before you do this, however, I'd like to introduce you to some of the ideas and thinkers (the 'cultural climate') known to Friedrich in the earlier part of his career as an artist. One of these was Ludwig Theobul Kosegarten, a local Pomeranian pastor and poet, and one of the earliest collectors of Friedrich's works. Kosegarten was a pietist: that is, he sought to revive piety in the Protestant church to which he belonged. He also held pantheistic beliefs. **Pantheism** is the belief that God's spirit is present everywhere in creation – in every rock, tree and living creature. Kosegarten also fuelled Friedrich's interest in Pomerania's legendary past, particularly in the tombs of Teutonic heroes. (The Teutons were members of a northern European tribe who had been enemies of the ancient Romans.) These tombs, or 'dolmens', made of large flat stones placed on uprights, were situated on the offshore island of Rügen (see Figure 12.4), where there were many oak trees and rugged, windswept cliffs.

While living and working in Dresden (where he moved in 1798), Friedrich became very well acquainted with a group of artists, writers and intellectuals (one of whom was the critic Friedrich Schlegel) who were known at the time as 'Romantics' (a term to which we'll return). At this time the Romantics were keen to revive various Catholic beliefs and practices of Germany's Middle Ages. Although Friedrich was Protestant, he was attracted to the way in which his Romantic contemporaries were accustomed to reading and representing the elements of landscapes. In particular, he became acquainted with the nature philosophy of Friedrich Wilhelm Joseph von Schelling (1775–1854). In his work, *On the Relationship of the Creative Arts to Nature* (1807), Schelling expressed the view that it is the job of artists to use their mind and spirit to penetrate the creative force or divine spirit hidden in natural forms. This is much more important than merely copying the outer form, shape or appearance of things:

> Nature meets us everywhere, at first with reserve, and in a form more or less severe ... How can we spiritually melt this apparently rigid form, so that the pure energy of things may flow together with the force of our spirit and both become one united mold? We must transcend form, in order to gain it again as intelligible, living and truly felt.

> *(quoted in Eitner, 1970, p.45)*

Artists, then, must 'commune' with nature: their spirit must fuse with the creative force trapped within nature's visible forms. This spiritual process penetrates the world of mere appearances. To orthodox believers, that is those who respected the doctrines and ceremonies of the established Church, this kind of spiritual process must have appeared both presumptuous and disturbing, not least because it could take place independently of church buildings, priests and ministers. Landscape paintings could become 'churches' or sites of worship in their own right,

FIGURE 12.4 Central Europe and Northern Italy, 1803, (Abbreviations: C. cape, county; D. duchy; EL. electorate; K. kingdom; LDG. landgraviate; MAR. margraviate, marquisate; PR. principality; REP. republic)

and the emotions of the individual artist or viewer experiencing the creative and spiritual force of nature could become more important than any rules or doctrines. Pantheism itself was not new. The third-century Greek philosopher Plotinus had expressed pantheistic beliefs. But Christianity had established itself so widely in Europe that Christians had become accustomed to very specific uses of art in their religion. Schelling and the Romantics seemed to be seeking a new relationship between art and religion. This is precisely why one of Friedrich's masterpieces, *Cross in the Mountains*, painted in 1808, was so controversial.

CASSETTE 4, SIDE 2, BAND 3

I'd like you now to listen to AC4, Side 2, Band 3, 'Friedrich's *The Tetschen Altar* or *Cross in the Mountains*'. On the audio-cassette you will hear a discussion of *Cross in the Mountains* and its controversial reception by Freiherr von Ramdohr, a conservative Dresden critic who favoured a classical style of art. The discussion asks you to look in detail at the painting and to compare it with other works.

You will need to have by you Colour Plates 41, 53, 54, 55 and 56 (David, *Brutus*; Friedrich, *Cross in the Mountains*; Mathis Grünewald, *Angels' Concert* and *The Nativity*; Claude Lorraine, *Landscape with Hagar and the Angel*; Jean-Baptiste Regnault, *Descent from the Cross*). You will also need Friedrich's statement on *The Tetschen Altar* in *Resource Book 2*, C4. From time to time you'll be asked to switch off the audio-cassette in order to find these sources, or to do some exercises based on close looking at paintings. It is important that you do not skip the audio-cassette at this point. Both the audio-cassette and TV12 are an integral part of our investigation into Friedrich. ■

Romanticism

What was **Romanticism**? It's usually described as a movement (that is, a set of aims, attitudes, practices and interests shared by a significant number of people) in art, literature, philosophy and music, which took place in the last two decades of the eighteenth century and the first half of the nineteenth century. It's also common, however, to stress that 'seeds' or signs of Romanticism, known as pre-Romanticism or proto-Romanticism ('proto' meaning original or primitive), were present earlier in the eighteenth century, and that the 'Romantic spirit' persisted well into the arts of the twentieth century. Although there were considerable variations of attitude and practice within the Romantic movement, many scholars feel there is enough common ground for it to be accepted *as* a movement. There have been countless debates and disagreements both about the possibility of compiling a list of typical Romantic characteristics and about the possible elements to be included in such a list. Does the

label 'Romantic', in itself, mean anything recognizable at all? Or does it imply different things for different artists/countries/periods? Let's begin with the views of one scholar, Joseph Leo Koerner, who has tried to define the Romantic movement in Germany in the early nineteenth century:

> What does it mean to say that Caspar David Friedrich is a quintessentially Romantic painter? Certainly his paintings embody a range of tastes, beliefs and attitudes commonly associated with the historical movement termed German Romanticism: a heightened sensitivity to the natural world, combined with a belief in nature's correspondence to the mind;[1] a passion for the equivocal, the indeterminate, the obscure and the faraway (objects shrouded in fog, a distant fire in the darkness, mountains merging with clouds, etc); a celebration of subjectivity[2] bordering on solipsism,[3] often coupled with a morbid desire that self be lost in nature's various infinities; an infatuation with death; valorization[4] of night over day, emblematizing[5] a reaction against Enlightenment and rationalism;[6] a nebulous but all-pervading mysticism; and a melancholy, sentimental longing or nostalgia which can border on kitsch.[7]
>
> [1] the belief that natural objects – trees, mountains and so on – share or express our own ideas and feelings.
> [2] the feelings and ideas of an individual mind, rather than scientifically proven or *objective* facts or views uninfluenced by personal feelings.
> [3] the view that the self is all that exists or can be known – that is, we can't genuinely *know* anything about things outside ourselves.
> [4] attaching greater value to.
> [5] signalling, symbolizing.
> [6] a reaction expressed through, for example, an emphasis on feeling and imagination.
> [7] the pretentious and the sentimental, of little value.
>
> *(Koerner, 1990, p.23; footnotes added)*

The problem with a movement which places so much emphasis on the feelings of the individual and on the equivocal (that is, on things of doubtful meaning or uncertain nature) is that it is bound to create art of infinite variety and appearance. There is not, for example, any such thing as a Romantic style, 'if by that is meant a common language of visual forms and means of expression, comparable with the Baroque or Rococo' (Honour, 1979, p.15). If we consider the range of art produced by artists considered to be Romantic, such as John Constable, Joseph Turner, William Blake, Eugène Delacroix and Friedrich, we can see that Romanticism could assume a number of formal guises. Even within Friedrich's work, the ideas and beliefs of Romanticism were expressed by a variety of stylistic means. While many of his objects are 'shrouded in fog' (see *Abbey in the Oak Forest,* Colour Plate 58), others are shown in stark clarity. Consider, for example, his *Arctic Shipwreck* (1824) (Colour Plate 59). Here we see the remains of a ship being crushed beneath the ice, a subject possibly inspired by accounts of William Parry's polar expedition of 1819–20 in search of the Northwest Passage. And yet it is

still possible to argue that many of Friedrich's works share Romantic qualities and that these qualities or attributes were more likely to express themselves in some stylistic characteristics than in others. For example, his works use light, colour and composition in a way which points to a more self-conscious and ambiguous (or equivocal) relationship between the viewer and a painted landscape. We've seen how uncertain is our viewpoint in *Cross in the Mountains*. Let's look briefly at some other works.

EXERCISE

Study closely Colour Plates 57 and 60, *Monk by the Sea* and *Wanderer above the Sea of Fog*. The first shows a monk, head in hands, looking out to sea. It was painted as one of a pair, its partner being *Abbey in the Oak Forest* (Colour Plate 58). The second painting shows a figure contemplating a mountain scene from a pinnacle of rock. Consider some of the qualities that Koerner defines as Romantic:

1 the equivocal, indeterminate, obscure and faraway;

2 the desire that the self be lost in nature's various infinities;

3 melancholy and sentimental longing;

4 a heightened sensitivity to the natural world;

5 infatuation with death.

Do the contents of Friedrich's paintings, and the ways in which they are composed, convey any of these qualities? (You will find it helpful when considering point 5 to look at *Monk by the Sea* in relation to its partner painting, *Abbey in the Oak Forest*.)

Note that in my discussion I will move beyond the stylistic qualities of Friedrich's paintings to consider their broader historical and cultural context and significance. In this way we will be addressing the two key issues set out in the aims of this unit (p.156).

DISCUSSION

1 We might say that both paintings deal with the equivocal, indeterminate, obscure and faraway. In *Monk by the Sea* a heavy mist hangs on the horizon. The monk is unidentified and we don't know what he is doing at the seashore, although there is little to suggest that he is enjoying himself. The haze of the fog and the uncertain identity of the central figure are certainly 'equivocal', 'indeterminate' and 'obscure'. *Wanderer above the Sea of Fog* also creates obscurity: the fog literally obscures the view at many points. The character and motive of the central figure are 'indeterminate' in that the painting gives us no clues to his identity or preoccupations: he has his back to

us. Both paintings invite us to look at faraway views. (How does this compare with David's *Brutus*? My own view is that the actions, characters and views in David's painting are less obscure, his spaces more confined and clearly defined.)

2 'Infinity' or boundlessness is suggested in both paintings: the sea and the mountains seem to stretch a long way. We're encouraged to dwell on this 'infinity' by the way in which the paintings are composed. In each case our eye is drawn to a figure whose gaze leads us outwards to a distant view. The figures themselves cannot remain the focus of our attention as they are given no personality or action other than that of gazing: their own thoughts are lost in the vastness of the scene before them. Note how lines converge on these figures – the diagonal lines of the rocks and slopes in *Wanderer above the Sea of Fog*, for example, and the 'lines' edging the shore and patch of bright sky in *Monk by the Sea*, in each case similar to two lines of a triangle. But these lines don't suggest depth like the perspective lines in David's *Brutus*. They lead our eye to a figure who then directs our gaze outwards. There is no obvious connection between foreground, middle ground and background in *Wanderer above the Sea of Fog*, no bridge, winding river or road to lead our view into the distance by more traditional means. The scale and greater detail of trees and grass nearer to us does give some sense of distance, however. These things become smaller, blurred and indistinct as they recede into 'infinity'. Compare the relative clarity and precision of David's *Brutus*, which doesn't recede into such deep space. Like Lorraine (see *Landscape with Hagar and the Angel*, Colour Plate 55), Friedrich uses the classical device of side stage 'wings' or 'coulisses' to suggest different planes or layers of space. But the fog in between them doesn't help us to see how these areas of space relate to one another; we are more easily 'lost' in the picture space he has created.

3 The monk's pose, head in hands, would have been recognized by Friedrich's contemporaries as an expression of melancholy. This impression is reinforced by the dark brooding colours of sea and sky. Does the monk's position at the seashore suggest a yearning for a life transcending a bounded earthly existence? To a Romantic mind, such as that of contemporary reviewer Heinrich von Kleist, this would be a distinct possibility. Of *Monk by the Sea* he said, 'Nothing can be sadder and more uncomfortable than this position in the world. The single spark of life in the broad realm of death, the lonely centre of a lonely circle' (quoted in Vaughan, 1994, p.187). There are fewer clues to the mood of *Wanderer above the Sea of Fog* but the sheer scale of the mountains might be said to express awe. Friedrich's contemporaries would have been familiar with the ideas of the Irish philosopher Edmund Burke, expressed in his *Philosophical Inquiry into the Origin of our Ideas of the Sublime and Beautiful* (1756), on sublimity in nature. Burke associated the sublime with a kind of

terror or awe aroused by ideas of darkness, uncertainty, confusion, obscurity, vastness and infinity: the dizzying heights of mountain views were a perfect prompt for such feelings.

4 A heightened sensitivity to the natural world is, I think, implicit in what I've already said. This sensitivity is particularly 'heightened' in *Monk by the Sea* by the fact that the painting is stripped bare of any distracting detail. The unbroken line of the horizon reinforces a sense of nature's boundlessness or infinity, and the lack of objects in the foreground adds to the painting's power. Kleist said, 'since in its uniformity and boundlessness it has no other foreground than the frame, when one looks at it, it is as if one's eyelids had been cut away' (quoted in Vaughan, 1980, p.93). Such compositional devices place the viewer in a more self-conscious relationship with the scene to be viewed, allowing us to enter imaginatively into it without encountering any foreground barriers. In many of Freidrich's paintings we seem to be invited literally to step into the shoes of a foreground figure so that we can survey the scene beyond.

5 There's no *obvious* infatuation with death in these paintings, unless we consider that *Monk by the Sea* formed a pair with *Abbey in the Oak Forest*. (This painting is discussed in TV12.) Its depiction of a funeral could offer an implicit comment on the monk's despair in the partner painting. Friedrich once wrote, in verse form, the following lines:

Why, the question is often put to me, do you choose so often as a subject for your paintings death, transience and the grave? To live one day eternally, one must give oneself over to death many times.

(quoted in Vaughan, 1980, p.76)

Christian ideas of death and redemption (humankind's salvation from sin and damnation) were very important to him.

It would be possible to find traces of Koerner's other Romantic qualities in these works. The way in which they are composed and the way in which our eye is led to vast horizons could encourage us to see our own moods and thoughts in the sea, sky and mountains. And perhaps this risks leading us into a kind of sentimental 'kitsch'. The lack of strongly characterized figures and actions, combined with the vast views, could be said to encourage our subjective response: we are thrown back on our own resources of feeling and thought in order to discover meaning. Rather than being offered any firm guidance we are offered the mystical and indeterminate views. There's a kind of irrationality or illogic about these paintings. Remember, from your work on the audio-cassette, how *Cross in the Mountains* placed us in an ambiguous viewpoint, our feet either on the mountain's slope or floating in midair. In *Wanderer above the Sea of Fog* there is a similar ambiguity. Do we view the scene from the rock in the foreground, or do we float in space with the clouds? The

fog itself is mysterious (as fog should perhaps be) – hiding some areas yet folding back to reveal others in some detail. Some trees and rocks seem to have been delicately painted over a white ground representing fog, so that they emerge in some detail, while others have been painted over in white or grey.

Priorities in Friedrich's style

I said earlier that no single style can be said to be typical of the Romantic movement. However, we can see from *Monk by the Sea, Wanderer above the Sea of Fog* and *Cross in the Mountains* how the particular style used in them differs from David's and seems to suggest different ideas and values. In these works by Friedrich we have single figures placed at pivotal positions in a landscape. Furthermore, our empathy with them is established in a particular way: Friedrich's 'Wanderer' turns away from us while David's 'Brutus' faces towards us. David sometimes isolated some individual figures but placed others in coherent groups. Friedrich grouped figures more rarely, as in *Moonrise over the Sea* (Colour Plate 61) where the figures gaze at the moon, interpreted by some of Friedrich's contemporaries, through traditional **iconography**, as a symbol of Christ and the consolation he offers. Friedrich gives us an ambiguous viewpoint whereas David uses architectural settings and linear perspective to control more tightly our view of a scene. David's figures are in more enclosed spaces and more highly individualized by their facial expressions, poses and gestures. The lines of his figures and objects are much clearer and bolder, and there are more vivid contrasts of colour. These differences of style (of composition, light and colour) seem to point to different priorities: David arranges people and objects so that they adopt clearer positions in relation to one another. His style is didactic in that it directs the viewer to a particular viewpoint. Friedrich uses style to suggest a more uncertain, contemplative and 'unearthly' relationship with nature. But this latter point is not true of *all* the art we might call 'Romantic'.

Friedrich was concerned with arousing feeling, with providing a view into a landscape which would encourage us to respond emotionally and spiritually. *Abbey in the Oak Forest* was the inspiration for a collection of sonnets by the Dresden poet Theodor Korner which was published posthumously in 1815. Korner died in 1813 when fighting as a volunteer soldier in Germany's war against Napoleon. Napoleon invaded Germany in 1806 in a bid to extend France's territory and power. One of Korner's sonnets contained the words, 'Here I boldly trust my heart;/Cold admiration I shall not have – no, I feel,/And in feeling art completes itself' (quoted in Koerner, 1990, p.110). This process of feeling or emotion was felt to be important both in the creation and the appreciation of a Romantic work of art.

Look at Georg Kersting's portrait *Caspar David Friedrich in his Studio* (Plate 153). The studio is stripped bare of all distractions. Friedrich often

used observational sketches of particular natural motifs (trees, leaves and so on) in his paintings (see *Plant Study*, Plate 154), but he did very few compositional sketches of the kind we saw by David. He liked to compose a total composition in his 'mind's eye' before proceeding to work on the canvas, first drawing outlines then painting. He said:

> The artist should not only paint what he sees before him, but also what he sees within him. If, however, he sees nothing within him, then he should also omit to paint that which he sees before him. Otherwise his pictures will resemble those folding screens behind which one expects to find only the sick or even the dead.
>
> *(quoted in Vaughan et al., 1972, p.103)*

Friedrich also said, 'Close your bodily eye, so that you may see your picture first with the spiritual eye. Then bring to the light of day that which you have seen in the darkness, so that it may react upon others from the outside inwards' (quoted in Vaughan *et al.*, 1972, p.103). These attitudes are very similar to those of Schelling who, as we've seen, thought that artists should rediscover spiritual and creative forces beneath the outer appearance of natural things and use these same natural appearances to bring the viewer closer to the spiritual depths of nature (see above, p.186). Appearances alone ('that which he sees before him', in Friedrich's terms) are empty and insufficient. If we look at a work such as *Woman before the Setting Sun* (Colour Plate 62) we can see how Friedrich's figures, often with their backs to us, invite us to identify with their experience of the natural world.

Art as a language of feeling

Unlike David who, we assume, was keen to impress viewers with the intellect and skill in his work, Friedrich sets aside a much greater role for personal and individual feeling in both artist and viewer. There is a kind of emotional power in David's work and a measure of uncertainty about how we should respond to Brutus (hero or criminal?), but there are also more explicit attempts to place us in an identifiable time and place which call on our intellectual understanding. For Friedrich, art becomes a language of feeling which gives precedence to subjective experience:

> The artist's feeling is his law. Pure sensations [feelings] can never be in contradiction to nature, but only in agreement with her. However, the feeling of another person should never be imposed upon us as a law. Spiritual affinities produce similar works, but this kind of relationship is far removed from mimicry.
>
> *(quoted in Vaughan et al., 1972, p.103)*

In other words, although art should arouse feelings in both artist and viewer, there is no law dictating *which* feelings should be experienced, nor any guarantee that those experiencing the same feelings will express them in exactly the same way.

Central to Romanticism was the idea that the individual, the unique and the subjective defy any attempts at uniform or 'closed' interpretations of art and that laws and rules are inappropriate. We have already seen how *Cross in the Mountains* defied any easy interpretation, despite the fact that Friedrich himself provided a 'key' to the meanings of its symbols. If we read Friedrich's art on the simple level of rock = faith; moon = Christ, we are denying its complexity (see Unit 1, Section 6). His art also defied many of the rules and traditions of previous art. Open and elusive meaning is essential to the Romantic ideal. But this has not prevented commentators from imposing on Friedrich's works meanings which derive from their cultural and political context, much as I have done in my references to Schelling, Kosegarten and Friedrich's own writings. Are we failing to respect the essence of Romanticism by proceeding in this way? In the final part of this section we'll look briefly at how political meanings have been attached to Friedrich's works.

Politicizing Romanticism

Cross in the Mountains could have conveyed political meanings to contemporary viewers. Friedrich designed the painting for and dedicated it to King Gustav IV Adolf of Sweden, the ruler of that part of Pomerania in which Friedrich was born. Gustav was a foe of Napoleon, who, you will remember, had invaded Germany in 1806. He brought Sweden into a European coalition against the French and negotiated an alliance with England in Dresden during the years 1803–5. The arched shape of the frame of *Cross in the Mountains* was considered to be in a Neo-Gothic style. The Gothic had particular associations in Germany at this time. Considered (wrongly) to be a native medieval style, it was seen by many of Friedrich's contemporaries as an antidote to all things French – French eighteenth-century Enlightenment ideas with their emphasis on classical culture, the 'grand' and socially sophisticated, for example. (Ironically, the real origins of the Gothic were French.)

French Neoclassicism was felt to emphasize a universal, intellectually elevated classical culture which had pretensions to dominate artistic debate and practice. When Ramdohr hurled insults at Friedrich's *Cross in the Mountains* (see above, p.188) many of these were in French, commonly considered the educated language of Europe: he supported French art in the classical tradition. Friedrich hated Napoleon and the French. In 1808 he refused to receive letters from his brother Christian, who was travelling in Paris and Lyons.

Gustav IV was also a pious man, a member of the Moravian Church, a Protestant denomination which placed great emphasis on inward devotion and emotion. Friedrich's *Cross in the Mountains* may have been made with these beliefs in mind. One of Gustav's symbols was the midnight sun – possibly the inspiration for the rays of sunlight in the *Cross* and for those shining out from the eye of God in the predella (base

of the frame). Unfortunately, Gustav's political situation changed rapidly and by the time Friedrich was ready to hand over *Cross in the Mountains* Gustav had been overthrown. His painting was then bought by the Count von Thun-Hohenstein for the private chapel of his Tetschen castle, at the request of the Count's wife.

All of this seems to amount to circumstantial evidence for a political reading of *Cross in the Mountains*. There is no doubt that Napoleon's invasion of Germany in 1806 led to subsequent anti-French feeling and to an explicit desire on the part of intellectuals to promote a quest for national unity, for a unified German state established by constitution and governed democratically with the consent of its citizens (ironically, the same aims as those of French revolutionaries). Wars of liberation were successfully fought by different German states, and their victory over Napoleon and the French was celebrated in 1814.

With this in mind, there have been many attempts to read messages of German nationalism into Friedrich's works, not least because he drew his inspiration from German landscapes such as his native Pomerania and the peaks and forests of the Riesengebirge mountains (south-east of Dresden) which he toured. According to tradition, for example, his *Wanderer above the Sea of Fog* shows a particular person, a high-ranking forestry officer, Col. Friedrich Gotthard von Brincken, of the Saxon infantry. He is wearing the green uniform of volunteer rangers – detachments called into service against Napoleon by King Friedrich Wilhelm III of Prussia. This man was probably killed in 1813 or 1814. So is the painting a patriotic tribute to an individual, or would such a meaning be too closed or specific?

It's true that we can come closer to answering such questions by adopting the 'mindset' of Friedrich's contemporaries and by reading signs and signals as they would have done. When visited in his studio, for example, Friedrich is reported to have declared that the men in *Two Men Contemplating the Moon* (Colour Plate 63) were 'plotting democratic intrigues' (Koerner, 1990, p.241). The figures are thought to represent Friedrich and a student. In early nineteenth-century Germany many universities were centres of nationalistic, anti-Napoleonic sentiment. During the wars of liberation such sentiments could be expressed by wearing an 'old German' (*altdeutsch*) costume, a revival of a much older fashion of the late Middle Ages and early Reformation. This consisted of high-waisted, high-collared, long-sleeved dresses for women and broad velvet hats, stand-up collars, short black jackets, soft leather shoes, bushy beards or sideburns, shoulder-length, unpowdered hair and wide cloaks for men. After Germany's liberation and Napoleon's defeat of 1815, 'German societies' with names such as Teutonia, Vandalia, Germania and Arminia were formed by students who banded together in larger groups rather than staying in their earlier regional circles. Their colours were black, red and gold and they sang patriotic songs. The moon, as mentioned earlier, was often interpreted as a symbol of Christian hope

and redemption. Its appearance in *Two Men Contemplating the Moon* links a Christian symbol with these other references to political regeneration.

We know that Friedrich made some works with an explicit and intentional political meaning. One of the works he exhibited at the 1814 Dresden exhibition to celebrate liberation from the French was *The Chasseur in the Forest* (Colour Plate 64). This shows a man in the uniform of Napoleon's cavalry, without his horse and about to enter a dark German forest. Again, uniform and context combine to encourage a reading of this painting as a reference to the vanquishing of the French foe.

Evergreen forests have often been associated with Germany or, more broadly, Northern Europe, not only because there are many of them there (there are, after all, many evergreen forests in other countries) but because myth, literature and history have combined to make the association between such forests and German national identity, particularly in more recent times when we have become more interested in the ways in which national identity can be expressed. (Think of the way in which white cliffs are often seen as a symbol of England.) Oak trees were often seen as references to Germany's pagan past while evergreens indicated eternal Christian faith. Germany's woodlands were also associated in the public imagination with its strength and valour.

In his *Decline and Fall of the Roman Empire* (1776–88) the historian Edward Gibbon spoke of the German barbarians who had 'issued from the woods' to challenge the power of the Romans and their empire. He spoke of the ancient German tribes as less civilized and well organized, but more brave and 'manly' than their enemies (see Eliot and Stern, 1979, pp.248–68). Rome was sacked by Alaric and the Goths in 410 CE. In the eighteenth century, Gibbon regarded the ancient Germans as important forefathers of modern European nations. In the nineteenth, native German landscapes were still seen as a cultural reply to David's Romans.

4 CONCLUSION

In this unit we have looked at the ways in which a historical, contextual analysis of the paintings of David and Friedrich can enrich our understanding of their potential meanings. We've seen the need for a careful examination of evidence when making connections between a painting and its historical and cultural context. We've also identified the differences between the rational spaces and linear clarity of David's didactic Neoclassical style and the more mysterious effects of Friedrich's Romantic art, which seem to invite a subjective response from the viewer.

We have seen how some very different works of art relate to, and are illuminated by, the historical and cultural contexts in which they were produced. We've also seen how the spectator's historical viewpoint can facilitate particular interpretations of both the style and subject-matter of a work of art. David and Friedrich produced works which might be seen to express two very different kinds of patriotism, one inspired by a reaction to an autocratic style of government, the other by foreign invasion. In each case, to return to our initial questions, the styles they chose were expressive of broad historical and cultural issues. Such connections can be explored by careful argument and accumulation of evidence. In this way, pictorial form and history become mutually illuminating.

GLOSSARY

bacchanalian relates to drinking and drunken revels. Bacchus was the Roman god of wine.

Enlightenment intellectual movement of the eighteenth century dedicated to the emancipation of knowledge from fear and superstition and to the use of independent reasoning and science.

form in painting, the choice and arrangement of line, colour, shape and paint (in the sense of arrangement, 'form' is often interchangeable with 'composition') and the treatment of pictorial space. More broadly, analysis of a painting's form can include discussion of facial expression and pose. When such factors are considered in relation to meaning, they are often evaluated in terms of our knowledge of the conventions of life and art as well as in more purely visual formal terms. This process is discussed in Section 7 of Unit 1.

iconography systematic study of aspects of a painting's subject-matter (as opposed to style) and their traditional significance. The term is sometimes used more narrowly to refer to pictorial symbolism.

Neoclassical see **Neoclassicism**

Neoclassicism artistic movement prevalent in art and architecture in the second half of the eighteenth century and in subsequent revivals. Neoclassical paintings dealt with a number of historical periods and subjects and included a range of stylistic nuances but the term Neoclassicism is most often associated with the ancient Greek and Roman subjects and the austere style of the French artist Jacques-Louis David and his contemporaries. David's Neoclassical style was characterized by clarity of line, logical and balanced composition, restrained facial expression, bold effects of light and a minimum of distracting detail.

pantheism belief that God is present everywhere in creation; identifying God with the universe.

rococo artistic style popular in early to mid-eighteenth-century France. This style was characterized by asymmetric shapes and compositions, S curves, pastel shades and the delicate, erotic painting of flesh. The term 'rococo' derives from the French word *rocaille*, meaning rock and shell work, and originally carried pejorative overtones of the decorative and frivolous.

Romantic see **Romanticism**

Romanticism artistic and literary movement prevalent in the late eighteenth and early nineteenth centuries and in subsequent revivals. Romanticism was established in opposition to the rational, intellectual approach of Neoclassicism. It gave precedence to the expression of the artist's subjective feelings, the mystical, the sublime and the obscure. The movement was prevalent in Britain, Germany and France, where artists working within Romanticism adopted a variety of stylistic expression.

style particular cluster of formal characteristics, identifiable with specific artists, groups of artists, phases in the careers of artists, or with a historical period.

REFERENCES

BROOKNER, A. (1980) *Jacques-Louis David*, London, Chatto & Windus.

CROW, T.E. (1985) *Painters and Public Life in Eighteenth-Century Paris*, New Haven and London, Yale University Press.

DU FRESNOY, C.A. (1973 edn) *L'Art de peinture*, Geneva, Minkoff (reprint of 1673 edition).

EITNER, L. (1970) *Neoclassicism and Romanticism, 1750–1850*, vol.2, Englewood Cliffs, Prentice-Hall.

ELIOT, S. and STERN, B. (eds) (1979) *The Age of Enlightenment*, vol.1, London, Ward Locke Educational/The Open University Press.

HERBERT, R. (1972) *David, Voltaire, Brutus and the French Revolution: an essay in art and politics*, Harmondsworth, Penguin.

HONOUR, H. (1979) *Romanticism*, Harmondsworth, Penguin.

KOERNER, J.L. (1990) *Caspar David Friedrich and the Subject of Landscape*, London, Reaktion Books.

MCWILLIAM, N. (ed.), SCHUSTER, V. and WRIGLEY, R. (1991) *A Bibliography of Salon Criticism in Paris from the Ancien Régime to the Restoration, 1699–1827*, Cambridge University Press.

VAUGHAN, W. (1980) *German Romantic Painting*, New Haven and London, Yale University Press.

VAUGHAN, W. (1994) 'Landscape and the "Irony of Nature"', in K. Hartley *et al.*, (eds) *The Romantic Spirit in German Art, 1790–1990*, London, South Bank Centre, National Galleries of Scotland and Oktagon Verlag, pp.184–90.

VAUGHAN, W., BÖRSCH-SUPAN, H. and NEIDHARDT, H.J. (eds) (1972) *Caspar David Friedrich 1774–1840: Romantic landscape painting in Dresden,* London, Tate Gallery catalogue.

SUGGESTIONS FOR FURTHER READING

You may find it helpful and interesting to look at one or more of the following:

CROW, T.E. (1985) *Painters and Public Life in Eighteenth-Century Paris*, New Haven and London, Yale University Press.

HONOUR, H. (1968) *Neoclassicism*, Harmondsworth, Penguin.

HONOUR, H. (1979) *Romanticism*, Harmondsworth, Penguin.

ROBERTS, W. (1989) *Jacques-Louis David, Revolutionary Artist: Art, Politics and the French Revolution*, Chapel Hill, NC and London, The University of North Carolina Press.

VAUGHAN, W. (1994) *German Romantic Painting*, 2nd edn, New Haven and London, Yale University Press; first published 1980.

UNIT 13
READING WEEK

Like Study Week Seven, this is a reading week and a chance for you to catch up, consolidate or get ahead. There is one television programme for you to watch, TV13 'Classical and Romantic Music', and you also have a TMA to complete.

INDEX TO BLOCK 3

This index includes references to the Colour Plates and Plates in the *Illustration Book*; these are indicated by 'CPl' for Colour Plates, and 'Pl' for Plates.

AN INTRODUCTION TO THE HUMANITIES

Block 1 Form and Reading

Study Week 1 Seeing
Study Week 2 Form and Meaning in Poetry: the Sonnet
Study Week 3 Listening to Music
Study Week 4 Reasoning

Block 2 The Colosseum

Study Week 5 The Colosseum
Study Week 6 The Colosseum Tradition
Study Week 7 Reading Week

Block 3 History, Classicism and Revolution

Study Weeks 8 and 9 Introduction to History, Part 1: Issues and Methods
Study Weeks 10 and 11 Rousseau and Democracy
Study Week 12 Art, History and Politics: David and Friedrich
Study Week 13 Reading Week

Block 4 Religion and Science in Context

Study Weeks 14 and 15 Studying Religion
Study Weeks 16 and 17 Here's History of Science
Study Week 18 Reading Week

Block 5 Myths and Conventions

Study Week 19 Studying *Pygmalion*
Study Weeks 20 and 21 *Medea*
Study Week 22 Expression and Representation in Music: Richard Strauss's *Don Juan*
Study Week 23 Jean Rhys: *Wide Sargasso Sea*
Study Week 24 Reading Week

Block 6 The Sixties: Mainstream Culture and Counter-culture

Study Weeks 25 and 26 Introduction to History, Part 2: Writing History
Study Week 27 Counter-movements in Science
Study Week 28 Religion and Counter-cultures in the 1960s
Study Week 29 Change and Continuity: Music in the 1960s
Study Week 30 Rothko and Warhol

Block 7 Looking Back, Looking Forward

Study Weeks 31–2